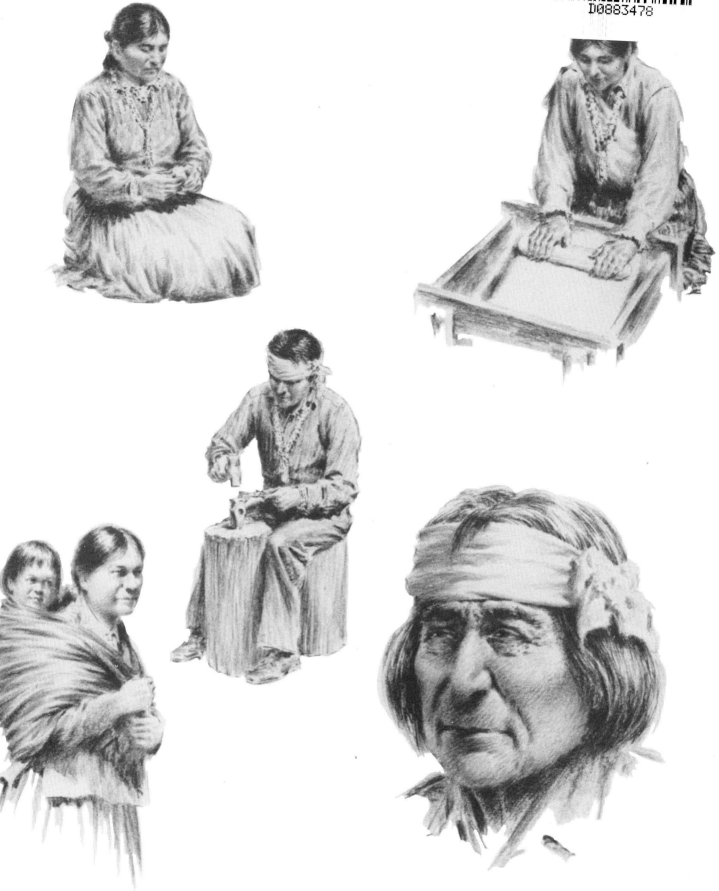

INTRODUCTION
TO
AMERICAN INDIAN
ART

WALSWORTH
Marceline, Mo., U.S.A.

INTRODUCTION
TO
AMERICAN INDIAN
ART

TO ACCOMPANY THE FIRST EXHIBITION OF
AMERICAN INDIAN ART SELECTED ENTIRELY
WITH CONSIDERATION OF ESTHETIC VALUE

The Rio Grande Press, Inc.

GLORIETA, NEW MEXICO · 87535

Two volumes in one.

First editions from which this edition
was reproduced were supplied by
MacRAE'S INDIAN BOOK DISTRIBUTORS
P. O. Box 2632
Santa Rosa, Calif. 95405
Which, with certain exceptions, is the
exclusive supplier of this title
to the book and museum shop trade.

A RIO GRANDE CLASSIC
First Published in 1931

LIBRARY OF CONGRESS CARD CATALOG 70-119862
I.S.B.N. 87380-047-8

Third Printing 1979

GLORIETA, NEW MEXICO · 87535

Publisher's Preface

Some years ago, we chanced upon these two scarcely-remembered volumes, first published in 1931 for the Exposition of Indian Tribal Arts in New York. Both books were paperbound, in a depressingly dilapidated state. Carefully we repaired them as best we could. They became one of our library treasures, always interesting, and because of the fine bibliography, always useful. For us, they truly were an "introduction" to the beautiful, graceful and colorful art of the American Indian. The various brief essays, each by a very real authority on the subject, are miniature masterpieces of popular writing on a subject many felt (in 1933) was esoteric.

Paperbound books are generally called "ephemera" by scholars and librarians, for they invite disregard and even destruction as the cover and the binding deteriorate with use or age. Originally, Part I was published in an 8½ x 11 inch format; Part II was published with 7¼ x 10¼ inch dimensions.

Part I contained nine color plates, and Part II contained one color plate. Each color plate in each volume was hand-tipped into place on the page--a time-consuming, and today, a prohibitively costly hand operation. After a great deal of thought and experimentation, we found there was no way we could practicably or economically print this book with color plates. Our options finally boiled down to (a) abandoning republication altogether, or (b) reproducing the 10 color plates in black and white instead of in color.

We chose the latter option. The color plates in the first edition were poorly printed to begin with, and the use of color in the first edition was not functional. We have therefore simply ignored the color to render the color plates as black and white halftones. While we would have liked to use color, the use of color was not essential to either the subject of the plate or the text. So here they are, all of the original halftone engravings (both color and black and white) printed better in this edition than they were in the first edition.

The elimination of color has enabled us to reduce the retail price of the book from our preliminary estimate, thus making the volume accessible at a modest

cost to a somewhat larger market. We always do this when we can. Our purpose and reason for being is not so much to make a million dollars overnight as it is to salvage some of the fine old books that might otherwise be forgotten and lost altogether. We are not moved totally by altruism, of course, but it is a potent factor in our operations.

We naturally had to enlarge Part II from the original size to fit into and integrate with the original size of Part I. This enlargement of Part II enhances the art considerably, and makes also for easier reading.

We have not indexed this title, as the character of the text does not really lend itself to useful indexing, and anyway, it is the kind of a book that does not really need indexing. We might mention that the first edition of both titles did not carry a table of contents, but we have added one. Both of the first editions amounted to, in effect, a binding together of a number of pamphlets on a variety of subjects, hence there is an oddness of format--especially in Part II--which we ourselves liked but which was impractical for a fully bound book. Each of the various papers started with page one, as in a pamphlet. We have put in a page folio number starting with one and carrying through in sequence to the end of the book.

We invite the reader to regard one of what we consider the most valuable features in the entire book--the bibliography on *Books on Indian Arts North of Mexico,* by Ruth Gaines of the Huntington Free Library in New York. According to Miss Gaines, it is not a complete listing of books on the various subjects, but in our opinion it is a very good *incomplete* listing, if incomplete it is. Confucious says that an incomplete bibliography is better than no bibliography at all.

We offer this handsome title as the 69th in our continuing series of beautiful Rio Grande Classics--magnificent reprints of distinguished Western Americana. Even with its occasional printing flaws (faithful reproductions of the same flaws in the original printing), we are delighted that this fine overview of a long-neglected subject has been finally restored to usefulness. First editions of what we have published here are real treasures, quite valuable on the rare book market. Wherever the original books exist, they should be stashed away and saved for the generations of book lovers to come. Our edition--this sturdy volume--is the one to be used, as it can easily be replaced while the first editions cannot.

Robert B. McCoy

La Casa Escuela
Glorieta, N. M.
December 1970

Limitations of space have made it impossible to cover all phases of any one craft in this Introduction, or to go into questions of technique. A series of pamphlets has been prepared specially for the Exposition by the leading authorities in the various fields, in which will be found complete, popular treatments of the different arts.

The grouping and installation of this Exhibition is the work of
LA FARGE AND SON, *Architects*

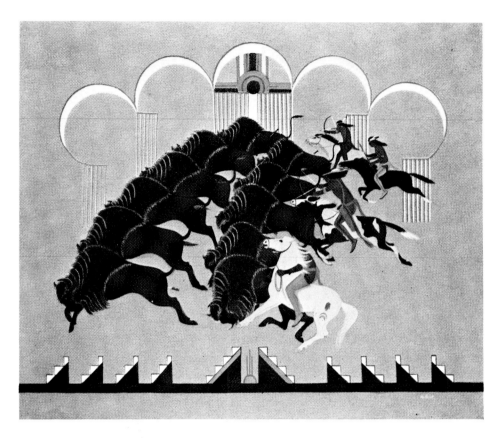

Plate I

INTRODUCTION
TO
AMERICAN INDIAN
ART

TO ACCOMPANY THE FIRST EXHIBITION OF
AMERICAN INDIAN ART SELECTED ENTIRELY
WITH CONSIDERATION OF ESTHETIC VALUE

THE EXPOSITION OF INDIAN TRIBAL ARTS, INC.

Table of Contents

LIST OF ILLUSTRATIONS

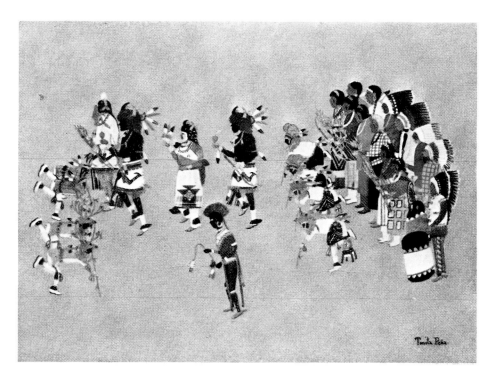

PLATE II

INTRODUCTION

TO

AMERICAN INDIAN ART

by

JOHN SLOAN & OLIVER LAFARGE

THE American Indian race possesses an innate talent in the fine and applied arts. The Indian is a born artist; possessing a capacity for discipline and careful work, and a fine sense of line and rhythm, which seems to be inherent in the Mongoloid peoples. He has evolved for himself during many thousand years a form and content peculiarly his own. We white Americans have been painfully slow to realize the Indian's value to us and to the world as an independent artist, although his work has already won recognition abroad.

Our museums have collected Indian manufactures with scientific intent, placing as it were, the choice vase and the homely cooking pot side by side. Bound by the necessity of giving a whole picture they have not been able to set forth their many beautiful specimens in an advantageous manner.

The casual tourist who goes out to the Indian country likes to bring back some knickknack as a souvenir and proudly displays it as a "genuine Indian" article. Unhappily, Americans know the art of the Indian chiefly through such cheap curios made for the gullible white man. Looking upon the Indian himself as a curio, and with this cast of mind failing to recognize the high artistic value of the best Indian products, if indeed he ever sees them, the tourist will not pay the price

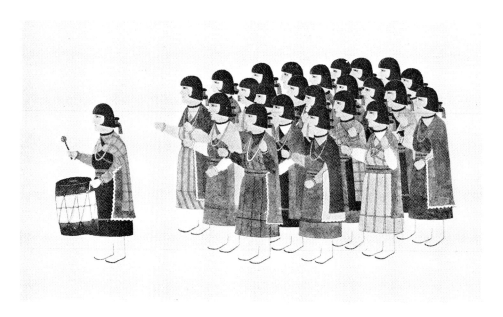

PLATE III

which any craftsman must ask for the mere time, labour and materials involved in his work. Thus the whites have forced the Indians, often extremely poor and in need of money, to meet their demand for little, sweet-grass baskets, absurd bows and arrows, teapots, candlesticks, and any number of wretched souvenirs which they never made until white men decided that these, and these only, were "genuine Indian souvenirs."

It is a far cry, indeed, from such miserable knickknacks to the water-colours of young Pueblo Indian artists, reproduced in this book. To any sensitive person, it is obvious that on the basis of these alone, our "curio concept" of the American Indian must be revised. Here are young men steeped in an ancient tradition and discipline who, coming into contact with our pictorial art, have not copied it, but evolved for themselves from their own background new forms—different for each tribal or cultural group—as satisfactorily Indian as the beadwork or the silverwork which Sioux and Navajo evolved from similar contacts, a new force coming directly into our world of art.

In these pictures we see the object combined with the artist's subjective response to it—a union of material and technique both symbolic and intelligible. These young Indians have applied to the painting of their pictures the discipline of line and colour developed through many centuries of decorating every imaginable object of daily or sacred use with designs innately suited to the objects decorated and charged with traditional cultural concepts. Simplicity, balance, rhythm, abstraction, an unequalled range of design elements, and virility, characterize the work of the Indian today.

The Indian artist deserves to be classed as a Modernist, his art is old, yet alive and dynamic; but his modernism is an expression of a continuing vigour seeking new outlets and not, like ours, a search for release from exhaustion. A realist, he does not confine his art to mere photographic impression, nor does he resort to meaningless geometric design. In his decorative realism he combines the elements of esthetic and intellectual appeal. He is a natural symbolist. He is bold and versatile in the use of line and colour. His work has a primitive directness and strength, yet at the same time it possesses sophistication and subtlety. Indian painting is at once classic and modern.

15

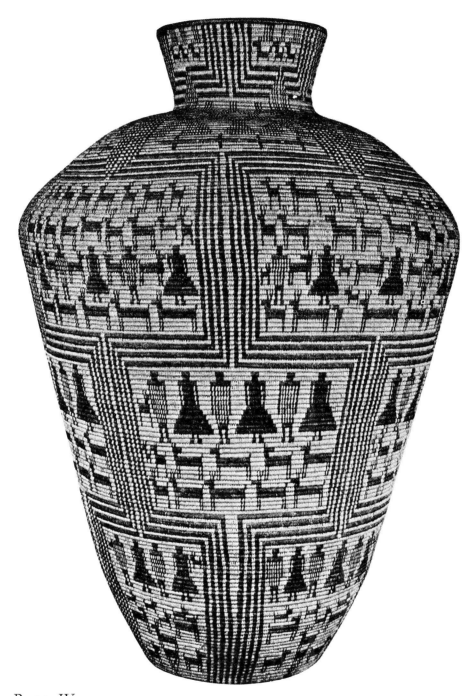

Plate IV

SUCH mastery does not spring up overnight out of nothing. Behind it is, not centuries, but thousands of years of development. At this present day we have only to turn from the paintings to the decorative arts of the tribes that have kept their crafts intact, to perceive all the elements from which the painters derive, within the limitation of applied design and utilitarian control of form—discipline, rhythm, colour, vigour, suitability, mastery of technique, and constantly recurring development of new methods and new forms.

We do not know what direct painting, realistic or purely decorative, may have been done on skins and wood and other material in ancient times. Probably there was plenty of it, but it has been lost to us. The oldest art traced in its course by the archæologist, and the most widespread, is basketry. Its bewildering diversity exhausts the possibilities of weave, material and shape, from the huge storage baskets of the Apaches to the tiny California creations with their infinitesimal stitches—hopeless to try to list them here. One thing may be said with emphasis, for the guidance of any white man who wants to buy something really Indian:—be it basket, necklace, robe or bow, if it be not well and truly made, an evidence of fine workmanship, and in good taste, it is not really Indian.

We have illustrated here two examples; one, Apache, is big enough for one of Ali Baba's thieves to hide in and tightly woven enough to hold the oil; the other, Pomo, is a small affair about the size of a sewing basket. The relative coarseness and fineness of the splints are nicely adjusted to the strength required in each case. In both, the shape is suitable, the curves have harmony. The big Apache storage basket is decorated with many small figures, some geometric, some naïvely approaching realism, arranged apparently at the weaver's pleasure. There is nothing to say to the beholders, "here is a pattern," or "the composition runs this way." Yet one's sense of ease in looking

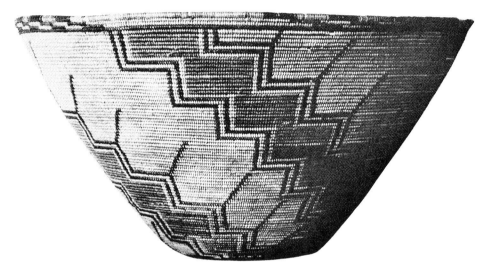

PLATE V

at it tells immediately that the maker's pleasure was an artist's sense of arrangement; less obvious than most Japanese prints, pattern is still there. Material, decoration, shape and size all belong together, all are part of a whole, without the least demonstration of effort toward the result achieved.

The Mono carries an obvious design with a frank, centripetal pattern. Stepped arrangements of squares with radiating, small diagonals are so placed on the curved surface as to assume the qualities of incomplete spirals. The shape of the basket has been used to achieve the design, and at the same time the decoration emphasizes the shape, much as in a pen and ink drawing of a round object, shading and highlights make its form apparent.

Restrictions of space limit us to these illustrations, but the same qualities will be found in any good examples of this ancient art, from the Basketmaker work of four thousand years ago, to the best of present day Hopi and Jicarilla weaves with their joyous colours. These colours, of course, are derived from the white man, and therefore the bright baskets are deprecated by ethnologists. The Indian, fortunately is not an ethnological specimen, any more than he is a curio, but a live man with his own initiative. His arts must grow, he cannot be kept from adapting to his own uses such of our materials as suit him. Thus in the beaded Paiute baskets shown in this exhibition, one of our ablest basket weaving tribes has developed a new form of an old decorative technique; since early times the California Indians have applied shell beads in amounts limited by the difficulty of making them; now, commercial beads being obtainable in quantity, they are covering whole baskets of appropriate shapes, with designs suitable to the technique. Under the influence of white buyers, it is true, they are sometimes led to adorn these with the fancy pseudo-symbols of the curio, but in these restrained and dignified specimens exhibited one can see only a desirable and handsome new development of the oldest craft.

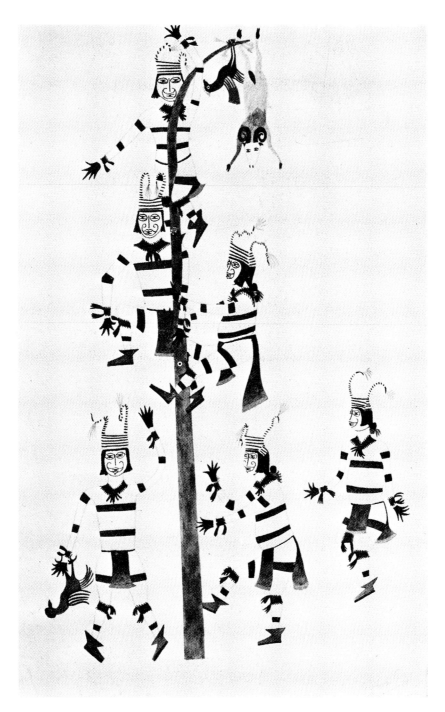

Plate VI

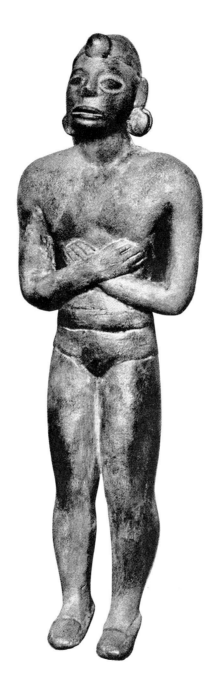

PLATE VII

21

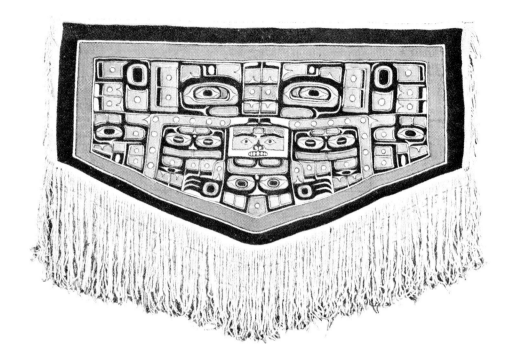

PLATE VIII

BASKETRY may be called the mother of weaving. That craft, though never as widespread, seems to be nearly as old. The ancient Basketmaker textiles already present many design elements familiar to us now in Navajo blankets, ceremonial altar paintings, and the pictures of the modern Pueblo school. Before the white man came, fabrics were made of cotton, yucca fibre, bark fibre, strips of fur, twine bound solidly with vari-coloured feathers, and the hair of wild animals. The greater ease of acquiring trade blankets and bright cloth from white men wiped out the craft in many sections. While today a fair number of tribes make sashes and other small pieces, often of complicated technique, there remain three major exponents of weaving:—In the Northwest, the Chilkat, in the Southwest, the Hopis, and the Navajos who borrowed their art from Hopis and Pueblos and have become the outstanding weavers north of Central Mexico.

The Chilkat blankets represent a survival of an ancient and primitive craft, going directly back to the days when the hair from the hides of wild animals was spun into yarn. The loom is crude, hardly more than a horizontal bar from which the warpstrings hang free, the weft being patiently twined in and out by the weaver's fingers.

The design is conditioned by the peculiar convention of the Northwest Coast. Under this convention an animal, often of ceremonial importance, is usually portrayed in a symbolic manner. Although theoretically full face, the entire animal is shown, actually as two complete profiles joined edge to edge. The head, trunk and limbs are arbitrarily and drastically rearranged to suit the design and the space occupied, and joints are indicated by depicting them as eyes—a narrow oval with pointed ends inside a rectangle with rounded corners. In a central space left vacant is placed another head, seen front view, as a filler. The whole, in a blanket, is executed in strong colours, bluish green, yellow, white and black.

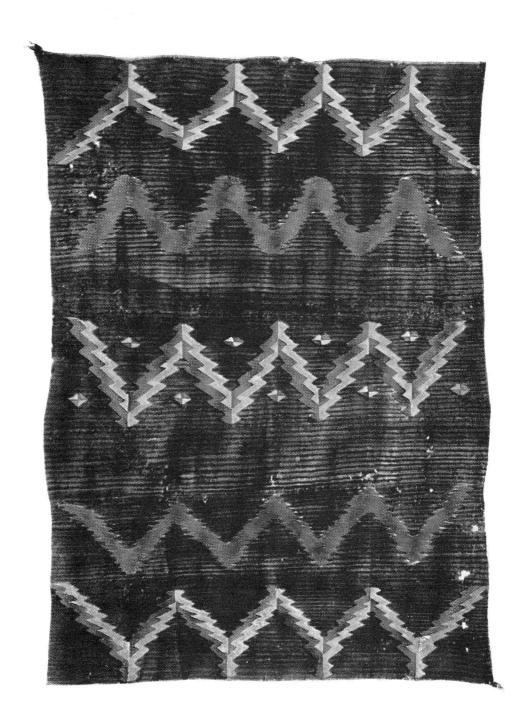

PLATE IX

This description sounds horrible. One look at the blanket in question, however, suffices to show that the actuality is, on the contrary, handsome. One does not perceive a portrayal of an animal, handsome or otherwise. When we see a representation of a highly conventionalized flower applied as a decorative motif in our art, we do not think of it as a tortured and grotesque object, but as a pleasing arrangement of line and colour, which we recognize, secondarily, as being derived from a flower, perhaps identifiable, perhaps not. The same thing is true of the Indian, although for certain ceremonial reasons he may want to have his blanket design associated with a given animal. That association, on the Northwest Coast is attended to by representing some well-known characteristic—such as the beaver's front teeth—which identifies the animal without interfering with the design.

What pleases us, what pleased the maker and the Indian who wore it, is the filling of this space with masses of variegated colour arranged in a logical pattern. Blocks of green, yellow, white and black, with some lines and small design elements such as the superfluous eyes to give emphasis and direction, are built up around a central space. The irregular order in which they are arranged is purposeful and successful. In the central space, placed usually above or below the exact centre, is a conventionalized unit which can be recognized as a face. In an area of relatively meaningless pattern, a face always holds the eye, centering the whole arrangement. Yet the blanket is not stupidly concentric. The lines of decoration rather lead around the central space, to a point of interest at the top—actually, the head of the symbolized creature. The net result is a balanced pattern of colours around a centre only mildly dominant, the whole being pleasing, not too obvious, and handsome.

Navajo blankets are a complete contrast. A versatile people, progressive, yet determined to advance in their own way, they have always borrowed freely. For the art of weaving, use of wool and other materials, various weaves, dyes, patterns, they have drawn upon Hopis, Pueblos, Spaniards, North Americans, even England and Germany. Yet the product which results from this assemblage is not only Indian, but deeply expressive of Navajo character.

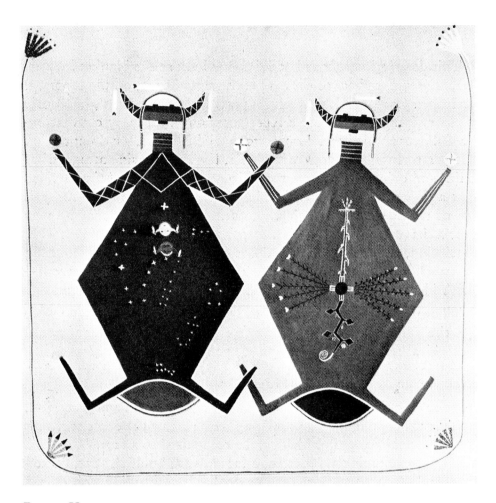

PLATE X

These blankets are not symbolic; despite the wild tales that some traders tell to innocent buyers, they do not "tell a story," they are not "ceremonial." True, some of the design elements are named, "Cloud, Big Star, Flint Knife, Tracks Meeting," and in a sacred dry-painting may represent such objects, but in a blanket they have meaning no more than it means we are thinking of a river in Asia Minor when we decorate something with a Meander pattern, or that we are fond of piercing and sucking eggs when we apply an egg-and-dart motif. Of course, just as a white man, fond of the sea, may choose a Greek wave design for his mantel-piece, so a Navajo woman may select of two suitable patterns, one with a happy symbolic association, but it is none the less true that the use of these designs is purely esthetic, successful or not according to the talent of the artist.

The essence of Navajo design is the arrangement and repetition of a few elements either in stripes or around a centre, or else spotting them against a plain or striped background with that extraordinary sense of spacing which is innate in the American Indian. Although in any one good blanket only a few design elements are to be found, examination of many pieces will show that they have at their command a wide variety from which they select with restraint and taste. Their choice of colours is strong, with contrast used as often as blending, but here again they limit themselves; in the best blankets, one seldom finds more than five colours or tones, including black and white.

In the past half century this art has been continually under one or another kind of deteriorating pressure from curio-minded white men. Bad aniline dyes, factory-spun yarns, sloppy weaving, bad designs, have been urged upon them again and again, resulting in a sharp decline in quality and value. Today, thanks to the growth of a small, intelligent demand, and encouragement from a few traders and outsiders, the art is on the upgrade again. There are still bad influences, notably towards superficially striking, dull, unusable designs coming violently into a centre, emphasized by a strong border—all non-Navajo characteristics—a demand for "curio" blankets full of fancy, wiggly decoration, and a sweat-shop system by which small blankets of standard pattern are turned out with the maximum possible rapidity.

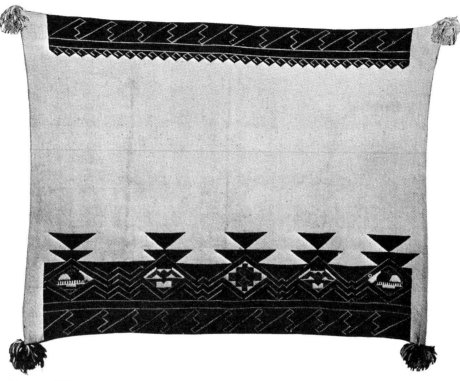

PLATE XI

A really good, modern Navajo blanket, if loosely woven is soft and warm, if tightly woven is smooth, flexible, and tough. The colours may be strong, but are not harsh; bright orange and purple do not occur. Undyed wool, black, grey and white, may be used. The handsomest, and most Navajo, have no border. Save for the sand-painting blankets, a new development of the Indians' own, no blankets portraying arrows, bows, thunderbirds, swastikas, animals or whatnot are really Navajo, no matter who wove them. The hideous lines of dancing figures alleged to be "ceremonial" are nothing but the reflection of white men's ingenuity and bad taste. A good Navajo blanket is dignified, strong, and has beauty that will stand being looked at for years. Plenty of poor weavers produce dull blankets, but from the artist's loom comes a work of art, for which a high price is asked, and which is well worth it.

Do not blame the Navajos, or any other Indians, for letting themselves be debauched into curio-makers. They are very poor, they have to make sales. If a barbarian market insists on gewgaws and "quaint souvenirs," they have to make them. If we will provide a demand for good things, the supply will appear immediately. It is to help create just such intelligent demand that this exposition is organized.

While Navajo women are the weavers, among the neighboring Hopis this work is done by the men, yet if the product of the two tribes be compared, Navajo blankets stand out as masculine, the Hopis showing greater virtuosity in their weaves, a quieter and weaker use of colour and design. Very ancient in type and strikingly beautiful are the Hopi ceremonial garments, embroidered in strong colours on a white cotton background. The most important are the wedding shawls, made by bridegrooms for their wives. The ground-colour is white, but across top and bottom run solid bands of black and green, allowing the background to show through in very fine negative designs. The lower border contains usually five diamond-shaped medallions in bright colours, true symbols of rain, butterflies or other important concepts, above each of which inverted, black triangles—rain clouds—rise into a white field. Here is real symbolism; each colour and each decorative line has significant meaning, but the symbols have been organized into a striking arrangement of unusual harmony.

29

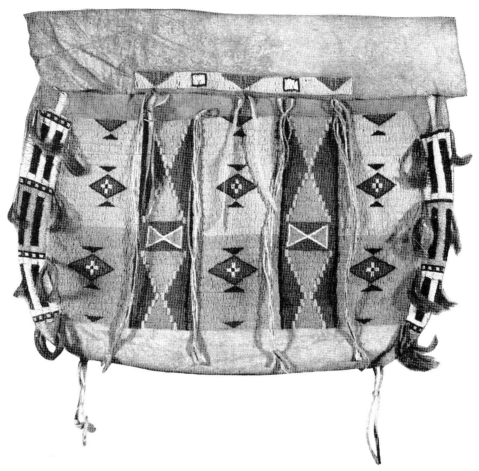

PLATE XII

BEADWORK

EVEN the weaving Indians made considerable use of skins for their clothing, and among many tribes weaving was never developed. Notably Plains Indians—the war-bonnet and tipi people—depended on hides, bison, deer, elk, bear, beaver, wolf, muskrat, rabbit and many others. Their bison-hide shields were tough enough to turn the stroke of an army sabre, their finest buckskin was pure white, soft and smooth as a delicate cotton fabric. Tipis, shirts, leggins, moccasins, skirts, cloaks, shields, bags, boxes, drums were made from skins, and all were adorned. Many were, and still are, simply painted. More striking in the old days was their porcupine quill work, the bright quills, dyed in strong colours, arranged in geometric patterns deriving almost always from the shape and use of the thing adorned. A noteworthy characteristic of Plains Indian applied design is its suitability.

The white man brought them ample supplies of beads, of many colours, which they promptly took over and put to characteristically Indian uses, partly replacing porcupine quill, and partly combined with it in new and richer combinations. Many collectors remove good beadwork from the objects to which it is attached, thereby depriving it of the vigour it derives from its well conceived application to that particular object, and reducing it to what it is merely in itself, a strip of handsome ornament. It is best seen and best appreciated in situ, whether on a small pouch, or all across the largest robe.

The range of design, with the distinguishing varieties for each tribe, is too great to describe here. Some Indians acquired floral designs from the French, many centuries ago, which, passing from tribe to tribe, have resulted in patterns as unlike the older, geometric type as the Chilkat blanket is unlike the Navajo. The Plains Indians have been quick to take up new elements, while fitting them into their

31

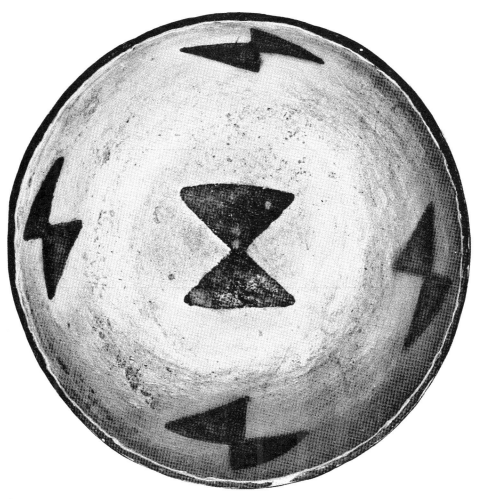

Plate XIII

older types, so that it is difficult to draw the line between what is, and what is not, truly Indian. They began depicting horses and American flags long ago. The criterion has to be largely one of taste, and of the Indian feeling. They turn out many silly things, such as ornamented rabbits' feet, or poorly conceived designs slapped onto factory made moccasins, but there are many of them even today who prefer the old, rich masses of decoration, containing still the vigour and brilliance of their ancient warriors.

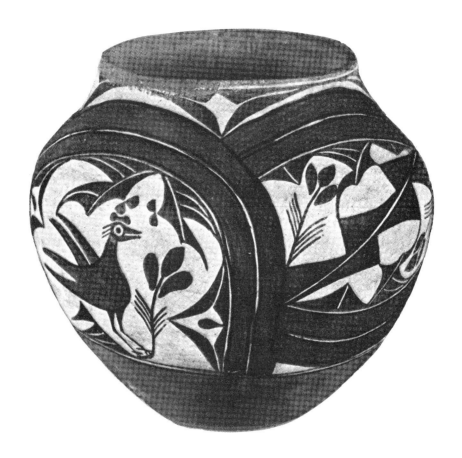

PLATE XIV

A PEOPLE moving about frequently, has little use for easily broken pottery. Ceramics were not developed until Indians, having discovered agriculture, began to stay put. But though the vessels may break, the pieces are almost indestructible; from shortly after the first nubbins of corn were harvested in the Southwest, archæologists can trace the history of the art, and even date the sequence of occupations by changes in style. Here, where we have a history documented over several thousand years, we can see how continuously the Indian improved, changed, revived old types, hit upon new and radical departures. The genius of individuals was evidently at work, even as in our own day Nampeyo of Hano and María of San Ildefonso have revolutionized pottery making in their respective villages, or as the Navajo, Tlah, in fear and trembling wove a sacred picture into a blanket, starting a new development among his people the results of which cannot yet be foretold.

To a weaving and basket-making people, pottery offered a smooth surface on which a curved line could be freely made, a wide choice of shapes, and a form and surface completed before the ornamentation was applied, instead of an unfinished object into which the design had to be worked while it was still making. There ensued, and still continues, a constant experimentation in design, treatment of surface, and methods of manufacture. The modern Pueblo potter has at her disposal one of the richest and most complete stores of design elements in the whole world. There is hardly anything from a Greek wave through a Norman dog-tooth to a Modernist abstraction of a leaf that one cannot find.

The nine pieces shown here do not begin to cover the whole range. Each Pueblo has its own favoured shapes, colours, and designs. As in

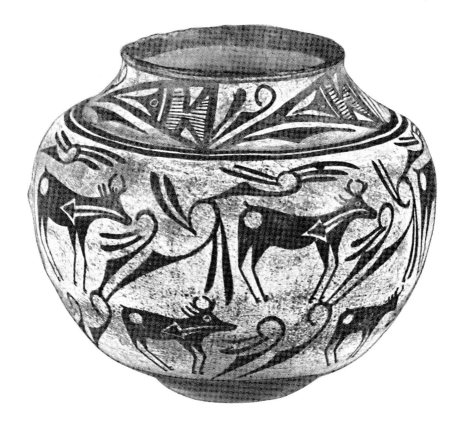

PLATE XV

36

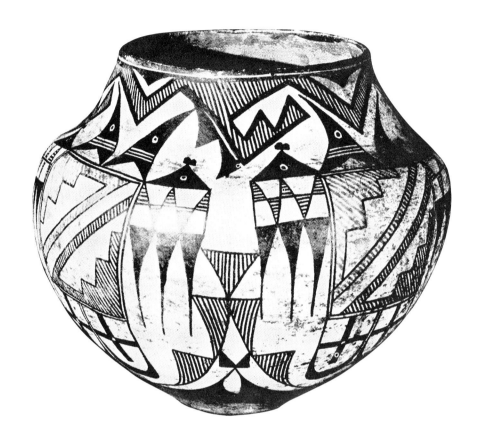

PLATE XVI

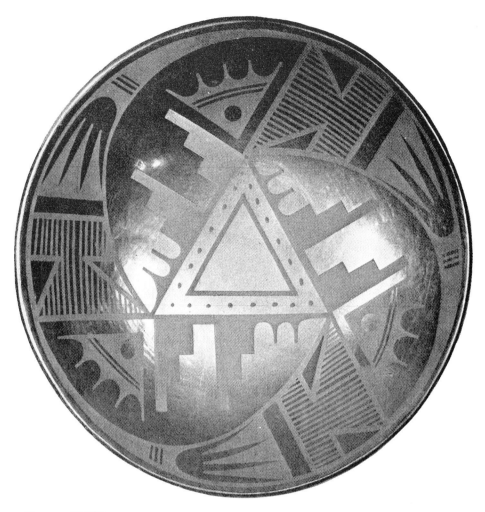

PLATE XVII

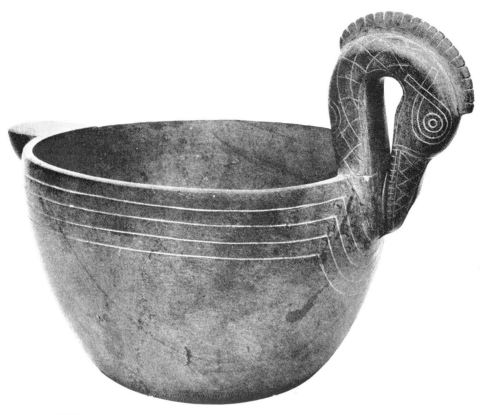

Plate XXV

39

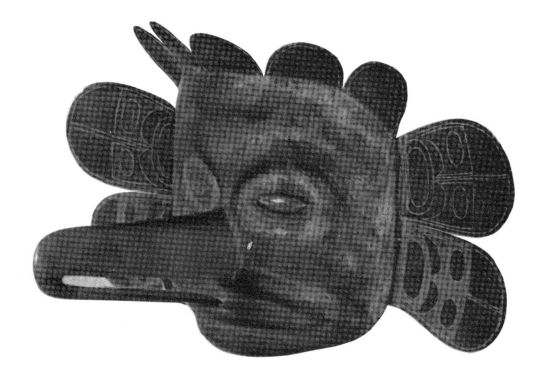

PLATE XXVI

the jar from Zia, complicated figures are built up partly by combinations of elements, partly by reducing realistic figures into patterns often far removed from their originals, and these arrangements are applied with a nice sense of balance, of the shape of the jar, and of the strong motion which the designs often possess. Realism is not uncommon, animals and plants being slightly conventionalized, or shown with accuracy and charm, combined with designs which may or may not carry an appropriate symbolic meaning.

From the pottery one sees the trail leading directly to the modern Pueblo painters. In pictures and in pottery, one is faced by the problem of symbolism, how much is meant to be interpreted, how much pure esthetic design. The answer probably is that it's all one. Potter and artist draw their spiritual sustenance from their tribal life, and that life is all a design, a dance and a ceremonial, from birth to death, and through all the ramifications of daily life; it is a whole, individuals are part of a pattern. The deer and the rain design and the unit derived from a butterfly, are used on jars and pictures, they are set deep in the life of the artists, they appear in other forms, still patterned and controlled, in the dances. Of course they are conscious of their symbols, but their whole life is charged with symbols, from them, inevitably they draw their esthetic patterns; the significance is quite different from what it would be for us, or for Navajos, who use true symbols only with specific intent.

Between the oldest and most modern piece illustrated, lie thousands of years. The newest is a dish by Tonita of San Ildefonso, painted in two contrasting qualities of black by a process invented by María of the same village. The design is built around a triangle, from which radiate curved figures, one might almost call them curved frets, returning on themselves with partial repetitions of the central unit. The conception is striking, the execution vigourous. The other is a simple, white bowl from an old cliffdwelling. Upon it the potter painted five hour-glass shaped, black figures which are yet obviously butterflies, placed with great knowledge in just the right positions within the white hemisphere.

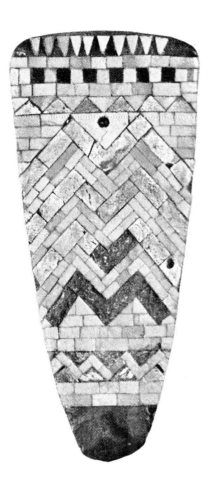

Plate XVIII

JEWELRY

THE idea of adorning oneself comes just as naturally and as early as the idea of adorning one's utensils, perhaps earlier. Certainly the archæologist's spade has yet to unearth man on this continent so primitive that he did not make at least a few beads and a bone wristlet. Free of our set standards of value in jewels, or our false convention which makes sheer value outweigh beauty, the Indian seized upon whatever material would give a handsome result—shell of all kinds, polished bone, turquoise, freshwater pearls, anthracite coal, seeds, malachite, teeth, claws, stained wood, quartz, crystal, whatever came to hand regardless of how hard it might be to work. With his amazing capacity for slow, painstaking effort, he shaped the most refractory or fragile materials to a fine perfection.

The Northeastern Indians took white and purple fragments of shell, grinding and boring them into long, cylindrical beads. When one thinks how many must have been broken, it becomes painful to imagine the labour of making a wampum belt. In the Southwest, similar bits of shell were, and still are, ground into flat disks—relatively easier to make—and strung together. A good necklace of this mis-called "wampum," white or bluish-brown, presents a perfectly even surface, the effect is of a snake-like string, an eighth to a quarter of an inch in diameter, broken at intervals by larger bits of turquoise.

In early times, Indian jewelers were already making fine mosaics of precious substances—turquoise, mother-of-pearl, red stone. They carved elaborate earrings and pendants from shell, worked turquoise matrix into "fetish" figures, and multiplied their types of necklace endlessly.

With the white man came that startling innovation, metal, both as tool and material. For a long time the material had little effect on Indian arts, then in the Southwest sprang up a remarkable silverworking industry, dominated by the Navajos, with the Zuñi close behind them. Derived from the Spaniards, and still in some ways reminiscent of them—the big, old type conchas are Spanish in origin, the silver

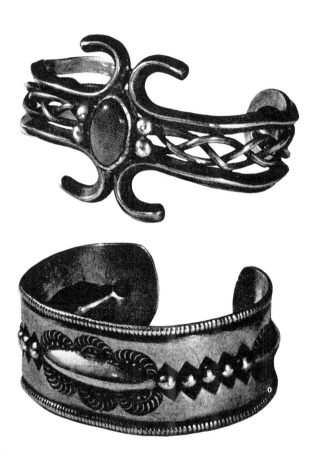

Plate XIX

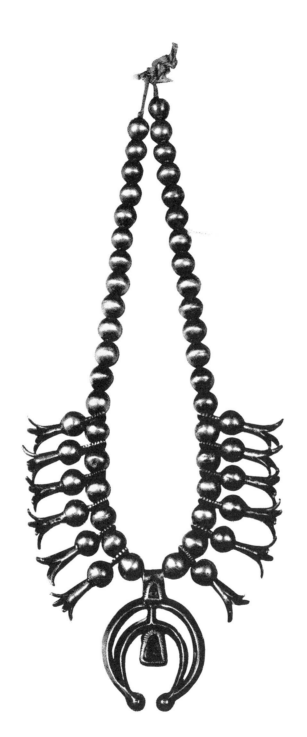

PLATE XX

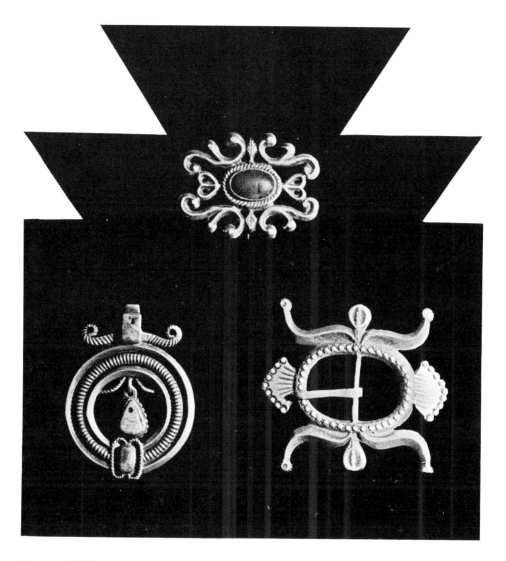

PLATE XXI

bridles trace back to Arabia—they have made it peculiarly their own, and with it revolutionized Indian jewelry throughout the Southwest.

Turquoise, shell, and mosaics continue, still well made by Indians of various Pueblos, but when one thinks of Indian jewelry in that area, he visualizes rich, soft silver and turquoise in a hundred combinations. The Zuñis are freest in combining the two elements, with them a silver bracelet is hardly more than a setting for fine, deep blue stones. The Navajo is the master of silver as such, with some slight attention to brass and copper, particularly in answer to the Apaches' demand for those metals.

To a Navajo, the big rectangle or rectangular design of silver which adorns the back of a bow-guard (the piece of leather which protects one's right wrist from the slap of the bowstring) demands a central turquoise, otherwise, he uses stones or not as he sees fit. The best belts, big, smooth oval or circular plaques, have none.

The keynote of Navajo jewelry is mass, simplicity, smooth surfaces of pure, soft silver, set off by the repetition of quiet and rather inert designs. This is shown particularly well in the fine, old necklace depicted here. The large, plain beads are in themselves a repetition of highlight and shadow and successive masses of smooth silver, set off by recurring, conventionalized squash blossoms, all leading down in an easy flow to the simple pendant, which reverses the natural curve of the necklace. On one of the bracelets exhibited, a raised boss in the centre appears to dwindle, on each side, into a line of small bosses set into small incised areas. At the upper and lower edges are low rims, also incised with simple diagonals. All the decoration moves with the curve of the bracelet, and derives its quality from the richness of the plain surfaces of silver. The other bracelet, in contrast, is entirely an arrangement of flowing lines, concentrated upon a central stone.

The Navajo jeweller can abandon simplicity when he chooses, without sacrifice of strength or becoming ornate. One illustration shows a particularly fine, circular pendant, related to the one on the necklace, but much more complicated and with the circle closed. This must have been made for an unusual necklace, or, more likely, the forehead piece of a special bridle. Within the smooth outer band is enclosed a strip so wrought as to give the effect of a very finely twisted rope, an

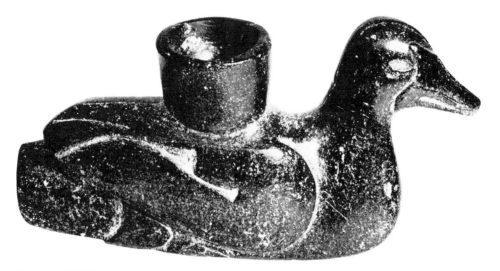

PLATE XXII

achievement of no mean skill. Repeating the outer curve, it presents a surface of narrow, diagonal, curved highlights and shadows made deeper by the oxidizing of the depressions—an effect consciously sought by the maker. Thus far we have an elaborated, handsome circle. It is brought to a stop, so to speak, pointed and centred by the nice placement of turquoise (evidently old eardrops were used), on and within the circle. It is still simple, but masterful.

Certain objects, such as belt buckles, lead naturally to striking shapes, but they are not ornate or in bad taste. Even a certain type of highly ornamented belt saves itself by its pleasing repetition. With few exceptions, none of the designs stamped or cut in the silver have any symbolic meaning whatsoever.

In recent years this silverwork has had to meet a more devastating attack than any other craft in the Southwest. First there has been the pressure to put swastikas, thunderbirds, and a hundred other gim-crack designs, on the silver. Then, there is a constant campaign by commercial whites to introduce low-grade, thin silver, and all the mechanical appliances of miniature factories; a drive, really, to bring this inherently expensive craft down to the souvenir price level, and which can succeed only by utterly debasing the product. More than this, factories are flooding the market with entirely fraudulent, low-grade silver, hideous beyond belief, cheap and satisfactory to the curio mind, while several ingenious souls have hired real Indians the public is invited to come in and see the real Indians at work—to man-ufacture jewelry wholesale by straight factory methods, save that de-signs are stamped on by a man with a hammer.

An Indian bracelet, that is a bracelet which, being made by an Indian, possesses any special quality which a machine could not give it, is conceived and made by one man, without the aid of machinery. From the lump of silver to the finished product and placing of the stones, it is all his. No one looking for a beautiful object would hesi-tate for an instant between a piece so made, and one turned out by mass-production methods, but as yet not enough Americans are look-ing for beautiful and valuable objects to keep good jewelers from being forced into the factories.

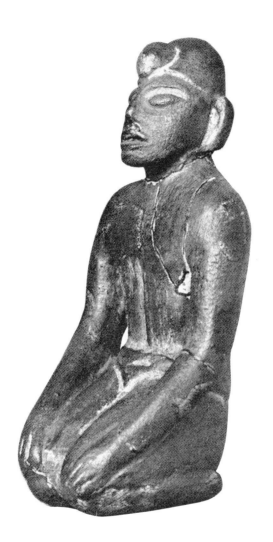

Plate XXIII

SCULPTURE

WORKING in, and constantly adorning, ductile clay, soft wood and stone of manageable texture, one would expect the Indian to have evolved a considerable art of modelling and carving, perhaps even statuary. It is surprising how little this phase of art was developed, perhaps because relief would hamper the utility of the objects concerned. Still, in the realm of ceremonial, one can imagine ample scope for the sculptor. In ancient times, save for small figurines belonging more properly in the jewelry class in the Southwest, only the Mound Builders of the Mississippi Valley produced really interesting relief work in any great quantity. This is in sharp contrast to the great Indian cultures from Mexico to Peru; some scientists hold that there was a contact between Mexico and the Mound Builders, perhaps they derived their art from the south.

Being chiefly concerned with the present day, we cannot go into the Mound Builder question, the many nations and strata of culture grouped under that name, the manifold aspects of their plastic arts in clay and stone, in vessels, pipes, figures, spearheads and adornments. As part of the American heritage, some few pieces are included in this exhibition; there is, perhaps, a direct descent from them to the more recent carved stone pipes. The diorite bowl which we illustrate, very simple in form, with the plain lines around the rim leading to a stylicized, severe bird's head, shows the Indian in a classical mood. The very finest of prehistoric Pueblo black-on-white pottery, a few rare pieces of their modern work, attain the same quiet beauty.

No other objects in this exhibition are as familiar in conception, from a European point of view, as the delicate figurines, one of which is illustrated in this Introduction. It has its own style, but the idiom is one which we can understand without effort.

Carving and modelling are continued today in various places; spotted on the map, the distribution is erratic. The Iroquois still make their wooden "false face" masks, well executed, competent, and

51

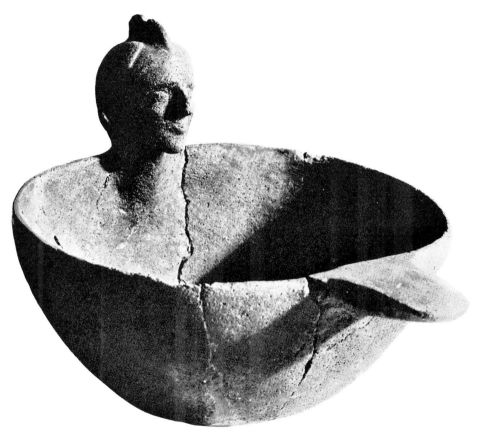

PLATE XXIV

rather unpleasant in conception. Some Plains or near-Plains tribes carve pipes of the soft red stone, Catlinite. In the Southwest, Tesuque Pueblo turns out uninteresting "rain gods" for curio trade. At Santa Clara they are beginning to model animals in the polished black ware, with humour and perception, but hovering on the edge of the silly gewgaw business. Almost every Pueblo potter, save the very greatest, models a few knickknacks for profit. The Zuñis continue carving pleasant little fetishes of stone. The Hopis make their Katchina dolls, cottonwood carved and painted in the images of their masked dancers, sometimes merely gay, occasionally handsome and even impressive. In the far North, Eskimos make skillful little figures and decorated objects from bone and ivory.

Within recent times, serious carving, work of importance in wood, copper, horn and stone, has been virtually monopolized by the tribes of the Northwest Coast. Their art presumably goes back to days as ancient as the Mound Builders, but if so, the materials being more perishable, most of their creations have been lost to us. These people make from wood and horn the large and small vessels and containers which other tribes fashion out of clay or hides, and, seamen, they build—and inevitably decorate—wooden boats; from this, perhaps, their gift for carving grew. Like most Indians, they brought their work under ceremonial sanctions, a great part of it is concerned with conventionalized representations of significant animals and ancestral or divine beings, closely related in style to the Chilkat blankets, as for instance, the copper mask shown here. It may well have been in carving and painting the figureheads of their high-prowed, seagoing canoes that they developed the convention of depicting creatures by two profiles joined together; certainly the same method carries the representation of a single animal around all four sides of wooden trenchers and boxes.

Most famous of their works are the totem-poles, huge ceremonial-heraldic emblems portraying men and animals, often in the full round and of heroic size. Frequently the animal intended can be recognized only by the established short-hand marks—two front teeth, a beaver; row of grinding teeth, a bear; sharply down-curved beak, a hawk; curved in another manner, a raven—while the figure has that form which the

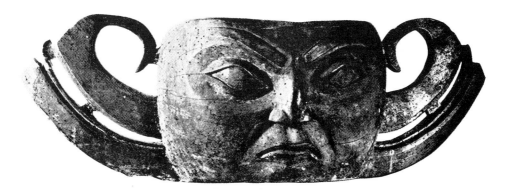

PLATE XXVII

artist chooses as most suitable to his purpose. But realism is also used, perhaps a single figure of a raven, with twelve-foot wing-spread and overhanging beak, placed just high enough on its base to seem free of earth, dominant; at sight one recognizes, not just a raven, but great Raven of the myths.

These Indians have achieved wide versatility in manner. The big wooden bowl figured here is far removed from the swarming totem-poles. The dominant feature is a curious, sad, human face, carved with simple directness in high relief. After so many objects in which a sense of design and formalization confine even the most pictorial efforts, this face is disturbing. We, too, associate naturalistic human faces on objects with Toby jugs and such paraphernalia; at first glance this bowl fails to charm eyes accustomed to the Indian's clear rhythms. But there is something arresting in the face itself, the more one contemplates it, the finer it seems; the execution is direct, simple, and strong. The whole shape of the vessel, with its two, graceful, wing-like handles is excellent. It becomes clear that the face belongs there; once the fascination of mere portraiture has subsided, it takes its place in the whole. Whether we have a bowl nicely calculated to set off a face, or a face used in a highly original manner to complete a bowl, it is hard to say, but the result is a surprising success.

Among these people, a modern type of sculpture in black slate has arisen, largely in response to a curio demand. Much of it is very poor, but the best pieces suggest a parallel development here to Pueblo Indian paintings, and the intricate arrangement of figures has some of the quality of good Chinese work in ivory. There is no attempt to work in our manner: a new Indian form has been evolved as a result of contact with us.

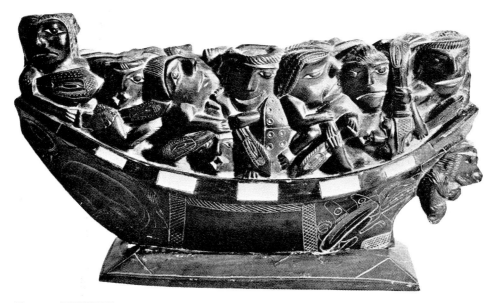

PLATE XXVIII

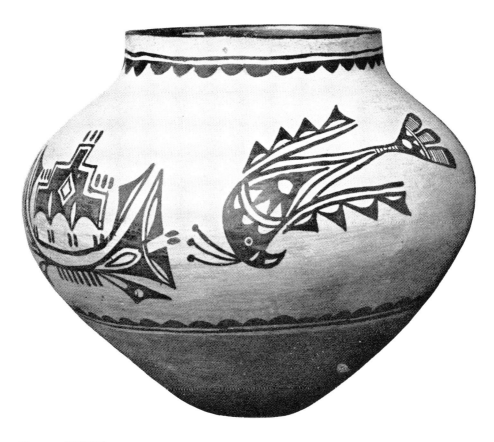

Plate XXIX

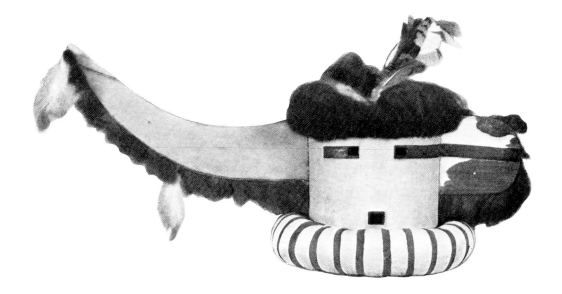

PLATE XXX

CONCLUSIONS

LMOST all the art discussed here is applied to the decoration of useful things; before the white man stepped in, this was always so, if we accept the Indian's view of religious objects as being among the most highly useful. This embodiment of the Indian's conception of use and beauty in the materials of his daily life is art in its widest sense; not up on a shelf to be regarded occasionally, but adorning and giving meaning to everything about him. Just so his religion permeates each least commonplace of his universe, and the search for harmony and success within himself and within the tribe, is voiced in dances by forms, designs, rhythms, symbols, until one is lead from them back to his art again, realizing that they are all beats of one pulse. The modern Indian artist may not be as orthodox as his ancestors, he may even have embraced the Christian faith or be, like most white men, religionless, but he still derives from the traditional forms and takes his strength from his ancestral pattern.

It is only recently that white teachers of Indian children have stopped trying to educate them away from their own art. For decades we tried, and in some cases unfortunately succeeded, in instructing Indians to forget their own culture and to force themselves into ours. Indian artists were given reproductions of masterpieces, Currier and Ives prints, or mere advertisements, and told that these only were art. We tried to mechanize their crafts and induce them to use factory mass production instead of their own individual tools and technique. No factory blanket could compare to one made with infinite patience and care by a Navajo woman from wool her husband sheared, dyed by her with her own dyes, woven on a primitive loom beside her desert hogahn. To the extent that white teachers succeeded in persuading the Indians to abandon their own methods, their art deteriorated.

To most Indians, the income to be earned from their industries is vitally important. For instance, the Pueblo of San Ildefonso was until

PLATE XXXI

recently in a bad way, having lost much of its land and water rights. The people were depressed and discouraged, all were poverty-stricken. They revived their almost forgotten pottery-making and their younger artists, encouraged by Dr. Edgar L. Hewett of the Museum of New Mexico, began to develop their watercolours. Having a good market in Santa Fe, they were able to earn the additional money so that today the pueblo is advancing, and increasing in numbers.

The American Indian is willing and competent, given a market, to earn a congenial and lucrative living through his art, with benefit to himself and to the country. Even today in the teeth of ignorance and neglect, he is keeping his talents alive and developing them. The preservation of these and related phases of his cultural life, ceremonies, dances and music, are necessary to his mental and emotional well being, for they afford him means of self-expression; with them to give him integrity, and through them, he can become increasingly self-supporting, self-reliant, self-respecting, and a valuable contributor to our modern scene.

The Indian Bureau of the Federal Government, recognizing these facts, is now encouraging the Indians to continue to create and to develop their own arts. The old, ignorant attitude of condemning anything Indian as "uncivilized," is giving way to sympathetic understanding, and even instruction in the schools by older tribal artists. At the same time, scientists and artists are painfully aware of the danger of losing what remains of the esthetic heritage of the Indians. They realize that if the arts are to survive, they can do so only as any other arts do, through the support of discriminating buyers anxious to possess the creations for their own sakes.

The Exposition of Indian Tribal Arts is expected to give thousands of white Americans their first chance to see really fine Indian work exhibited as art. And it will give the Indian a chance to prove himself to be not a maker of cheap curios and souvenirs, but a serious artist worthy of our appreciation and capable of making a cultural contribution that will enrich our modern life.

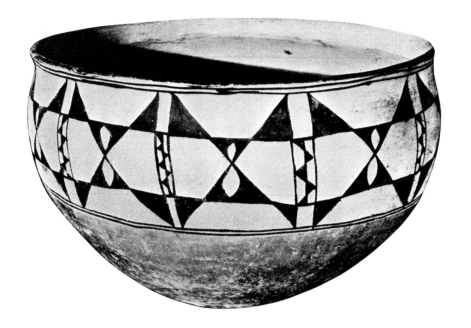

PLATE XXXII

THE PRINCIPAL TRIBES

THERE were more than one hundred and fifty tribes of Indians in what is now United States territory, when the white men came, and archæology reveals almost as great a number of cultural sub-divisions in earlier times. The prehistoric cultures represented in this exhibition, and the main historic culture groups, together with some of the most important tribes, are listed here.

PREHISTORIC

The Mississippi and Ohio Valleys. The Mound Builders, having many subdivisions; the full range of their civilization is not yet known.

The Southwest. Basketmakers, initiators of agriculture and weaving within the United States. They were followed by the Prehistoric Pueblos, including the Cliffdwellers, from whom the modern Pueblos and Hopis spring.

HISTORIC

The Eastern Woodlands. The Iroquois tribes, Chippewa, Pottawotomi, Sauk and Fox, Illinois, Shawnee, Winnebago, Abnaki, Micmac, Pequot, Delaware, Powhatan.

The Southeast. Tuscarora (later united with the northern Iroquois), Cherokee, Yuchi, Creek, Seminole, Chickasaw, Choctaw, Natchez, Biloxi, Atakapa, Chitimacha, Caddo, Quapaw.

The Great Plains. Blackfoot, Piegan, Gros-Ventre, Assiniboine, Crow, Hidatsa, Mandan, Cheyenne, Arapaho, Dakota Sioux, Omaha, Iowa, Kansa, Osage, Kiowa, Comanche, Ute.

The Central Plateau. Shushwap, Thompson, Kutenai, Flathead, Nez Percé, Salish, Shoshoni, Paiute.

The Southwest. Rio Grande Pueblos, Laguna, Acoma, Zuñi, Hopi, Havasupai, Walapai, Mohave, Yuma, Pima, Maricopa, Papago, the Apache tribes, Navajo.

The Northwest Coast, extending up into Alaska. Tlingit, Chilkat, Haida, Tsimshian, Chilkotin, Kwakiutl, Coast Salish, Nootka, Chinook, Kalapooian, Waiilatpuan, Klamath.

California. Yurok, Wiyit, Wintun, Maidu, Pomo, Wappo, Miwok, Yokuts, Mono, Washo.

On the Northern Coast of Alaska are found the Western Eskimos, and in the interior, many Northern Athapascan Tribes, forming an extension of the Mackenzie Basin culture.

THE Exposition of Indian Tribal Arts, Inc., was organized in 1930 for the purpose of stimulating and supporting American Indian artists by creating a wider interest and more intelligent appreciation of their work in the American public at large, and to demonstrate to the country what important contribution to our culture the Indian is making. To this end, an exhibition of Indian products in the fine and applied arts, selected from the best material available, both old and new, has been arranged. The exhibition opens in New York, November 30th, 1931. Sponsored and circulated by the College Art Association, it will go to the principal cities of the United States, on tour of about two years' duration.

THE EXPOSITION OF
INDIAN TRIBAL ARTS, INC.

ENDORSED BY AND CIRCULATED THROUGH
THE COLLEGE ART ASSOCIATION

SPONSORED BY THE HONORABLE
THE SECRETARY OF THE INTERIOR
THE COMMISSIONER OF INDIAN AFFAIRS

HONORARY CHAIRMAN
HON. CHARLES CURTIS

PRESIDENT
JOHN SLOAN

VICE-PRESIDENTS
MAJOR-GENERAL HUGH L. SCOTT
HON. CHARLES G. DAWES
WALTER L. CLARK

TREASURER
EDWARD C. DELAFIELD
PRESIDENT, BANK OF AMERICA

CHAIRMAN, EXECUTIVE COMMITTEE
AMELIA ELIZABETH WHITE

SECRETARY
MRS. ROBERTS WALKER

Board of Directors

S. T. BLEDSOE
GEORGE B. CASE
FRANK CROWNINSHIELD
EDWARD C. DELAFIELD
H. W. DEFOREST
MRS. CHARLES H. DIETRICH
CHARLES DONNELLY
DR. PHILIP GOETZ
J. E. GORMAN
CARL R. GRAY
CHAUNCEY J. HAMLIN

F. W. HODGE
PERCY JACKSON
OLIVER LA FARGE
MRS. EUGENE MEYER
MRS. VICTOR MORAWETZ
MRS. DWIGHT W. MORROW
MRS. VERNON MUNROE
MRS. JOHN D. ROCKEFELLER, JR.
MRS. JOHN SLOAN
JOSEPH LINDON SMITH
DR. H. J. SPINDEN
MARTHA R. WHITE

The Exposition is indebted to the following collectors for the loan of exhibits

MRS. HERBERT HOOVER
MR. AND MRS. CHARLES J. RHOADS
DR. HARTLEY BURR ALEXANDER
AMERICAN MUSEUM OF NATURAL HISTORY
MR. R. B. BERNARD
BROOKLYN MUSEUM
BUFFALO MUSEUM OF SCIENCE
MR. WITTER BYNNER
MR. JACQUES CARTIER
MR. AND MRS. H. S. COLTON
MISS ELIZABETH DALY, NEW YORK
DENVER ART MUSEUM, DENVER, COL.
REV. C. W. DOUGLAS, EVERGREEN, COL.
MRS. H. K. ESTABROOK
MISS ANNE EVANS
MR. GORDON GRANT, NEW YORK
MR. AND MRS.
 WILLIAM PENHALLOW HENDERSON
DR. EDGAR L. HEWETT
MISS MARGARETTA HINCHMAN
MR. AND MRS. JOHN MEAD HOWELLS
INDIAN ARTS FUND
MR. OSCAR B. JACOBSON
MR. W. P. KENNEY
 VICE PRES., GREAT NORTH. RAILWAY CO.

MRS. ARTHUR ALLEN MARSTERS
MISS MARGARET MCKITTRICK
MUSEUM OF THE AMERICAN INDIAN,
 HEYE FOUNDATION
MRS. FRANCES NEWCOMB, NAVA, NEW MEX.
MISS GRACE NICHOLSON
DR. LILA M. O'NEALE, BERKELEY, CAL.
PEABODY MUSEUM OF HARVARD UNIVERSITY
COL. LEIGH M. PEARSALL
MRS. JOHN D. ROCKEFELLER, JR.
MR. HENRY SCHNAKENBERG, NEW YORK
MR. JOHN SLOAN
MR. AND MRS. JOSEPH LINDON SMITH
DR. H. J. SPINDEN
UNITED STATES NATIONAL MUSEUM
UNIVERSITY OF ARIZONA
UNIVERSITY OF PENNSYLVANIA MUSEUM
UNIVERSITY OF TULSA
MRS. ROBERTS WALKER
MISS MARY CABOT WHEELWRIGHT
MISS AMELIA ELIZABETH WHITE
MISS MARTHA ROOT WHITE
WILLIAMS COLLEGE
M. H. DE YOUNG MEMORIAL MUSEUM

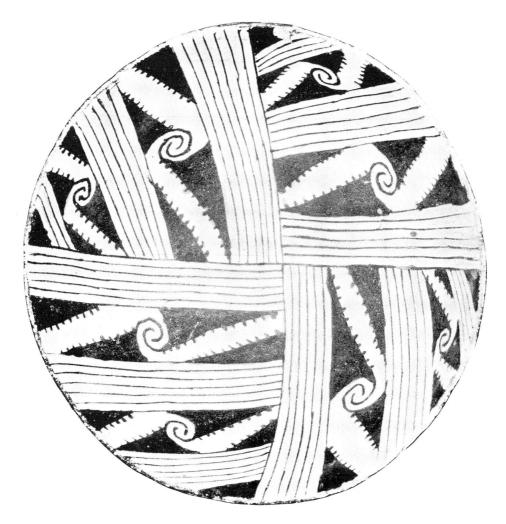

Plate XXXIII

FINE ART AND THE FIRST AMERICANS

By

HERBERT J. SPINDEN

THE EXPOSITION OF INDIAN TRIBAL ARTS, Inc.

Permanent Office, 578 Madison Avenue

New York, N. Y.

FINE ART AND THE FIRST AMERICANS

By

HERBERT J. SPINDEN

THERE comes to my mind a phrase from the Night Chant of the
Navaho:

In old age wandering on a trail of beauty, lively may I walk.

Everyone knows that the American Indian passed on to us, and through
us to the world, a heritage of utility beyond the dreams of avarice. This was
in such homely things as the inestimable food plants which he had brought
from the wild to a high state of domestication. Few seem to know that he
has prepared a second heritage of beauty, a gift of fine arts, illusions and
immaterial creations which rise above mere utilities as the mountains rise
above the plain. The Welsh look to the Mabinogion and the English find
in Arthurian romance a never-failing inspiration. Just so Americans of the
future will surely realize an epic grandeur in the song sequences and world
stories of the first Americans. The Night Chant of the Navaho and the Hako
of the Omaha will take their place in the foreland of our national literature
as mysterious and beautiful dramas which somehow prefigure the American
ideal.

The Indian is a true artist unusually qualified by natural abilities in
several provinces of esthetic expression. His dramatic ceremonies combine
music, dancing, and pageantry with the use of words in the forms of poetry
and imaginative prose. He is also gifted in applications of color and design,
and retains an ancient but ever-growing skill in the home crafts of weaving
and pottery-making and in the illimitable fields of painting and sculpture.
These facts are attested by the pre-Columbian record of his activities which
archeologists have brought to light and by the intimate revelations of the
symbolism and significance which ethnologists, after patient and sympathetic
questioning, have found in his works. They are attested still more effectively
by departures of the present day.

In 1917, when the Tewa pueblo of San Ildefonso was at its lowest
economic ebb, several Indians turned their hand to water-color drawings
which pictured the native ceremonies. These at once caught the attention of
connoisseurs as beautiful and naïve expressions patterned in the Pueblo tradi-
tion. Ethnologists had long been aware that Indians are generally competent
to illustrate the outstanding elements of their religion by drawings and
sculptured models. More than a generation ago Dr. J. Walter Fewkes had

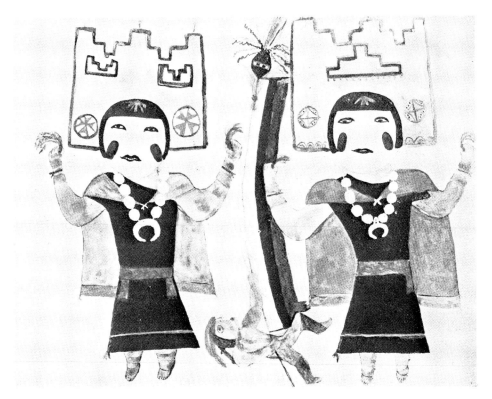

The Butterfly Girl or Tablet Dance of the Hopi. (After Fewkes)

obtained from an unschooled Hopi a remarkable series of drawings designed to explain the symbolism of the different gods and the costumes of dances in which gods are impersonated. These were published in color in one of the Reports of the Bureau of American Ethnology and the original sheets bound into four volumes and labeled "Codex Hopiensis." The works of Awa-Tsireh, Oqwa Pi, and other gifted youths at San Ildefonso do not picture the really esoteric phases of the Indian life, which are taboo, and there have been radical developments in style since the first attempts were exhibited. Awa-Tsireh shows his versatility in three styles, the first realistic, the second modified by decorative symbolism, and the third marked by a creative imagination working in the field of the esoteric. Tonita Peña and Velino Shije live in Cochiti, while Fred Kabotie and Owen Polilonema dwell in the Hopi country and are somewhat favored in a wider choice of permitted subjects. Several Indian painters belong to the Kiowa tribe, and others are found among the Sioux. It is not too much to say that Indian youths have astonished the world of art by the spontaneous beauty of their paintings which follow a tradition of good taste.

Indian art is filled with social purpose and in its normal development conscious individualism has had little play. Some of the earliest designs emerged from constructional possibilities, as in basketry, and were restrained in their development by corresponding constructional limitations. In regions

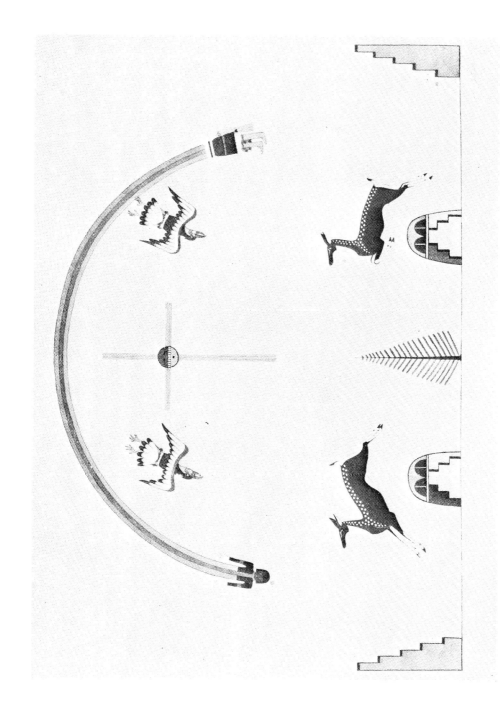

"Deer." Painted by Awa-Tsireh of San Ildefonso, Pueblo, New Mexico
(Collection of Mrs. John D. Rockefeller, Jr.)

of low culture these designs remained abstract, while in regions of high culture they gradually acquired symbolic significance. It is the rule rather than the exception for Indian designs to have meaning.

Esthetic forms which are the outward and visible expressions of Indian philosophy are found almost intact among some tribes and in others are nearly lost. The more favored Indian communities possess ceremonial traditions which go back to ancient modes of life followed by the Cliff-dwellers, the Mound-builders, and other ancestral groups. Perhaps the most perfect survival is found in our Southwestern states, where a long archeological record reveals the steady enrichment of the social mind. This may be illustrated by the application of sympathetic magic to designs on pottery that are prayers for rain and to designs on shields that will ward off danger or give intelligence of the enemy's whereabouts to the warrior.

I once inquired of a woman of Nambe how she would begin making an embroidered mantle. "First of all," she said, "I would feed corn-meal of all colors to the butterflies, because they know how to make themselves beautiful." Similarly I was told that the best way to insure that a boy would be a good singer was to feed the mockingbird and ask its help. The battle of Wounded Knee fought by the Sioux at the height of the Ghost Dance religion in 1890, had a high mortality for the Indians because of a tragic failure in magical design. It seems that the old decorations on buffalo-hide shields were intended to attract the arrows, which could not pierce the defensive weapon. But the white man's bullets were of a different sort. Before this battle the Indians painted their shirts with bullet-proof designs picturing the spider, the dragonfly, and the thunderbird. Nevertheless many Indians still believe, and rightly I hope, that art can help them in the problems of life.

Foolishly or wisely, Indian art is filled with illusion and marked with the joy of supercraftsmanship. The California Indians had no agriculture, and their needs were simple. Yet they made the finest basketry of either hemisphere and set a standard of thorough sincerity and intricate perfection in a universal craft.

Textile art among the American Indians generally brought out the best that the weaver was capable of giving. It reached in Peru the world's peak on practically all counts of excellence: fineness and variety of weave, vividness of coloring, etc., setting a standard which machines can never equal. The true loom, independently invented in tropical America, extended up from Mexico into the region of the Pueblo tribes, and on it cloth of cotton and other fibers has been made from ancient times. It is a fact not generally appreciated that the species of cotton domesticated in America have superseded the comparable fibers of the Old World. Indeed the oldest known examples of cotton weaving are found in remains of the first Cliff-dwellers although real origins must be sought farther south.

At the Hopi towns weaving is a man's job and at Zuñi both sexes participate in this art, but pottery-making falls exclusively to the woman's lot. The young bridegroom should weave the trousseau of his wife-to-be. Among the Navaho, who did not begin to weave until they secured sheep from the Spaniards, through Pueblo Indians and Mexicans, a century and a half ago,

the woman does this work. Her rich designs in tapestry are never quite the same. On the Northwest Coast a sort of warp-weighted loom is found, but it is scarcely more than a weaving frame. But inadequacy in the machine did not embarrass the Chilkat woman intent on putting the mysteries of land and sea into her fabric.

It is now indicated that pottery was independently developed in the Southwest, although probably on suggestions coming up from Mexico. The first decoration was a copying of designs already in vogue on basketry. Soon, however, pottery came into its own as a special field of artistic expression. When the expedition of Coronado arrived in 1540, the Hopi villagers were producing a fine yellow ware with highly esoteric designs, and the Indians along the Rio Grande were using galena as a material for glazed paint. The Pueblo Indians never went far into the plastic possibilities of clay beyond the requirements of pottery. Among the Mound-builders, however, there were artists who did excellent modeling, usually by adapting a human or an animal figure to the required shape of the utensil.

There was no smelting of ores or casting of metal north of Mexico before white men came, but the Mound-builders grew quite proficient in handling native copper and native silver of the Great Lakes region by hammering and repoussé. They even found and made use of meteoric iron and some gold. In southern Alaska copper was handled in the pure metallic form, as it also was in northern Canada.

There have been interesting expansions of metal-working among Indians in our own times. The Navaho, whose skill and ingenuity in the making of silver objects is generally recognized, have been working in this field only since the seventies of the last century.

In monumental sculptures the North American aborigines produced nothing comparable to the splendid work of the Central American tribes; nevertheless they disclosed latent abilities of no mean scope in the manufacture of small objects. One thinks of the great totem-poles of the Northwest Coast, which may rightly enough be called family trees, since the figures, one above another, are clan ancestors who may be humans or mythical animal helpers. It seems from recent studies that while house-posts and grave ornaments were being carved when the first European fur-traders arrived, the larger totem-poles followed the introduction of iron tools. The forms of art fixed in smaller objects are here magnified to heroic size.

The Mound-builders were especially skillful workers of stone, although none of their productions are of large size. They made very interesting ceremonial tablets and lavished a wealth of imagination on tobacco pipes which are carved in many animal forms. Somewhat more conventional are the *kachina* carvings of the Southwest, which are in the nature of costume models.

The Indian has eagerly adopted new materials which could be applied to colorful design. Before glass beads were introduced by European traders, other beads were in use, but these did not offer much opportunity to the designer. In those days the Indian's love of color had to be satisfied by moose-hair and porcupine-quill embroidery and by paintings on dressed hides. It is a remarkable fact that beautiful uses of beads in very different fashions

rose rapidly in all parts of America. The first designs were in the traditional modes, but a great wealth of new forms soon came into being. Indeed Indian tradition, while always stimulating, has never proved a hampering mortmain. The ideas of beauty which arise in the red man's consciousness move with the times, and the spiritual forces behind them are not held to the trail of the vanished buffalo.

Mexico and Peru are acquiring new social personalities through coalescence of the traditions and capabilities of the Indian and the Spaniard. In a similar way our own aborigines must supply an ingredient to the national character of the United States. We may safely trust these first Americans with a mandate of beauty. In a world which grows mechanical they seem able to keep contact with the great illusions. This is well, because these great illusions enrich the oversoul of society and fix the interdependence of individuals in patterns of collective efficiency.

Who is not moved by Byron's apostrophe to the dead of Thermopylae that they come forth to restore the glory of Greece? Who does not echo the plaint of Wordsworth:

> Great God! I'd rather be
> A Pagan suckled in a creed outworn,—
> So might I, standing on this pleasant lea,
> Have glimpses that would make me less forlorn;
> Have sight of Proteus rising from the sea;
> Or hear old Triton blow his wreathed horn.

We have in our Indians a reality of Arcady that is not dead, a spirit that may be transformed into a potent leaven of our own times. I doubt if any greater appeal can be made to young America than is contained in the verities of Indian life and achievement. Shall it be said that we conquered the world and lost ourselves, that we slew beauty as a vain sacrifice to unsufficing machines? It would be far better to recognize an obligation to walk fittingly where the wonders of the earth are spread. I let a Tewa artist who worked in words make the argument.

> Oh, our Mother, the Earth; oh, our Father, the Sky,
> Your children are we, and with tired backs
> We bring you the gifts that you love.
> Then weave for us a garment of brightness;
> May the warp be the white light of morning,
> May the weft be the red light of evening,
> May the fringes be the falling rain,
> May the border be the standing rainbow.
> Thus weave for us a garment of brightness
> That we may walk fittingly where birds sing,
> That we may walk fittingly where grass is green,
> Oh, our Mother, the Earth; oh, our Father, the Sky!

The Brooklyn Museum,
Brooklyn, New York

INDIAN SYMBOLISM

By

HERBERT J. SPINDEN

THE EXPOSITION OF INDIAN TRIBAL ARTS, Inc.

Permanent Office, 578 Madison Avenue

1 9 3 1

INDIAN SYMBOLISM

By

HERBERT J. SPINDEN

THE graphic and plastic art of the American Indian is rich in decorative quality and especially rich in symbolism. By this I mean that the shapes used by the Redman while gratifying the esthetic sense frequently have significance over and above all direct or natural meanings. Symbolic designs express the peculiarities of communal thought, especially in matters of religion and philosophy.

Important classes of decorative design may be entirely free from symbolism or richly impregnated with it, as the case may be; nor can symbolic intent be easily inferred. Ordinarily the proofs of its existence rest on social usages. Aside from questions of symbolism it is obvious that the field of art can be divided as regards explanation under several headings. First, there are realistic renderings of natural subjects; secondly, there are conventional

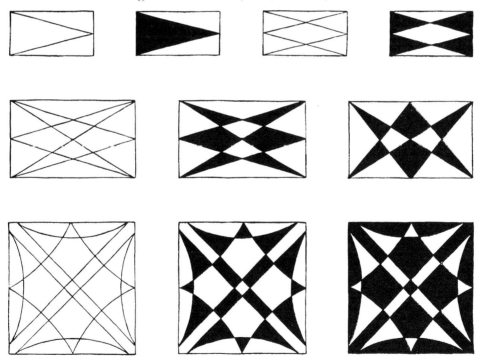

How Designs are Developed Abstractly on Modern Southwestern Pottery. Patterns of this Kind Have no Meaning

renderings, including many where formalization has been carried so far that the subject is unrecognizable to persons not acquainted with the line of historic changes; thirdly, there are invented geometric shapes called by the names of natural objects which they happen to resemble; and fourth, there are abstract geometric shapes which have remained devoid of even an adventitious association with nature. To all of these classes symbolism may attach itself, but it is not a necessary accompaniment of any one of them.

Cases where a part stands for the whole are not to be taken as examples of true symbolism unless there is a further extension in significance. But when the paw of a grizzly bear stands not for the bear alone but for exceeding power, the device has symbolic value. Or when horse's hoof-prints are shorthand for intertribal raids in buffalo-hide records and on warriors' costumes, it is fair enough to call them symbols. Or a realistic picture of an eagle, with lightning flashing from eyes and beak, becomes symbolic once it can be identified with the mythical Thunderbird.

True symbolism is widely distributed at the present time among those American Indian tribes which have retained important elements of their

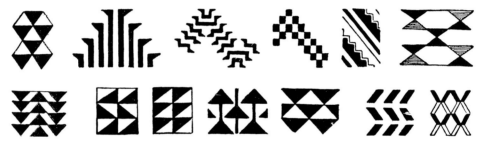

Abstract Shapes Used for Decorative Purposes on Western Basketry. Sometimes these have Descriptive Names Taken from Nature

ancient modes of life and habits of thought. It finds its best expression in the arts and ceremonies of the Pueblo Indians who are still effectively immersed in an atmosphere of social illusion. As a rule, the newest manifestations of American Indian design, such as the ornamentation of Navaho blankets, is practically devoid of symbolism, although the more ancient—and also more sacred—sand-paintings of the Navaho are alive with symbolic interest. The earliest designs revealed by American archeology are apparently unsymbolic, as are those of present Indians on the lowest plain of culture. The development of symbolism in New World art may be regarded as an efflorescence of Indian idiosyncrasy, but also there are historic problems of dissemination.

The Unsymbolic Design of California.—Symbolism is not a necessary part of good design, but when it does occur, one can truthfully say it provides emotional enrichment. The Pomo Indians of California are generally awarded the distinction of being the most skillful weavers of baskets in a region where basketry reached its peak of technical excellence. The designs of the Pomo are necessarily formal by reason of the constructions through which

they must be expressed, but they are mostly explained in terms of animal and plant life.

Dr. Kroeber, of the University of California, has this to say about Pomo art: "Pattern names are descriptive, often elaborately so, with reference to size, position, or combination of elements. These forms breathe no prayers, express no wishes, and serve no ulterior purposes; in short, they are not symbolic." But he does admit a few details which at least contain the germ of symbolism, for he adds: "Only at the start of their baskets the Pomo sometimes, for religious reasons, place an initial design or *shayoi* and if the pattern is an encircling band, they scrupulously leave a break of some sort in its course, that they may not be struck blind."

Ethnologists have made careful surveys of the names which the Pomo and other California Indians apply to the decorative shapes used in their basketry. Generally, it seems that the design came first as abstract decoration and that afterward a convenient designation was given to it. There is no evidence that the motives were formerly more realistic than now. The names which refer to natural objects are merely descriptive, such as our "egg-and-dart" for a certain classic molding. A California pattern called "quail-plume" might better be called "quail-plume-like." Investigation shows that such designs as "earth-worm", "fish-teeth", "eyes", "flying geese" are not coordinated in California with religious beliefs or the usages of daily life. Some basketry designs have a wide distribution up and down the Pacific coast, but the names applied to these designs often change in a startling manner. Thus, the "quail-plume" unit of the Pomo becomes a "pine-cone" among the Maidu.

In spite of the remarkable excellence of their basketry, the California Indians are culturally retarded in many ways. Undeveloped conditions of thought, which survive among them, may once have existed in other places. If we pass east into the region of the Pueblo, comprising most of Arizona, Utah and New Mexico, and parts of other states, we find that the first decorative art disclosed by archeology is also largely concerned with basketry. Archeologists allow three cultural stages for the more or less nomadic Basket Makers, and five for the sedentary Pueblo or Village Indians who followed them. The great change in manner of life was produced by the introduction of corn, beans, cotton, etc., from Mexico several thousand years ago, and by the invention of pottery which supplanted basketry in many household uses. It is quite probable that the mass of decorative designs for the Basket Makers and the first two levels of the Pueblo culture were unsymbolic. The patterns on early Southwestern pottery are frankly adapted from those which had been developed under the textile process.

Symbolism Begins in Art with a Magical Purpose.—Perhaps symbolism begins with the first attempts to make decoration an instrument of magic. Now stuffed heads of ducks and geese attached to artificial bodies are found among the cave deposits of Basket Maker I age in Nevada, and ducks are pictured on early baskets in Arizona. Later there are bird-effigy bowls which become simplified into oval pots. If we could be sure that the duck

was regarded as having some magical jurisdiction over water, we might understand its importance in this early art. But the stuffed birds of Lovelock Cave, Nevada, have been explained as decoys used in hunting, and the later effigy bowls have been explained as plastic decoration without ulterior intent.

Pictographs are notoriously hard to date, but in the Southwest supposedly early ones are found which suggest hunters' magic. These are of a rather precise type as regards style, and they occur not only in the Pueblo area but also far to the north and west over the plateau. It therefore seems possible to explain them as originating on the pre-agricultural level and

Conventional Ears of Corn

Top, left: An ancient ear from a cliff-dwelling. *Top, right:* Three vessels from Pueblo Bonito, New Mexico, with corn designs. *Below:* Conventional ears of corn on dance wands; and, *in center,* two "prayer-sticks" representing ears of corn with feathers attached.

perhaps surviving the advent of farming community life. Various animals are shown, but especially mountain goats. One sees hunters shooting these animals with arrows or even lassoing them; but for the greater part the goats are in clusters and hunting is implied, if at all, by drawings of animal and human foot-prints.

It is possible, of course, to interpret pictographs as records of events, but the question arises whether simple happenings of the chase are important enough to justify the very considerable labor of painting, incising, or pecking animal pictures on hard boulders or high up on the face of cliffs. I think it more likely that these quaint representations of the hunt were widely regarded as prayers or even as coercive formulas for abundant supplies of game.

That artistic representations were held to be magical in the Southwest at an early date is disclosed by the conditions under which a certain lot of non-decorative objects was found. This is a famous cache of sunflower and prickly-pear models packed neatly in a Cliff-dweller jar along with a carved and painted bird and carefully buried in a cave. The wooden sunflowers have yellow petals and brown hearts, and the cactus fruits are painted red and made glossy with pitch. Since both the seed of the sunflower and the fruit of the cactus are favorite foods, these models were probably made to insure good crops. The idea of "increase by magic" is firmly implanted among the modern Indians of Arizona and New Mexico.

Still another evidence of early symbolism in the Pueblo area is seen in little clay images of women. These correspond to the Archaic figurines of

Pueblo Rain Magic Designs

Top, left: Rainbow over mountain; cloud with rainbow and dragon-flies; clouds, mountains, rain, dragon-flies, stream of water; clouds with rain falling on mountain. *Bottom, left:* Clouds, rain, lightning, leaves; tadpoles and dragon-flies under cloud terrace; cloud people, lightning, dragon-flies, rainbow, etc.

ancient Mexico which have been explained as fetishes to insure crops. To be sure, the interpretation rather begs the question, nevertheless it is supported by the extremely wide distribution of a well-styled art which rose after the invention of agriculture in Mexico and Central America, and which spread into adjoining territories hand-in-hand with the first set of domesticated plants. The general decorative art in pottery of the Archaic period is obviously formal and probably unsymbolic.

Rain-Magic Symbolism of the Pueblo Indians.—The first occurrences of the rain-magic symbolism which the present Pueblo Indians use in many decorative applications belong on the archeological horizon known as Pueblo III. This was an epoch of the consolidation of small farming communities into large towns either for safety or because of an urban urge. It ended about the year 1275 with a drought, and began perhaps 500 years earlier. The rain-magic symbolism in which pictures of clouds, frogs, dragon-flies, etc., are used to express a wish for rain may be due to contact with Mexico. Not that the style or precise details of Mexican symbolism were copied, so

much as that the eyes of the Pueblo artists were opened to a new philosophy of coercive art. Before discussing the question of derivation, perhaps it would be best to explain the present situation of symbolic usage in the Southwest.

The modern Pueblo Indian personifies nature at every point of contact with his own welfare. He believes that the spiritual powers behind the phenomena of the world can be won by the flattery of artistic imitation to the point that they will assist man in his struggle for existence. He also believes that his system of direct flattery through imitation has been perfected to such a degree that it is almost if not quite coercive. Now the outstanding need in the desert environment of the Southwest resolves itself into water. For while the food plants which are raised in the cultivated fields of the Indian are personified by youthful deities—the Tewa have twelve Corn Youths and twelve Corn Maidens, one for each coloring of maize—these, like the Indian

Maize Symbolism

Left: Corn Maiden of the Hopi, who wears terraced clouds on the top and at each side of her head, an ear of corn across the forehead, and a rainbow over her mouth. Her dress has cloud and rain symbols. *Right:* A Navaho mask with a cornstalk as the nose.

himself, are in the laps of the gods who rule the rains. Obviously, the picturing of rain-clouds with lightning flashes and falling drops, and the picturing of flooded fields with freshly springing leaves, are proper as a first approach. Other imitations help, such as blowing clouds of smoke or of ashes, or making cloud bubbles in soap-weed water. Lightning flashes can be imitated by certain stones of crystalline quartz which make a glow when properly struck in the darkness, and by the mechanical device of the Lazy John tongs which stretches and draws back in zigzags, while thunder is readily produced by the whirling of a bullroarer.

The next step is to appeal by pictures for the magical help of frogs or tadpoles, and dragon-flies, especially since they are always found near water. Then comes the very powerful plumed serpent believed to dwell in storm clouds: his body is marked with clouds and rain streaks, and his tongue is barbed lightning. Finally, there are "Cloud People," real gods of rain, who live in cloud mansions where they drum out thunder and hurl lightning, or at other times in lakes; and who walk to Indian dances on mist streaks and rainbow bridges. They are imitated in very sacred dances by masked persons in gorgeous costumes. The details of headdresses, masks, mantles, etc.

worn by these impersonators of the gods again deal with symbols of rain and freshly awakened flowers.

The rain-magic designs of the Pueblo Indians are painted on pottery receptacles and embroidered on clothing which therefore have the value of

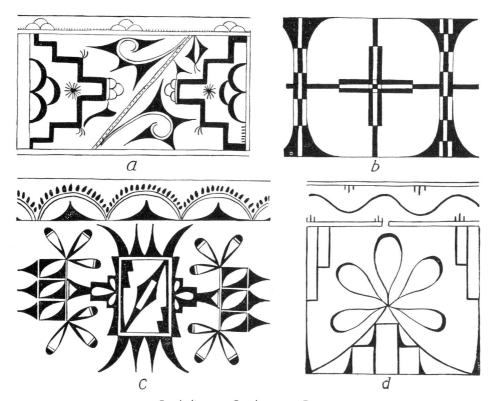

Symbolism on Southwestern Pottery

a. The upper border is clouds and rain; below are two cloud-capped villages of the Rain Gods in the sky, each containing clouds and the Morning Star. The diagonal dotted line is the road to and from the underworld which men travel during life. The two spirals are irrigation ditches under little hills.

b. This is a "close-up" of the Morning Star in the sky house where the pillars are inlaid with turquoise.

c. Rainbows across scattered clouds and over the pointed hills form the upper border. Below is an altar in the underground ceremonial chamber and on each side are feathers placed as offerings at springs.

d. The wavy line above with the rain-markings is a conventional form of the "cloud serpent." The break in the lower part of the border is called the "road." The rest shows an altar of stones on which is an offering of feathers.

constant prayers. They are repeated on altars and altar screens. They are involved in color patterns for the four cardinal points of the earth, as well as for the above and the below. And the visual representations are supplemented by chants which repeat the same ideas in words. One small passage will suffice:

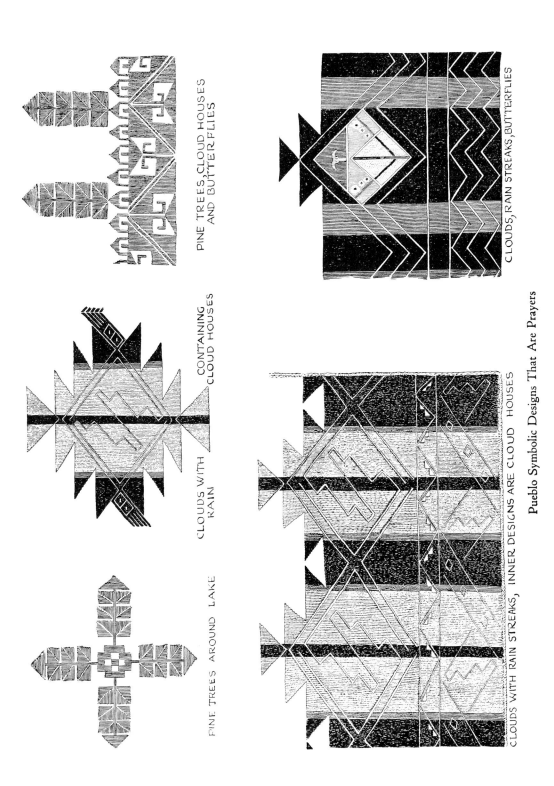

PINE TREES, CLOUD HOUSES
AND BUTTERFLIES

CLOUDS, RAIN STREAKS, BUTTERFLIES

CONTAINING
CLOUD HOUSES

CLOUDS WITH
RAIN

PINE TREES AROUND LAKE

CLOUDS WITH RAIN STREAKS, INNER DESIGNS ARE CLOUD HOUSES

Pueblo Symbolic Designs That Are Prayers

Here and now we bring you, Oh! our old men gods,
Sun Fire Deity and Blue Cloud Person of the North,
Sun Fire Deity and Yellow Cloud Person of the West,
Sun Fire Deity and Red Cloud Person of the South,
Sun Fire Deity and White Cloud Person of the East,
Sun Fire Deity and All-colored Cloud Person of the Above,
Hereat we bring you now your special prayer-stick,
We make for you an offering of sacred meal,
A little bit for all, we make these offerings to you!
Stand ready, then at dawn to walk
With rain upon the northward mountain top.
 etc., etc.

Hopi "Universe Painting" in Colored Sands
Before an Altar

The four directions of the world run in concentric fashion around the center, because in every part of the world there are always four directions. On each side is a cloud symbol, on top of which an ear of corn of the appropriate color is placed, along with one or more stone axes. The diagonal line in the lower right-hand corner is the road to the underworld, with walking-sticks.

A Tewa Idyl of Summertime

Hummingbirds among the bee balm, while raindrops fall in light showers from white and black clouds.

In Navaho sand-paintings we find rain-magic of the Pueblos, with invocation to male and female rain, to male and female lightning, used not to bring water for crops which they fail to plant, but instead to cure disease.

The symbolism of animistic philosophy attaches itself to the heavenly bodies, to animals and birds, to rivers and mountains wherever these are in position to help man, each according to an outstanding efficiency. Beasts of prey like the mountain lion teach skill in hunting; bears give shamanistic power in the curing of disease; the deer and buffalo yield their bodies to slaughter; the hummingbird conveys invulnerability; the sun and stars guide warriors in the quests of war.

Diffusions in Symbolism.—Reading backward the pages of archeology we trace the vestiges of this school of symbolism to certain great ruins of a previous epoch in Pueblo history—precisely to those ruins which were flourishing when the Toltecs of Mexico established trading contacts in this northern territory. Before the times of the Toltec contacts, evidences of rain-magic embodied in graphic symbols or in regalia of the Pueblo In-

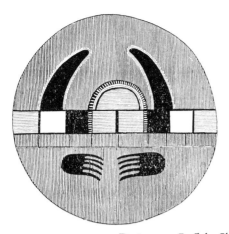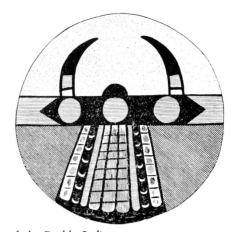

Designs on Buffalo Shields of the Pueblo Indians

Left: Buffalo-horns and the sun above the Milky Way, with bear's feet below: a prayer for strength and knowledge. *Right:* Buffalo-horns and sun above the Milky Way and three stars of Orion's Belt; below, the sun's shirt, namely, the streamers of light when the sun goes behind a cloud.

dians are conspicuously wanting. The geometric patterns of the early black-on-white pottery are coldly formal without the *élan* of inner meaning.

At the end of the Pueblo II period the Utah region was abandoned by small farmers and the typical villages of the Southwest expanded considerably into what is now Mexico. In the meantime the Toltecs were pushing the frontiers of their empire farther and farther to the north. Then copper bells and parrot feathers of the Toltec traders were exchanged for tur-

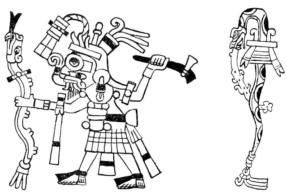

Tlaloc, Mexican Rain God, with Lightning Serpent and Thunderbolt
Left: Lightning serpent in a pre-Spanish Mexican book

quoise. Many ceremonially buried parrots have been unearthed at Pueblo Bonito and other ruins of northern New Mexico. Copper bells, although not found in quantity, occur rather widely in the Southwest and especially in places where Mexican influences are discernible in changing art.

Behind these Toltecs, who came bearing illusions, loom the achievements of the Mayas, aptly described as Greeks of the New World. We cannot tell what manner of decorative art was brought into America from Asia by the first rude immigrants, but at least we may be assured that it did not comprise

deep-seated symbols of this or that religious mystery. But animal draw-
ings for hunters' magic were not beyond the psychology of these immigrants,
especially since the mass of Paleolithic representations in the Old World may
come under this category. Man's entrance into America was made during
Neolithic times when the polished stone celt had already passed into general
use. As we now read the earliest archeological records of the New World,
permanent forms of designs may first have been reached in basketry. If
so, they were doubtless abstract shapes developed from constructions or sig-
nificant shapes drawn from nature but formalized by constructions. Next
came pottery as a household art and with it the weaving of cloth, the old

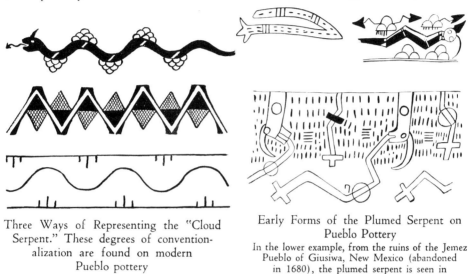

Three Ways of Representing the "Cloud
Serpent." These degrees of convention-
alization are found on modern
Pueblo pottery

Early Forms of the Plumed Serpent on
Pueblo Pottery
In the lower example, from the ruins of the Jemez
Pueblo of Giusiwa, New Mexico (abandoned
in 1680), the plumed serpent is seen in
the rain

thesaurus of basketry patterns being applied in both new crafts. But clay
was a plastic medium and soon in Central America figurines were being
modeled. While these may have had a cult value in relation to the new
interest in agriculture, no important developments in symbolism can be in-
ferred from the graphic motives which have come down to us from the
Archaic civilization.

 A sweeping advance in symbolic ornament was made by the early Mayas,
the movement beginning before the time of Christ and continuing till after
600 A. D. Ideographic writing was invented and a pantheon of grotesque
divinities furnished subject matter for inspired artists. In general it seems
that the first gods were composed of separate elements drawn from nature.
Various animals contributed quotas of special efficiency to the upbuilding of
a synthetic god. The early Mayas spread about them a spell of significant
beauty, visualizing for their neighbors an unguessed universe of associations.
On the highlands of Mexico a really vast difference exists between the
Archaic and the Toltec styles, and on analysis the new and vitalizing ingre-
dients can be traced down to lowland Maya sources. The Toltecs put a fin-
ishing touch of their own on borrowed ideas and then spread the complex
far and wide.

The extended influence of the Toltecs is explained on the surface by their successes in trade beyond a large territory which they subjected to the force of arms. But they could not have conquered uncivilized peoples. The constructive demonstrations of the Mayas had been acting as slow leaven, and five hundred years after the actual abandonment of the early Maya cities, several nations of Mexico and Central America were enjoying peaceful life and cultivating the arts—especially the new craft of working gold, silver, and copper. The Mayas had long since reestablished themselves in northern Yucatan. The times were ripe for conquest.

Our actual knowledge of the Toltecs goes back to the twelfth century. After being some time in Yucatan they conquered Chichen Itza in 1191. The complex of ideas which the Toltecs spread abroad seems to have taken definite form in this city, being especially concerned with cults in which eagles and jaguars were the patrons of warriors' societies and in which the plumed serpent was a potent symbol. Originally the resplendent trogan and the rattlesnake had been combined by the Mayas into a grotesque God of Rain. Even in early days this god had secondary powers in war because he yielded lightning as a weapon. A great Toltec ruler adopted the plumed serpent as his oriflamme and attempted to restore the religion, science, and ethics of the early Mayas. His followers, however, were hopelessly Philistine. The associations of warriors which regarded eagles and jaguars as their helpers may be compared to the European orders of knighthood; they were still powerful among the Aztecs when the Spaniards arrived. In art the Eagles and Jaguars, associated with the Plumed Serpent whose power was as the storm rack and the lightning flash, were represented in half-animal, half-human forms. These knights believed that after death they would become gods provided the God of Death could be appeased by human sacrifice. Their ceremonies were involved in cosmic patterns, with special colors, animals, trees, sacrifices, etc., distributed to the four directions of the earth or the six directions of the universe. The sun was their special deity and the symbols of human sacrifice were used by them as motives of decora-

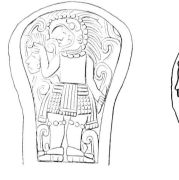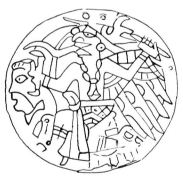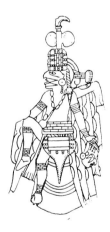

Eagle-men with the Heads of Victims

Left: Design on a Totonac palmate stone; Vera Cruz, Mexico. *Center:* Design on a shield gorget: Etowah, Georgia. *Right:* Design on a copper plate; Etowah, Georgia

tion. These symbols, joined in series, included shields, lances, knives, hearts, skulls, crossed bones, and severed hands.

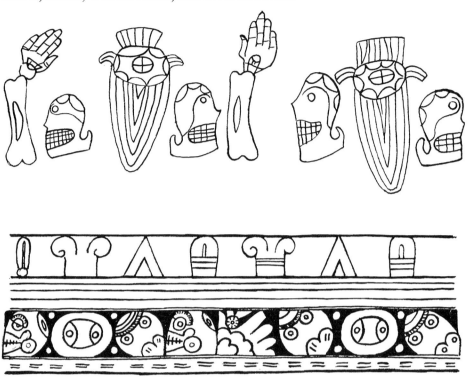

Designs Dealing with the Apotheosis of Warriors
Above: From a Mound-builder vessel (bones, hands, skulls, shields). *Below:* From a Mexican vessel (skull, shield, heart, skull, hand, heart, shield, heart, with bones and rays in upper zone)

The tree-ring calendar by which Dr. Douglass gives dates to Pueblo ruins establishes chronological conformity between the Mexican dates for Toltec activity and the first appearances of Plumed Serpents, Eagles and Mountain Lions, Cosmic Symbols, etc. in the Southwest. The present-day Eagle Dance reproduces quite accurately the accoutrements of the Eagle Warriors in pre-Spanish Mexico.

When we pass to the Mound-building area, the acceptances of Toltec symbolism are still more striking. Indeed, the elements which follow the Mexican mode in subject matter are precisely the ones which dominate the highest art of the Mound-builders. These are humanized eagles as warriors holding severed heads as they do in Mexico; Plumed and Horned Serpents, which may also be supplied with wings; various cosmic symbols or diagrammatic representations of the Sun; the world and the universe conceived as having four or six parts; and symbols in series which include shields, lances, skulls, bones, hands, etc. The hands frequently have an eye in the palm, an idea also used in Mexican art. It seems not unlikely that the Toltecs found a way to reach the copper supplies about the Great Lakes by coast-wise trade from northern Vera Cruz.

Survivals and New Growths of Symbolism.—Among the modern Indians of the Eastern Woodlands, the Great Plains, and even of Alaska, there are strong survivals of these symbolic concepts as well as many extensions.

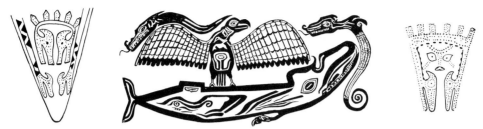

Thunderbird and Lightning Serpent of the Northwest Coast
Middle figure: Thunderbird carrying off a whale which he has killed with two lightning serpents.
End figures: Designs on harpoons representing two-headed lightning serpents

The Eagle-man gave rise to the widespread Thunderbird motive. The Horned Snakes and the Underworld Panther deity of the Menomini, for instance, are doubtless divergences from the early suggestions. Military

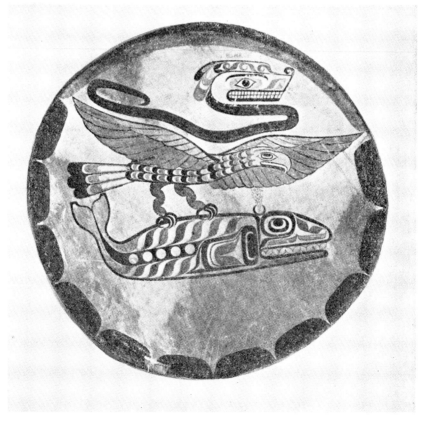

Nootka Indian Drum Painted to Represent the Thunderbird Carrying Off a
Whale and Surmounted by a Plumed Serpent
(American Museum of Natural History)

societies are exceedingly important on the Plains, and the scalping ceremony may well go back to Toltec inspiration. In these military societies symbolism is often seen in costume details which are recognized insignia of achievement according to degrees of valor. Buffalo shields in the old days were frequently painted with designs which appeared to warriors in dreams. While some are really personal, others keep close to a vogue in which the Thunderbird, the Whirlwind, the Spider, etc. are the special protectors of warriors. The Spider was of considerable importance in Mexican symbolism also, and the Whirlwind of the Plains was condensed to the cocoon of a fluttering moth, perhaps derived from the Obsidian Butterfly of the distant south.

Symbolism on Warrior's Costume. Plains Indians
At the left, above, is the camp-circle of tipis; below is a line of the enemies' horses, while the rows of hoof-prints represent successful horse-stealing raids. The figure at the right is a feather which means that the wearer was wounded in battle, and the lower one that he was first to touch an enemy.

On the Northwest Coast the Thunderbird is conceived as a monstrous Eagle-man who flies out over the ocean and kills whales by throwing the Lightning Serpent. This special adaptation of the general Thunderbird motive is distributed from Oregon to Bering Strait, and is especially developed in southern Alaska and British Columbia. The Indians carve Thunderbird heads upon whale-bone clubs, and they engrave on their whale harpoons the picture of the Lightning Serpent.

If space permitted, it would be possible to give the evidence of these diffusions in great detail and trace the modifications which have crept in during the centuries. Also, it would be possible to show that the same general set of ideas spread southward from Mexico till it reached Peru.

Back of this story of symbolical associations with its historical problems, lies the fact of a special American Indian psychology which accounts for acceptances and continuities of designs which have magical purposes. In closing I quote from a recent book of Carleton Beals: "There is something Oriental in the Indian, at least in his patience, his renunciation of too much

worldly endeavor; yet there is something more truthful and wholesome in his life than in that of the East. We Americans shut out the roaring tide of life by externals, by living outside our bodies and minds, by conquering nature instead of ourselves; the Oriental escapes the roaring tide of life by shutting out the world, by conquering himself instead of nature. But the Indian lives close to the spirals of nature itself. There is a healthy interpenetration of himself and nature. . . . The American is practical, the Oriental metaphysical, the Indian poetical. We live for action; the Indian for aesthetics; the Oriental for thought or religious ecstasy. The super race, perhaps, will be that which combines all three successfully."

The symbolism of the American Indian indicates, in a word, his conquest of an imaginative and immaterial universe.

Brooklyn Museum,
Brooklyn, New York

INDIAN POETRY

By

MARY AUSTIN

THE EXPOSITION OF INDIAN TRIBAL ARTS, Inc.
Permanent Office, 578 Madison Avenue
New York, N. Y.

INDIAN POETRY

By

MARY AUSTIN

INDIAN poetry is the key to Indian design, perhaps to all art among all peoples everywhere. But when we speak of primitive poetry we mean a little more than the word "poetry" means among us; we mean the formal expressiveness into which a man puts the whole of himself, his thought, his heart-beats, his breath, his voice, the movement of muscles rippling in the emotionally controlled effort of the "inside man" to explode into something which signalizes his experience of the moment. Poetry for primitive man is a thing done, precisely as a decoration on a water-jar is done: the abstraction of an experience sketched upon the audience with the poet's self as the tool. He uses the pound of his feet, the movements of his body, vocables, both melodic and articulate, and if these are not enough he will add to himself other means of expression: paint in various colors, feathers, rattles, drums, anything which will communicate himself to the hearer. He does all these things and does them movingly before he has any word meaning poetry, as distinguished from dancing, singing, and dressing up expressively. He does them before he makes anything in wood or clay or textiles, and often his poetry is so far advanced in expressiveness that by the time he arrives at decorative design and the beautification of useful things, all these are strongly marked with the moods and the methods of poetry.

Primitive design always tends to poetic significance; it undertakes to say something rather than to picture something. Even when a picture is introduced, as it often is in Pueblo pottery, it is not the picture as portrait which interests the Indian, but the picture as idea. Thus the remarkably life-like drawings of deer, or skunk, or buffalo, used in decoration are not so much to say deer or skunk or whatever, but to say food, vitality, summer, good hunting, fecundity, spiritual power, ideas and experiences associated in the tribal mind with the animal represented.

But if you go further back into the use of these animals in poetry, you will find this association of ideas worked out into what we call figures of speech, as in the Paiute song, in which the poet means that he is beset by unhappy events but says

>Truly buzzards
>Around my sky are circling

or the Plainsman sings

>The sharp hawk (of death)
>Is over me.

95

Other elements carried along from poetry to later arts can be clearly traced. Rhythm, of course, as the fundamental of poetic form, rhythm of number, especially of sacred numbers; incremental rhythms, the phrase repeated with slight additions or alterations; rhythms of symmetry, sounds patterned in a verse by much the same principles that color is patterned in a blanket. Indian poetry seldom rhymes, perhaps never intentionally, but it chimes. It has no formal measures, but agreeable sound clusters tend to recur at intervals according to patterns deep within the Indian consciousness, which are not reduced to rigid rules as with us. It is possible that if as much study were given to Indian poetry as to Greek, or French, definite underlying patterns would be discovered, but the Indian poets themselves can not help much. They have taste in respect to their own productions, so that the poems they tell us are most esteemed among them, when translated, exhibit those characteristics which make the best poetry everywhere, but they know no rules.

It must always be remembered in connection with all Indian art, that it is racially akin to the art of the Chinese, and that the local influences are all American. Running through all Indian poetry and all Indian decoration, there is that subtle network of the association of ideas which makes Chinese poetry so difficult to translate. Words and phrases do not only mean literally what they say, but refer to myths, to religious beliefs, to stories and tribal incidents which the reader unfamiliar with Indian thought would never suspect. Or they may refer to associations of fact in the background of a particular tribe, which could not be guessed by one unfamiliar with that environment. This often leads to amusing errors when people not acquainted with the Indian's life try to translate his songs.

Anyone, however, who will read such translations made by people with poetic skill—which the scientific collector of Indian songs does not invariably possess—will be in a better position to understand the mode of Indian decoration. All design, whether of words or patterns or color, tends to follow the sacred number of the tribe. A pottery unit of design resembles a poetic phrase, being expressive of an association of ideas rather than an association of mass or form. In the Rio Grande pottery there will frequently be found a design, executed in black on white, of a growing flower, but in place of any recognizable flower pattern, at the top of the plant appears a design of scalloped cumulus clouds. The association of ideas is clear in the rain-songs of the various pueblos in which the clouds are called up as

> White blossom clouds
> Let the sky be covered with clouds
> As the earth with flowers

Other associations of designs indicate poetizing ideas such as the rain dropping from the wings of the clouds, rain as wing feathers, lightning like arrows, or like serpents, all of which may be discovered, repeated many times, in the Pueblo corn- and rain-dance song-cycles.

The interrelation of songs with all other arts is shown in the magical properties attributed equally to certain songs and certain decorations. All art is magical, and never so powerfully so as when sung. Often the song and

96

the act go together, as the corn seed is trodden into the ground, the pot is shaped, the healing medicine swallowed or applied. Primitive man seldom supposes that he does anything important by his own powers; he feels himself assisted by the inherent *wakonda,* the spirit power of natural things. He thinks of poetry as evoking this power, and the making of a poem or the making of any beautiful thing as an act of spiritual communion with the Powers, by whatever name he calls them. So there is a song when the newborn child is held up to the light, a song for the corn planting and one to bring the deer down from the mountain; a song for the building of the house, for the cure of the sick, for the making of the bow, for the soul in departing. Friends of the Indian are often accused of "poetizing" the Indian. But the truth is that this is what he has done for himself, done it so completely that our failure to follow him on to the poetic level at which his important processes take place is the chief reason for our failure to understand him. Nothing disconcerted him more than learning that the white man could raise corn without singing over it; nothing has been more difficult of adjustment than realizing that we can like his songs and not share their spiritual content.

Santa Fe, New Mexico

MODERN
INDIAN PAINTING

By

ALICE CORBIN HENDERSON

THE EXPOSITION OF INDIAN TRIBAL ARTS, Inc.

Permanent Office, 578 Madison Avenue

New York, N. Y.

MODERN INDIAN PAINTING

By

ALICE CORBIN HENDERSON

THROUGH the roof opening of the *hogán* a beam of sunlight falls on the bent shoulders of men and boys at work on a Navaho sand-painting. The fine colored sands—white, black, blue, yellow, and red—are sifted through thumb and forefinger with incredible precision. The design grows, as if from a seed or kernel. On the first smoothed space of the sand floor, the priest, looking above to the roof opening, marks a spot directly under it, and this spot is the center of the painting. The figures in the central portion are blocked in, edged with thin lines of the four sacred colors, decorated with masks, bands, feather-tipped arrows and head-dresses—each step completed before the next is taken; the design expanding as the space expands—more and more men working on it, until at the outer edge, with barely room to stoop beneath the slanting roof, the painting is entirely finished.

The design, and every smallest part of it, is wholly symbolic. It has an archetypal, elemental significance. However intrinsically beautiful, its beauty to the Indian is in its meaning. It represents a philosophic conception of life. Its purpose is to convey this philosophy, and, once it has been used in the ceremonial ritual that follows, the painting is entirely erased and destroyed with the same ceremonial precision with which it was made.

This is the spirit of Indian art—difficult to explain because it is so different from our modern individualistic conception of art. It belongs to a world where expression is subservient to the "idea"—where the forms of art are never collected or hoarded as such, but the idea or image is tenaciously held and preserved through centuries.

This primitive form of art exists today in the Southwest as it did in the earliest beginnings. And even though younger Indians have begun to work individually as artists, and to make watercolor drawings independent of ritualistic ceremonies, the old spirit still animates their work and their point of view. Art is not, to them, individualistic self-expression, not subjective, not *précieux*. It is as happily objective as making turquoise beads or weaving a blanket. And perhaps it is this complete freedom from self-consciousness that gives their work its feeling of fresh spontaneity. We are surprised by the beauty and skill, the fresh image, the indelible precision, the unspoiled vision of these native American artists. But, for them, there is nothing new or surprising in this new-found form of expression—it is merely a continu-

Eagle Dance. Painted by Quah Ah (Tonita Peña), of Cochiti Pueblo, New Mexico
(Collection of The Exposition of Indian Tribal Arts, Inc.)

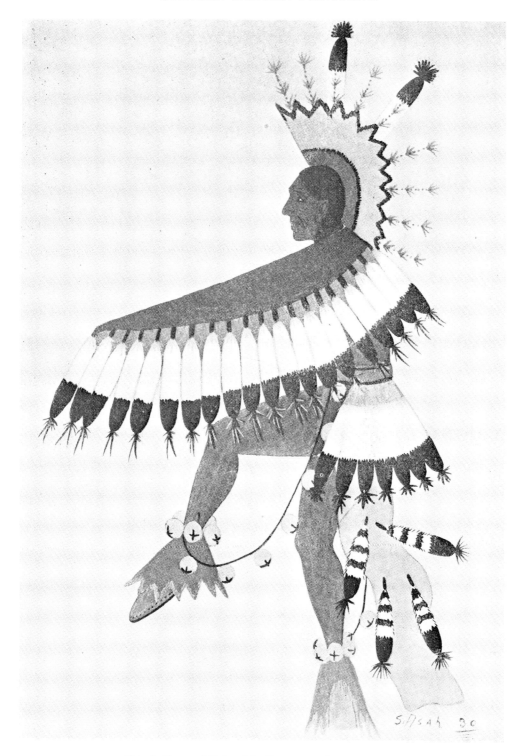

"Eagle Dancer." Painted by Spencer Asah, Kiowa Artist
(Collection of Prof. Oscar B. Jacobson)

103

ance of an age-old tradition. The spirit that produced these paintings is still living and fluid in the dance-rituals, of which they so often furnish the graphic counterparts, in the whole body of myth and philosophy that make up the living matrix of Indian life and culture. These artists are a part of this living culture, and their work is a reflection of a philosophy that feels every object magically alive—the deer with its exposed breath-arrow, the basket or bowl with its breathing space, the *hogán* that must be breathed and blessed into life, the painting that must be magically created and that will still go on living unless it is ceremonially destroyed.

It is impossible to appreciate Indian art fully without knowing something of this background, although I think no one can possess one of these watercolors without feeling this underlying spirit. The intrinsic beauty of the drawing, of course, needs no introduction. But if you talk to any of these young artists, you will find that they possess no equivalents of our art-terms. All that they are interested in is that the drawing shall be "made

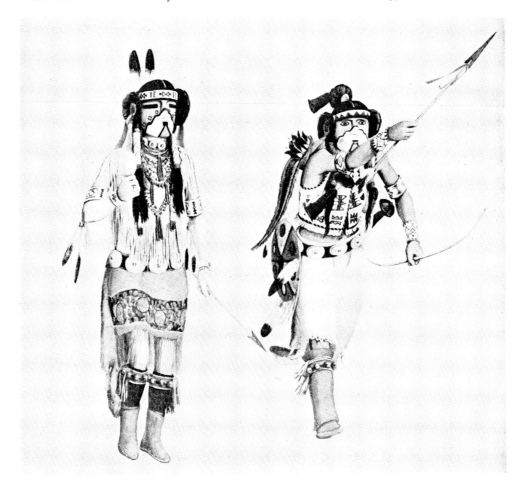

Hopi Kachinas. Painted by Fred Kabotie, Hopi Artist
(Museum of the American Indian, Heye Foundation)

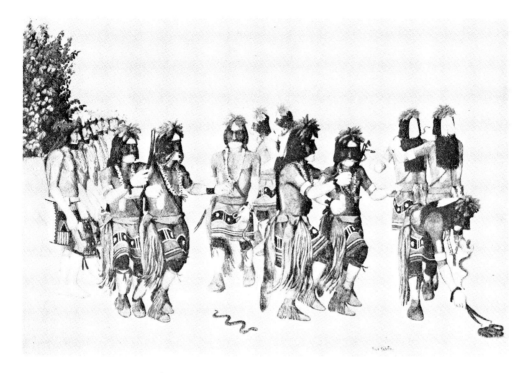

Hopi Snake Ceremony. Painted by Fred Kabotie, Hopi Artist
(Museum of the American Indian, Heye Foundation)

good." If you enter their world you will find, too, that competition of one artist against another does not exist. In the beginning these artists signed their pictures only when they were asked to do so. And competition had so little entered their minds that one artist, when he found that his signed work had come to command a higher price than the work of a younger friend, was perfectly willing to add his signature to work which he considered quite as good as his! It was hard for him to understand that in our world this was not ethical. The idea of buying a painting for its signature did not occur to him any more than it would occur to him to look for a signature on a bow and arrows or a pair of moccasins. I think it would have been quite impossible to explain that in our world paintings are often bought for their signatures alone!

Of course this primitive (and perhaps enlightened) point of view will not last, but it is illustrative of the tribal conception of life and art, as of something possessed in common; and particularly characteristic of their conception of the function of art, in which everyone shares, with greater or less degree of ability, but with no limit on participation or on potential skill. Art is, functionally, another form of language; the artist is a vehicle—it is the work that counts.

So far as I know the Indians have no art "shop-talk." It was suggested to me that I "interview" some of these artists whom I have known for years, but in this respect I must record myself an abysmal failure. We could talk

"Young Men's Spring Ceremony." Painted by Fred Kabotie, Hopi Artist
(Collection of Dr. Edgar L. Hewett)

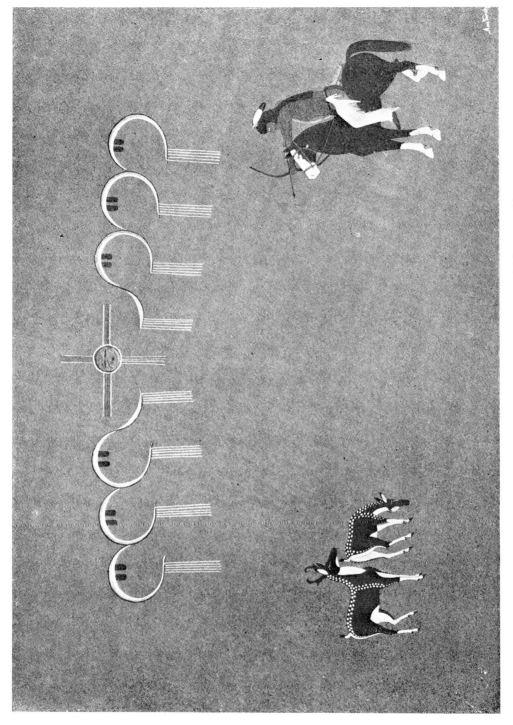

"Deer Hunter." Painted by Awa-Tsireh of San Ildefonso Pueblo
(Collection of Mrs. John D. Rockefeller, Jr.)

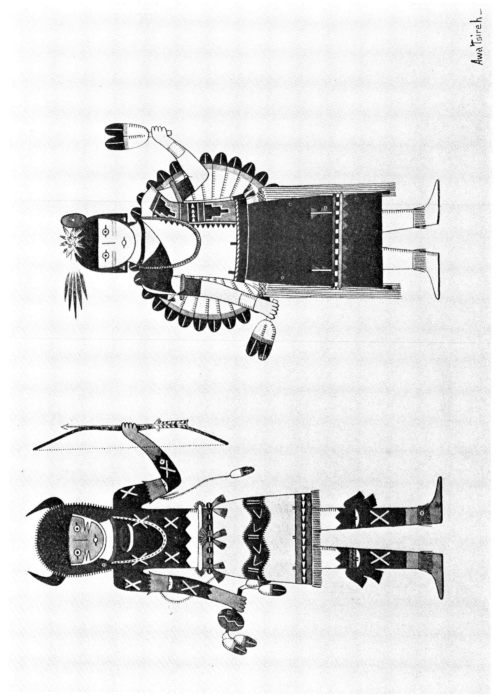

"Two Dancers." Painted by Awa-Tsireh of San Ildefonso Pueblo

(Collection of the Indian Arts Fund, Santa Fe)

about everything but their work. When it came to that, they would put a new picture in my hand—and if I did not understand that, what *was* there to talk about?

And what, after all, can one do about art—except to look at it? I have tried to give a little impression of the background, but the work of these Indian artists will make its own appeal on its own merit, and I have no doubt of the result.

I may, however, say a few words about the growth and development of this new phase of Indian art in the last fifteen years. Several years ago I wrote an article in the *New York Times* telling how I first became interested in the work of Awa-Tsireh and other artists in the Rio Grande and Hopi pueblos. My interest dates back to 1917 when I began to follow the work of Awa-Tsireh (Alfonso Roybal) and Te-e (Crecencio Martinez), who were virtually the leaders in this new form of expression. A year or two later John Sloan entered some of these watercolors in the Society of Independent Artists show in New York, and since then they have become widely known through subsequent exhibitions and private collections. As a result of this appreciation, there are today at least twenty young Pueblo Indians in Arizona and New Mexico, and a group of Kiowa in Oklahoma, who are making these distinctively original watercolors—purely Indian in motive and with an increasingly beautiful technique. It is pleasant to remember that the first artistic appreciation of these paintings came from an American artist who was interested solely in their intrinsic beauty; for, whatever the background, it is only on this basis that any work of art can be judged. The gesture was a frank tribute, not because these painters happened to be Indians, but because they were artists.

And this tribute was particularly refreshing because Indian art, as art, has received all too little recognition. It was, in fact, a precursor of this present EXPOSITION OF INDIAN TRIBAL ARTS, of which Mr. Sloan is the President.

The other day, when I was reading Mr. Jacobson's introduction to his portfolio of Kiowa paintings, I came across a remark which it may not be amiss to quote here: "The Anglo-Saxon smashes the culture of any primitive people that gets in his way, and then, with loving care, places the pieces in a museum." There is a pertinent sting in this remark, although I am not sure that it is only the Anglo-Saxon who deserves it! At any rate, there is enough truth in it to make us wonder why we in the United States have given Indian art less appreciation that it has received in Europe.

If Indian culture were a thing of the past, we should have to be content with museum relics. But it is anything but that! This Exposition is a presentation of living Indian art—it is a current art show. True, the traditional background is given, but only as a background for the art being produced today by living Indians. And in this contribution these modern Indian watercolors have a large share.

Santa Fe, New Mexico

109

SAND-PAINTING
OF THE
NAVAHO INDIANS

By

LAURA ADAMS ARMER

111

THE EXPOSITION OF INDIAN TRIBAL ARTS, Inc.

Permanent Office, 578 Madison Avenue

New York, N. Y.

112

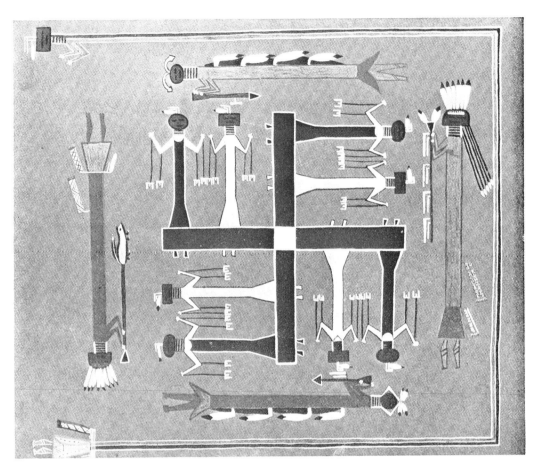

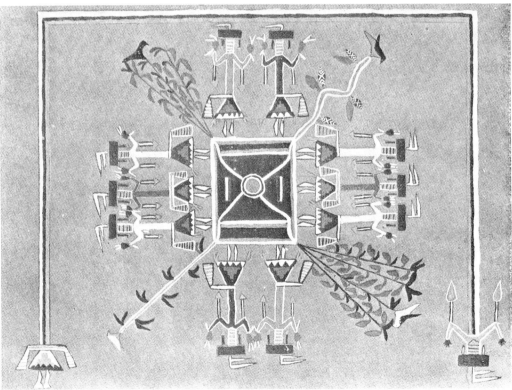

Navaho Sand-paintings

(Collection of Miss Mary Overholt, Fayetteville, Arkansas)

SAND-PAINTING OF THE NAVAHO INDIANS

By

LAURA ADAMS ARMER

IN AN austere land, whose miles stretch from the Rio Grande to the Rio Colorado, thirty thousand Navaho Indians subsist peacefully today among mesas, mountains, valleys, and cliffs.

In the days of the Spanish conquistadores, the non-sedentary Indians were little understood. They roamed their arid land in thieving bands, killing if necessary, and escaping to their impregnable cañons to live as their ancestors had lived for centuries.

Today they are little understood by motor-traveling tourists, whose cars penetrate the wilderness of sand and sagebrush with comparative ease.

Seen superficially, the Navaho are a picturesque people, herding their flocks, riding after their cattle, weaving their blankets, and making their silver-turquoise jewelry. In appearance they fit their country—rugged, colorful, and mysterious. How well they fit their country can be known only by spending years in close contact with their medicine-men, those shamans who sing the myths of an ancient people and an ancient land, who conduct ceremonial dances, and who supervise the making of the sacred sand-paintings.

Old myths, born of heroic living in a land whose physical features challenge the imagination, are blended with historical facts in the songs and the paintings.

High mountain peaks, rocky gorges where cactus plants make traveling precarious, thunder-clouds, lightning serpents, and forest prowlers, the "Old Age River"—all stimulate the dwellers of this arid region to personify the elements. Deity lives in every rock, in the winds and whirling sands. Deity is sung and portrayed in the nine-day "sings" held throughout the winter time for the healing of some sick member of the tribe.

A medicine lodge is built and within its sacred precincts age-old ritual is performed. For three or four mornings paintings are made with dry colors on the floor of the medicine lodge.

The process commences with the spreading on the floor of clean dry sand to the depth of about two inches. From four to twelve young men work under the direction of the shaman, who sits on the west side of the lodge.

The sand is smoothed with a curved stick. The artists work from the center outward, so that the design will not be spoiled. They rest on their knees, bending over the sand.

115

One man sits by the eastern doorway grinding the colors on a stone metate. Sandstone from the variegated cliffs has been furnished him. Yellow, red, and white, he grinds from the native rocks, and black from charcoal made of piñon twigs. He mixes the black with white, producing a gray-blue. The four sacred colors of the cardinal points are now ready for the artists—white for the east, blue for the south, yellow for the west, and black for the north.

The red is sunlight color and is used side by side with blue for rainbows. Brown is sometimes used for beaver or otter skins, making six colors for the sand palette.

Sometimes white and red are mixed into a pinkish hue and sprinkled with some shining mineral powder called "sparkling color."

The ground powder is placed separately on concave bits of juniper-bark. The artist takes a pinch of the desired color between his thumb and fore-finger and lets it trickle in the lines of his design. All the drawing is free-hand. Very delicate lines can be made, and large surfaces filled in solidly.

When the painting is finished, perhaps fifteen feet in diameter, with the light from the smoke-hole bringing out its exquisite color and detail, an ephemeral work of art greets the initiated.

The healing ceremony is held while the patient sits naked on the painting, facing the east. After an hour or so of ritual, the painting is destroyed, bit by bit, in the order in which it was made. The colored sand is removed in a blanket, to be deposited north of the lodge.

No one knows how many paintings the medicine-men use. It is my opinion that there are at least four hundred. I have copied one hundred during my research, and know that I have only just begun.

Every chant or ceremony has its own paintings. Every chant is for the healing of a specific disease. The lightning chant cures trouble due to snake-bites and thunderbolts. The chant of "Terrestrial Beauty" heals the spirit, restores the mind to beauty. The "Big God" chant cures blindness and stiff-ness.

The sand-paintings, representing very old traditional art, are a direct outgrowth of religious emotion. They are the only uninfluenced examples of aboriginal American art produced today. While they are highly stylized designs which must be made perfect according to the shaman's knowledge, there was a time in the remote past when they were spontaneous productions of artist priests. They link religion and esthetics to such an interesting degree that artist and ethnological student each finds in them a rich field of research.

They are the most ephemeral of all art, living only in the minds of old men fast dying. It would be a valuable gift to American culture to save these age-old symbols, and it is imperative that the work be done quickly, as the chants are fast becoming extinct.

Rainbows, clouds, corn, squash, beans, tobacco, animals of the mountains, serpents of dark hidden places, and reptiles of the dry sand are pictured with the gods of day and night, of the winds and lightning. Mother Earth and Sky Father lend their beneficent presence inside the solemn medicine lodge.

116

Constellations sometimes figure, and, very often, lone morning and evening stars.

Coyote follows a trail of beauty. The Dawn God, with his squirrel-skin tobacco-pouch, leads a glowing pantheon across the desert sand.

Mystery, faith, and beauty reign supreme while the multicolored symbols breathe out divinity under the sky-hole of a Navaho "House of Song."

Berkeley, California

DESCRIPTION OF THE SYMBOLISM OF A
SAND-PAINTING OF THE SUN*

By Mrs. Frances L. Newcomb

THIS sand-painting has no central emblem. In each of the four sections is an oval masked face with white on the forehead, a band of black beneath, and blue and yellow on the lower portion. The eye and mouth slits are black.

The eastern figure, or the one to the right, has blue horns, tied to the tips of which, with two cotton cords, are eagle-feathers. At the top of the mask two strips of cotton cord fasten an eagle-feather and a rain-feather, the latter being a breast-feather of a turkey. Similar feathers form appendages to each of the other masks. From the top and bottom of the eastern mask are wide zigzag wind strips in black, white, blue, and yellow; these are the hurricane winds. Projecting from the mask are four red wood-pecker-feathers. At each side of the mask are four small sun-dogs or spirit spots. This mask and its horns, like all the others, are outlined in red.

The mask in the southern section has black horns. The four feathers which point in the different directions are black, indicating the crooked path of the winter whirl-wind. This is also guarded by sun-dogs or spirit spots.

The masked face in the west has white horns tipped with white eagle-feathers, and similar feathers extend from the mask in four directions. From the top and bottom of the mask project straight lines of black, white, blue, and yellow, representing cyclone winds.

The northern mask has yellow horns. Pointing in four directions from the mask are red feathers with black tips. On the upper feather is a spiral of yellow symbolizing the sand whirlwind of summer. The decorations are identical with those of the other masks.

This painting is protected on three sides by an arc of mist from which extend four groups of feathers, five feathers in each group. The eastern opening is guarded by a bat on a field of corn pollen, and the sacred medicine-bag always used in the ceremony for which this sand-painting is made.

*The opposite plate depicts a Navaho sand-painting of the Sun which was copied by Mrs. Newcomb and is here reproduced with her description of its symbolism. It should be said that the plate and the description are incorporated in this appropriate place without reference to Mrs. Armer's article.

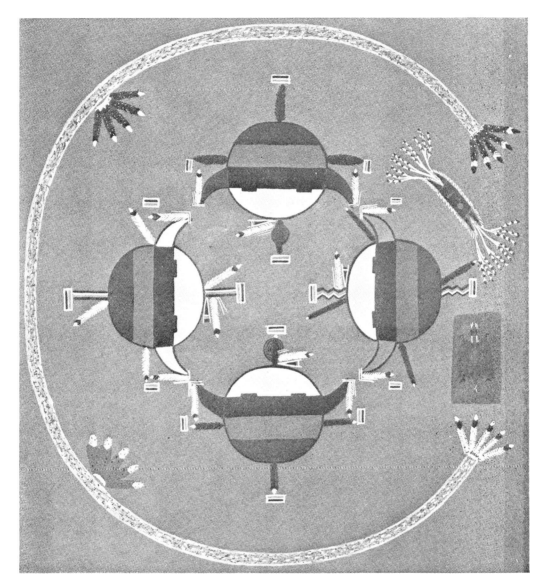

Navaho Sand-painting of the Sun
(After Drawing by Mrs. Frances L. Newcomb)

INDIAN POTTERY

By

KENNETH M. CHAPMAN

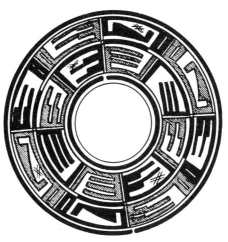

Hawikuh (New Mexico) Pottery Decoration

THE EXPOSITION OF INDIAN TRIBAL ARTS, Inc.

Permanent Office, 578 Madison Avenue

New York, N. Y.

INDIAN POTTERY

By

KENNETH M. CHAPMAN

O F ALL the arts which we associate with the American Indian, that of pottery-making affords the best medium for a study of tribal growth and decline, through a period of countless centuries, from earliest pre-Columbian times to the present. The basketry and finer textiles of America's earliest craftsmen have all but perished; the finest of tribal beadwork dates only from colonial times, and silversmithing is but the product of a mere century; while the art of painting, now so highly prized, is largely a development of only the last twenty years, although in much simpler form pictographs were made in early prehistoric times, and historical records, like the winter counts of the Plains tribes, have been drawn or painted for at least a few generations. But the well-nigh imperishable products of the potter have endured, and now, brought to light in the excavation of long deserted mounds and pueblos, afford us an extended record of cultural changes and shed light on the art as it survives among the tribes of today.

The ceramic art was a native development on American soil, and its spread in ancient times was limited only by the needs of each group. Thus, chiefly in the Pueblo region of the Southwest, and the great mound area of the Mississippi Valley and the Southern States, where agriculture led to occupancy of permanent homes, the medium found its greatest development. Among other less settled groups it served only for occasional use, or had gained no place with other lighter and less fragile utensils.

The knowledge of firing was doubtless acquired by the accidental contact of clay objects with great heat. No permanent kilns were ever constructed; instead, the primitive method of setting fire to fuel carefully piled about and over the sun-dried earthen receptacles was employed among all tribes and is still in vogue wherever the craft survives. Most of the local clays required the admixture of some tempering material to prevent the thin walls of pottery from cracking in drying or during the process of firing. By experiment, each community came to use its own ingredients, such as sand, pulverized shells, and even the pulverized fragments of old discarded pots, a temper still favored by some of the Pueblo potters of the Southwest.

Pottery-making among the American Indians has always been a woman's craft, though undoubtedly certain pieces were made by men for use in rituals in which women took no part. The potter's wheel was, and is still, unknown

to our native tribes. That simple mechanical device which led the ancients of the Old World into factory methods of production has had no place in the Indian's scheme of things, and even today each bowl and jar is fashioned entirely by the quick and sure movements of deft hands.

Many of the early forms were made in imitation of natural objects, such as gourds and squashes. Still others were given the forms of the utensils of an earlier period. This curious tendency to fashion new materials into old and familiar forms is nowhere better revealed than in the cooking-pots of the Iroquois, which show clearly their derivation from the more ancient jar of birch-bark within which hot stones were dropped to cook the steaming food. The Iroquois potters held to the old bark form of squared shoulders and seldom neglected to imitate, by scratches in the soft clay, the stitching by which the edges of the bark were held together.

As with every race, the experiments of imaginative individuals resulted in many odd and apparently useless forms, but these were seldom copied. On the other hand, a certain tribal consciousness held most of the potters to practical and well-devised standards of proportion. Much of the ancient ware is admirably adapted to the uses for which it was designed; indeed many of the forms might well serve as models for our own potters of today. In surface textures also, the early potters, particularly of the eastern half of the United States, gave great variety to their wares. Much of their product was finished by pressing the outer surface of the clay with a pad of coarse textile fabric. This gives, incidentally, a hint as to the great variety of weaves known to the ancients, for these textile imprints are clearly recorded on the enduring surface of clay. As time went on, the imprint of fabrics was regarded not as the mere mark of a process of manufacture, but rather as a desirable surface decoration, and this in turn was followed by more ornamental effects produced by the imprint of wooden or earthenware paddles or roulettes carved with elaborate geometric patterns.

In some localities, particularly within the Southern States, incised ornament was in great favor. This was produced by the pressure of a pointed tool, with which lines were drawn upon the plastic surface. The motifs run the gamut from simple bands to more elaborate geometric designs, volutes, meanders, and highly conventionalized figures of birds, serpents, and the human form. With these the effect was occasionally enhanced by rubbing white or red into the incised lines. Here the ancient potters went even further with decoration, for in many specimens unearthed from burial mounds certain portions are cut out to produce bold openwork patterns. It is evident that these were designed for ornament or for ceremonial use only, as the openings, often in the lower part of the jars, rendered them unfit for domestic use.

The great variety of clays throughout the Eastern and Southern States insured the production of many distinct colors and tones, and there is evidence of a knowledge of smudge firing by which gray and black could be produced. The beginnings of painted decoration also appear in some of this early ware, though these primitive potters were far behind their co-workers of the Southwest in their use of permanent pigments, such as black, brown,

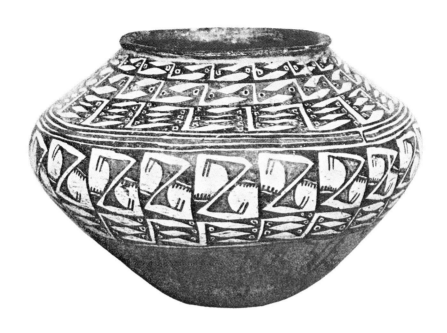

Modern Zuñi Jar with Adapted Ancient Decoration
(Indian Arts Fund, Santa Fe)

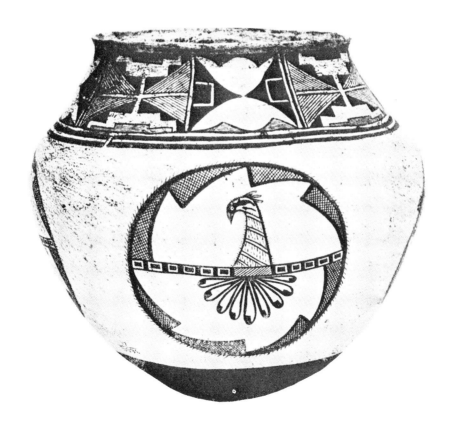

Old Zuñi Jar. Probably XVII or XVIII Century, but Ceremonially Used Until Recently
(Museum of the American Indian, Heye Foundation)

red, orange, yellow, and white. But if they sometimes lacked the means of recording their tribal taste in enduring colors, they gave rein to their creative impulse in the modeling of jars of human, animal, and bird forms. Many of these will stand among America's best examples of aboriginal sculpture. They speak of prosperous times in the distant past, when tribal life in our Southern States afforded serenity and leisure, and so gave zest to the creation of objects transcending the mere needs of domestic life.

East of the Mississippi the potter's craft is now practically extinct. To the westward, in the area of the great plains, stretching from western Canada to the Rio Grande, lived tribes which followed the buffalo and had little use in their wanderings for so fragile a product as pottery. But farther to the southwest, the great Pueblo area gave rise to another distinct culture. Here in a land of fertile valleys set amidst mountain ranges and semi-arid wastes, the Spanish explorers in the sixteenth century found populous and thrifty communities, the men skilled in agriculture and the women, above all, adept in the potter's craft so necessary in a region where water must be brought from a distance and conserved for household needs. Here, as in the East, pottery-making appears to have developed long after basketry and textiles had reached a high degree of perfection. The first crude, shallow trays of clay recovered from excavations in the cave shelters of the early "Basket Makers" show by the imprint on their bases that they were made by pressing moist clay, mixed with shredded cedar-bark, into shallow baskets. These sun-dried trays were left unfired and their preservation is due only to the extreme dryness of the caves in which they were abandoned.

As the "Basket-Makers" disappeared or merged with the earliest of the Pueblo people, new ideas in ceramics were forthcoming and the art developed at a remarkable rate. Bowls became deeper and jars were built up by the coiling of strips of clay to form the walls of the vessel. It was inevitable that this process should leave its impress upon the consciousness of these ancient potters. From a mere constructional feature it became a test of supreme skill as the overlapping strips became finer and more evenly placed. No greater craftsmanship has ever been displayed in the potter's art. Jars of several gallons' capacity have been unearthed, their thin walls of fine overlapping coils unsmeared by the careless touch of even one finger. In many, a peculiar wavy effect of the coils was produced by a regular repetition of the pressure of thumb or finger. In others, still greater variety was effected by the alternation of smooth and thumbprint coils, or by giving a wavy effect to the coils within triangular, diamond, and other regular spaces.

Unlike the potters of the East, the early Pueblos had learned the use of a great variety of permanent slips and pigments. To the southward, in the region of the Gila river, they perfected a buff-colored ware with coarsely brushed decorations in varying tones of red, as well as polychrome vessels painted in red, white, and black. To the north, in a much greater area, the prevailing type was whitish, with decoration in black. The motifs were clearly derived from basket and textile designs, and this geometric style prevailed through many centuries.

The most remarkable development of this "black-on-white" ware is

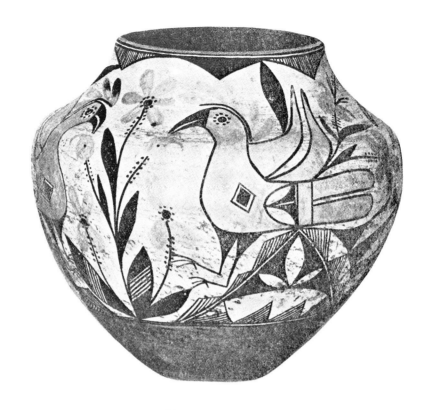

Old Acoma Water Jar
(Indian Arts Fund, Santa Fe)

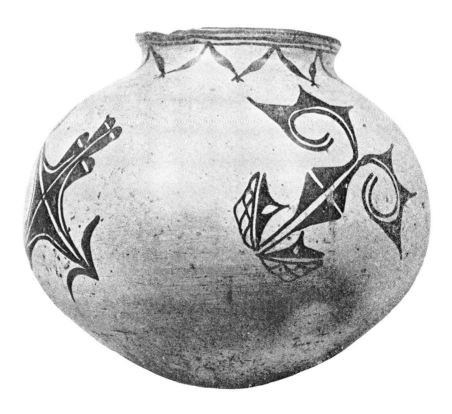

Cochiti Water Jar
(Indian Arts Fund, Santa Fe)

found in the Mimbres area in southern New Mexico, where hundreds of food bowls have been unearthed from burials within or about the ruins of communal dwellings abandoned long before the Spanish conquest. For precision of technique in the handling of fine brush lines and broad spaces in black, the geometric art of these ancient potters is unsurpassed. And done with the same geometric precision are hundreds of delineations of birds, beasts, fishes, and insects, as well as human beings engaged in various occupations and ceremonies.

In other regions the "black-on-white" ware was replaced by new types. The most remarkable of these later regional developments was that of the ancient Hopi in the midst of the Painted Desert of northern Arizona. Here superior clays, slips, and pigments led to the production of a distinctive ware with painted decorations in black and red, upon a surface beautifully varied in firing, from pure white through cream, yellow, and orange to brown. The decorative motifs, perhaps the most widely used by our own artists of today, consist largely of volutes cleverly combined with remarkably stylized birds. These are seen at their best within bowls, where problems of mass in relation to space have been handled with admirable style. A true mineral glaze also

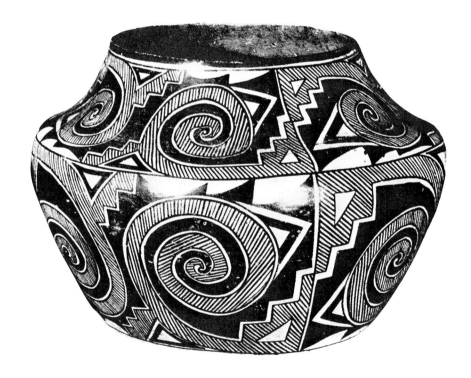

Old Acoma Jar, New Mexico
(Indian Arts Fund, Santa Fe)

128

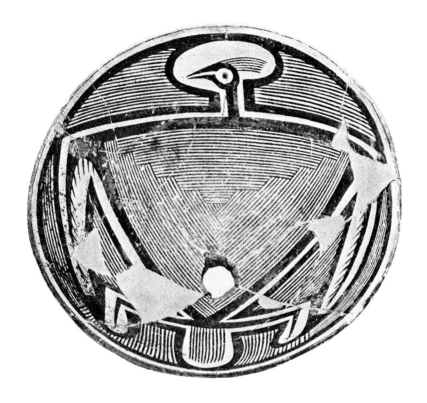

Prehistoric Mimbres Black-on-white Bowl with Bird Design in Fine-line Decoration
(Museum of the American Indian, Heye Foundation)

had a limited regional development in pre-Columbian times, though this was never used by the Pueblo potters to produce a waterproof surface. Instead, it was applied only in broad lines and spaces, giving a striking decorative effect of glossy black, brown, or rich green, in contrast with the lighter body tones of the pottery.

The Spaniards under Coronado, in 1540, found pottery-making the principal craft in well-nigh a hundred of these populous villages of the Southwest. Then followed a century and more of strife which culminated in the great Pueblo rebellion of 1680. Driven from the Southwest, it was a full twelve years before the Spaniards again gained control. Finally subdued, the Indians regrouped themselves into a scant third of their former communities, and here they carry on today, less influenced by our alien culture than any other tribes within the United States. The early pottery of this post-Spanish period is the rarest of all, for but little of it has survived the wear of domestic service or even of occasional ceremonial use. But by persistent collecting, a few of the important museums of our country are now provided with enough to tell a fairly coherent story of its development in each pueblo.

129

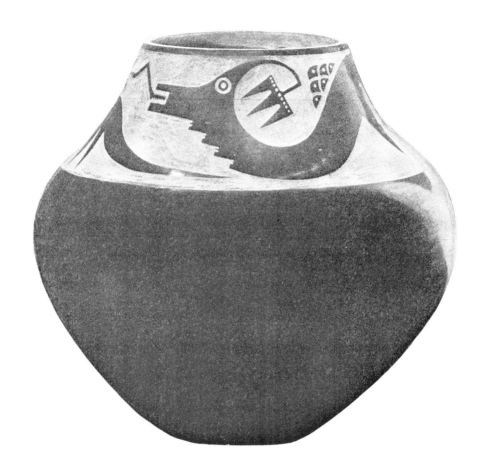

Modern San Ildefonso Jar
(Collection of Miss Amelia Elizabeth White)

Pottery-making is still an important craft in more than a dozen pueblos, each of which has developed its own distinctive art. In a few, the potters still carry on as did their grandmothers before them, producing only the old traditional wares and symbolic designs, unmindful of the strange uses to which they will be put by the tourists who buy. In others, they have succumbed to the roadside demand for small trinkets. In still others, new types of pottery have been devised—wares so perfectly formed and so beautifully finished that they cast suspicion upon themselves, for one must watch every process in their production to be convinced that they are really hand-made, from the first mixing of the clay to the final polishing, decorating, and firing. Yet these are the development of potters still in their prime, whose children are being taught at an early age to perfect themselves in a craft which has brought prosperity to more than one village.

The Maricopa of southern Arizona have also developed a considerable sale for their product. The Apache, the Navaho, and still other Southwestern tribes once made plain undecorated ware in considerable quantities for domestic use, but the craft is now practically abandoned.

Thus, of all the ancient pottery-making tribes within the United States, the Pueblos alone carry on, quite appropriately, the craft in which their ancestral potters won such distinction, countless centuries before Europeans appeared to change the whole fabric of Indian life.

Laboratory of Anthropology,
Santa Fe, New Mexico

Pattern on the Exterior of a Hawikuh Bowl

INDIAN SCULPTURE
AND CARVING

By

NEIL M. JUDD

Carved and Engraved Ivory Pipe. Eskimo. Alaska.
(Museum of the American Indian, Heye Foundation)

THE EXPOSITION OF INDIAN TRIBAL ARTS, Inc.

Permanent Office, 578 Madison Avenue

New York, N. Y.

INDIAN SCULPTURE AND CARVING

By

NEIL M. JUDD

I F BY sculpture we mean something "above" the utilitarian level, then it may truthfully be said that few Indian tribes from Mexico to the Arctic were successful sculptors. The things they made, whether of stone, bone, wood, or shell, were mostly required in the household, in the garden, or on the chase. But such artifacts, even though embellished in greater or lesser degree, are generally not classified as sculpture. It is only when we come to something a little higher, something associated perhaps with religious or ceremonial practices, that we find what might properly be termed esthetic appreciation. Witness the stone images from lower Mississippi Valley mounds, the tobacco pipes of the central mound-building Indians, or the incomparable wooden masks and figurines found by Cushing in the muck of Key Marco, Florida.

Within the historic period the Haida and their neighbors of the Northwest Coast, as carvers of slate and wood, have surpassed the work of every other tribe north of Mexico. Their wooden vessels, covered with deep-cut, symbolic designs; their black slate figurines, often illustrating tribal myths such as that of the "bear-mother," possess qualities far above the average of aboriginal American handiwork. Despite the fact that these carvings are all post-European, since they were shaped with steel tools, they remain purely native both in concept and execution. While nothing like these exquisite creations has yet been recovered from prehistoric village sites, it seems almost incredible that so distinctive an art could have come into being and reached its current perfection since Cook and Vancouver sailed cautiously up the coast on their pioneer voyages, one hundred and fifty years ago.

Authorities are now generally agreed that the large, spectacular totem-poles and memorial columns of British Columbia are comparatively recent. They all bear the marks of steel blades. So, too, do wooden masks found in Alaskan caves, and yet these latter, perhaps also the totem-poles, may well be later manifestations of an art that found more modest expression in an earlier period. From Alaska, also, come those remarkable lamps, carved from a single block of stone, in which a human figure, a seal, or a fish seems actually to float across the vessel's inner surface. But it is only in the lower levels of the oldest rubbish heaps that one finds the best in Eskimo carving—rich, curvilinear designs incised on fossil ivory.

135

Statuette from the Turner Group of Mounds. Ohio
(Peabody Museum, Harvard University)

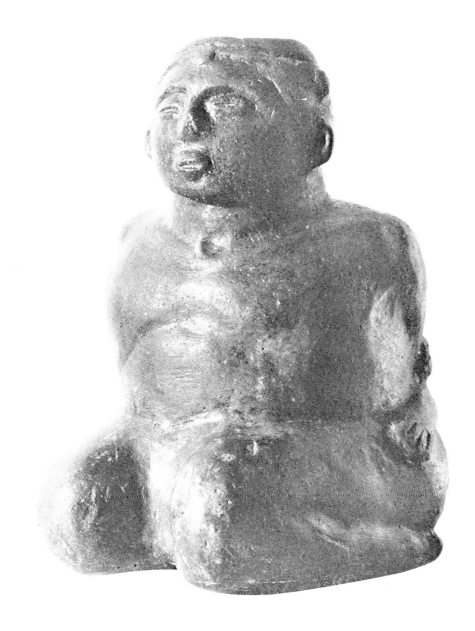

Prehistoric Effigy Jar, Representing a Captive with Arms Bound Behind Him
Southwestern Missouri
(Museum of the American Indian, Heye Foundation)

Carved and Etched Dipper of Ivory
Aleut Eskimo
(Museum of the American Indian, Heve Foundation)

Although the Pueblo tribes of our Southwest are now and long have been unexcelled in pottery manufacture and in the use of stone in domestic architecture, their attempts at sculpture are crude and childlike. Rare stone images from New Mexico ruins have only the vaguest resemblance to the human form they were intended to simulate; Pueblo hunting fetishes, widely sought by collectors of curiosities, are usually so elementary in execution that not every Pueblo can distinguish between, say, the mountain-lion and the chipmunk. On the other hand, Pueblo potters for a thousand years or more have had the skill to model effigy jars that leave no question as to the idea intended. And shell carvings from prehistoric ruins in southern Arizona compare favorably with those from Tennessee and Kentucky.

Undoubtedly the well-known female statuettes from the mound-building area of our Southeastern states most nearly correspond with the occidental idea of a statue. However primitive these specimens may be as works of art, they are not unsuccessful attempts at portrayal of the human form in the round. And there can be no doubt that the individuals who carved those images were capable of greater perfection had such perfection been one of the prerequisites. It appears, however, that faithfulness to nature has always been less essential to the Indian sculptor than faithfulness to tradition. Archeologists concur in the belief that these statuettes were carved, not as individual works of art, but in agreement with the traditional conception

138

Pottery Effigy Vase from the Nacoochee Mound, Georgia
(Museum of the American Indian, Heye Foundation)

of some mythological being whose presence was desirable in the performance of certain tribal rites.

From this same Southeastern area come earthenware and, occasionally, stone vessels with a bird or mammal head as protruding rim decoration. Among the best known of the latter are two limestone bowls from Moundville, Alabama, carved to represent the eagle. From one side of the vessel the tail spreads fanwise; from the opposite, the neck curves gracefully so that the beak comes to rest against the body. Here, too, chiefly in Alabama, are found those remarkable earthenware portrait-jars—human heads with modeled features showing scars, tattooing, and even facial expression. These, like the stone bowls above noted, may be classed as outstanding examples of Indian sculpture.

Human heads sometimes serve as bowls on stone pipes found in the mound-builder area of Ohio and neighboring states. But they are stolid heads, unflinching and unsmiling. More frequently these tobacco pipes are carved to represent a bird or a mammal of some sort, and often the carving is so

139

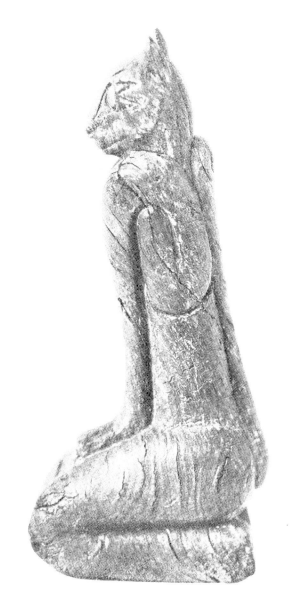

Wooden Statuette of
Key Ma
(United St

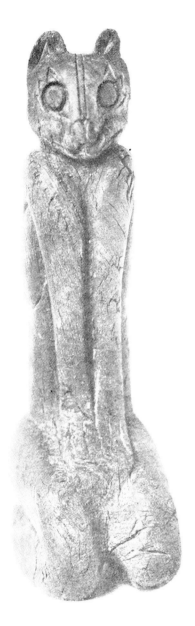

in or Panther Man God"
Prehistoric
onal Museum)

141

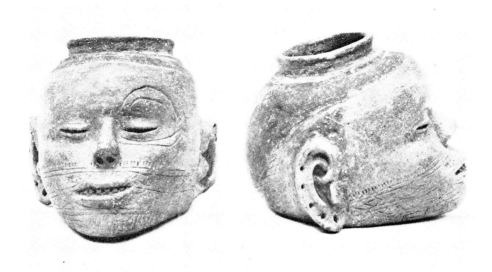

Jar Representing a Human Head, Front and Profile Views. Blytheville, Arkansas
(Museum of the American Indian, Heye Foundation)

faithful to nature that the creature represented may easily be identified as to species. Not so with the stone fetishes of the Pueblos where even the professional mammalogist must admit defeat.

Like their fellows of other races and other times, these prehistoric pipe-makers of the mound area occasionally grew ambitious and attempted subjects beyond their native ability. But there were among them individuals of unquestioned skill who truly deserve place in that small fraternity of the world's famous sculptors. I recall the figure of a nude male, carved from red Tennessee claystone, its weight resting on the left knee and its chin supported by the right hand. The face wears just the faintest suggestion of a smile; the curved back carries a shallow bowl from which the justly proud owner drew the rich fragrance of native tobacco and an understandable sense of satisfaction in possessing so rare a treasure. While this is truly an exceptional example, many other pipes approaching it in skill of execution have been recovered from mounds of the central Mississippi valley. And among them all none surpasses that remarkable specimen found by the late W. C. Mills in Adena Mound, near Chillicothe, Ohio—a full-length carving of an Indian man, wearing loin-cloth and ear-spools, whose feet encompass the bowl of a pipe and whose headdress forms its stem.

Along the middle Atlantic coast, steatite was quarried and rudely carved into vessels which, more often than otherwise, were broken under the shaping processes. But these utensils, largely owing to the character of the material itself, do not begin to compare either in size or in symmetry with the soapstone cooking-pots and deep sandstone mortars painstakingly produced by certain of the now-extinct California tribes. Nor do the latter vessels surpass in beauty of form those rare Alaskan stone mortars, externally decora-

142

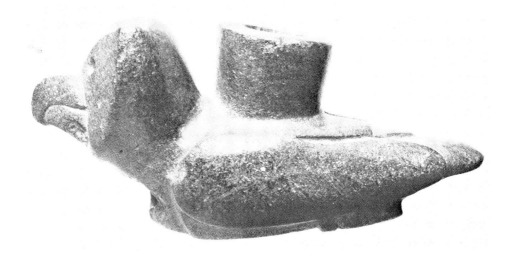

Owl Effigy Pipe of Stone. Mound-builder Culture. Blount County, Tennessee
(United States National Museum)

ted with carved masks which may or may not be human. These faces natur-
ally bring to mind the so-called "ape heads" from Oregon and Washington
—Indian sculptures which have remained a controversial subject for more
than a generation and which are probably not apes at all but native attempts
to portray the seal or the sea-lion.

The above uncertainty prompts repetition of the present writer's oft-
expressed conviction that aboriginal sculpture and carving, especially north
of Mexico, by its very nature usually defies final interpretation. Pictographs
and complex designs, pecked with stone hammers on exposed rock surfaces
from the Atlantic to the Pacific, have whetted our curiosity since the May-
flower landed. One may guess at their meaning but never know how far the
guess goes astray. Even our modernized Indians are of little assistance in
such cases, for, weaned from their native cultures as they now are, most of
them are just as ill-prepared as the average white man to interpret the more
abstruse records of their own tribal history.

After all, it is not necessary to know the aboriginal significance of a
given work to appreciate its craftsmanship. It may fall short as a work of
art if measured by our variable standards, and yet, by the same token, have
quite satisfied the native who made it. Too, we are prone to forget that these
prehistoric sculptures were carved with rude stone tools and by abrasion.
Excepting a soft bronze used mostly as ornaments by the pre-Spanish Peru-
vians and Mexicans, our American Indians were quite unfamiliar with metals
suitable for stonecutting until after the advent of Europeans. To be sure,
tribes dwelling in the Lake Superior region mined native copper and pounded
it into knives, digging-stick blades, and divers objects for bodily decoration,
but they could not carve stone with any of these. Archeologists find abso-
lutely no support for the perennial "hardened copper" fallacy. Nor do they

143

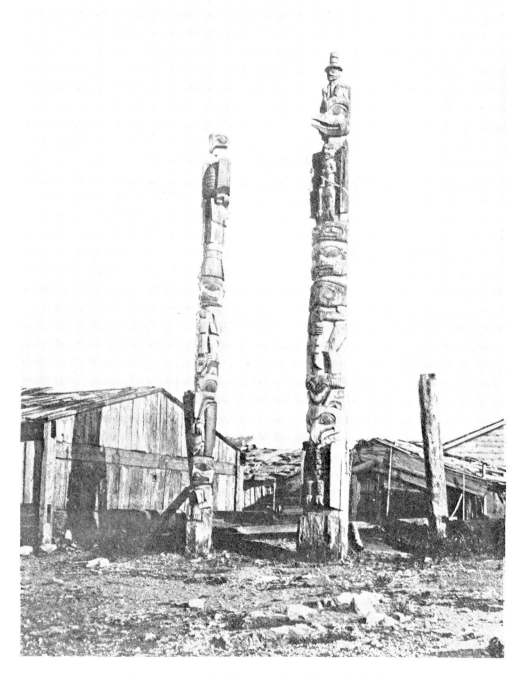

Totem-poles of the Tlingit at Fort Wrangel, Alaska
(From an old photograph)

forget that the tribes of both North America and South America continued to live in the stone age for a long while after white men had marked trails into every dark corner of the hemisphere.

As stone-age folk our American Indians devised such utensils and implements, whether of wood, stone, shell, or bone, as best met their daily needs. To a certain extent all such artifacts—stone axes and gouges, gorgets and amulets, mortars and cooking-pots—all come within the scope of sculpture. So do the so-called "pigment plates" of southern Arizona; more especially, certain stone tablets from the lower Mississippi Valley. On some of these latter appear incised designs of interlocking rattlesnakes—indubitable influence from the highlands of Mexico. The same cultural associations are even more apparent when we closely examine many of the shell gorgets from Tennessee mounds and note their intricate ornamentation of plumed serpents or masked human figures. None will deny that these are, indeed, works of art. With several such before us, we can scarcely avoid the feeling that among all the tribes formerly inhabiting the present United States at least the Mound-builders had a well-developed sense of the esthetic: that they had an appreciation of art for art's sake.

If it be argued that, in sculpture and in carving, the American Indian north of Mexico never attained the high plane he reached in pottery, in basketry, and in weaving, let it be borne in mind that his standards of excellence naturally differed from ours. But even so, as we view the things he fashioned with his rude tools, we invariably come to see qualities which render much of his handiwork in every sense worthy of classification as art. And the remarkable thing is that the inherent artistic genius of these dissimilar tribes should have persisted through four hundred years of alien domination and remained so little modified by exotic ideas and materials. As artists and as craftsmen in stone, wood, and shell, the prehistoric American Indians and their descendants are only now winning the appreciation their work has long merited.

United States National Museum,
Washington, D. C.

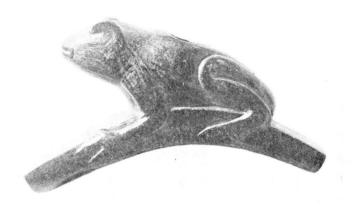

Carved Stone Effigy Pipe. Prehistoric. Illinois
(Museum of the American Indian, Heye Foundation)

INDIAN MASKS

By

CHARLES C. WILLOUGHBY

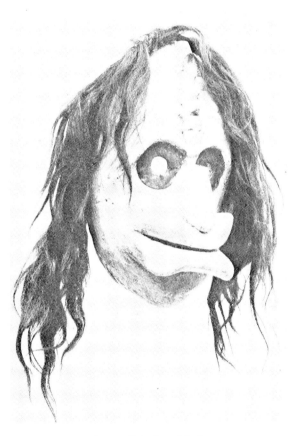

Seneca Falseface Mask
(Museum of the American Indian, Heye Foundation)

THE EXPOSITION OF INDIAN TRIBAL ARTS, Inc.
Permanent Office, 578 Madison Avenue
New York, N. Y.

INDIAN MASKS

By

CHARLES C. WILLOUGHBY

DANCING is one of the earliest and most spontaneous methods of expressing emotion, and has been universally practiced by man in all stages of culture. Among our American tribes dancing was largely ceremonial, and had to do mainly with religious observances, tribal and family traditions, and war. The painting of the body with symbolic designs and colors preparatory to taking part in a dance probably preceded the wearing of masks, for there are many tribes having elaborate and picturesque dances in which no masks are worn.

In northern America the mask had its greatest development among the people of the Northwest Coast. From the central portion of this territory its use probably spread northward to the Aleut and Eskimo of the west coast of Alaska, and southward to the Nootka and Makah of Vancouver Island and Washington.

The Pueblo region was another center of development. Here a very different type of mask was evolved. These are usually simple coverings for the head to which symbolic appendages of wood or other material are attached. Masks of this general type appear among some of the neighboring tribes, notably the Navaho. In other parts of northern America masks appear sporadically. They are found among the Iroquois and also among the Cherokee. Several of the Plains tribes used the buffalo-head mask during the buffalo dance. Cushing obtained several well-made wooden face masks during his excavations at Key Marco, Florida, which were undoubtedly prehistoric. Certain embossed copper plates and engraved shell gorgets show conclusively that masks symbolizing the spotted war eagle were worn in dances by the builders of some of the great mounds of Georgia and the neighboring states.

Masks of the Northwest Coast

The masks of the tribes of the Northwest Coast are of unusual interest, exhibiting as they do a degree of mechanical and artistic excellence unequaled by those of any other northern group. They are carved from cedar or other easily worked wood and are usually painted with symbols in red, black, or green. Many are in the form of the human face. Others represent heads of birds or animals, or mythological monsters and spirits, all having supernatural powers. Clan masks represent totems or crests originating in the

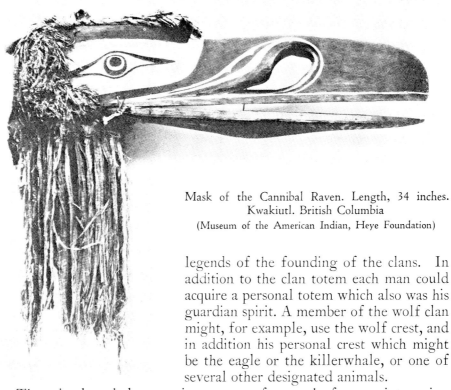

Mask of the Cannibal Raven. Length, 34 inches.
Kwakiutl. British Columbia
(Museum of the American Indian, Heye Foundation)

legends of the founding of the clans. In addition to the clan totem each man could acquire a personal totem which also was his guardian spirit. A member of the wolf clan might, for example, use the wolf crest, and in addition his personal crest which might be the eagle or the killerwhale, or one of several other designated animals.

The animal symbols appearing on many face masks form an interesting study: The hawk is indicated by a beak-like pointed nose, strongly recurved at its lower end which sometimes touches the mask. The eagle is distinguished from the hawk by a much shorter beak which curves downward. The killerwhale may be recognized by an abnormally elongated dorsal fin; this may be painted across the face of the mask. The shark is known by a group of short curved lines, one above the other, upon either cheek; these represent gills. Such markings occur in great variety and in many combinations.

According to ancient legends certain clan ancestors of the Kwakiutl Indians were given the right to perform special ceremonies and to belong to secret societies established by a guardian spirit of the clan. On joining one of these societies the novice came under the protection of its special spirit. The most important of these was the Hamatsa, or Cannibal Society. The right to belong was hereditary in the clan, but each individual, who by descent or marriage was entitled to its membership and wished to join, must be initiated by the spirit who founded it. The name of this spirit is Galukwiwi, the Cannibal Bird, whose house is in the mountains of the north. He is always in pursuit of men for food. In his house near the door sits the Cannibal Raven, his chief servant, who lives upon the eyes of the people whom his master has devoured. To this far-distant house the candidate is supposed to travel and he is usually away from the village for two or three months. To compensate Galukwiwi for the initiation, the youthful novice, on his return to

the village, must take part in the succeeding ceremony held by the society which supplements that supposed to have been held in the mountains. In this dance Galukwiwi is personated by the novice. The Cannibal Raven also appears. The dance is really a dramatic performance of the myth relating to this spirit. In ancient times the members of this society partook of human flesh during the ceremony. The masks of Galukwiwi and the Cannibal Raven are large and show excellent workmanship, that of the latter sometimes being more than four feet in length. The lower part of the beak is hinged to allow its being opened and closed by manipulating strings.

The above brief account will give the reader a slight insight into the character of some of the Northwest Coast dances in which masks are worn. While the ceremonies of this region differ in character, they have many features in common.

The masks are sometimes much more elaborate in the lesser societies than in the dance of Galukwiwi. Many are double, one being placed over the other. The outer is usually in two or four pieces, hinged and arranged with strings, so that it may be opened by the wearer, thus exposing the inner mask to the audience. The inner sides of the pieces of the outer mask are often

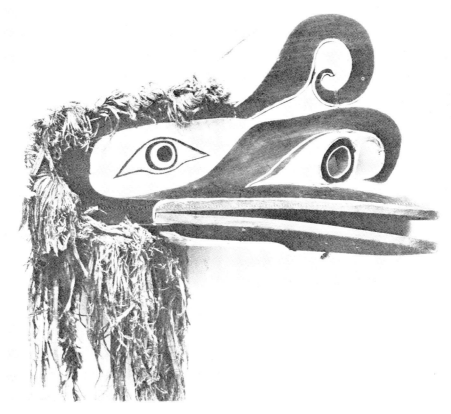

Galukwiwi (Cannibal Bird) Mask. Length, 34 inches. Kwakiutl. British Columbia
(Museum of the American Indian, Heye Foundation)

151

painted with designs supplementing those of the inner one, and when unexpectedly opened by the dancer, produce a most weird effect.

The various masks of Hamshamtses are especially elaborate in this respect. One may represent the raven in combination with the double-headed serpent or the sea-monster, Iákim, and the killerwhale.

A part of the paraphernalia of a Northwest Coast shaman, or medicine-man, consisted of masks representing animals or spirits over which he had control. While wearing a mask the shaman is transformed into the animal or spirit which it represented, thus imparting to him superhuman powers over the disease.

Practically all of the masks were ceremonial. The Tlingit, however, had invented a protective face mask and helmet which they wore with their slat and rod armor. The mask and helmet were separate, the former consisting of a broad band of wood bent to nearly a circle and large enough to fit loosely around the head. This was held in place by the wooden staple projecting from its inner side, which was grasped firmly between the teeth. Eye notches were cut in the upper edge of the mask which nearly met the brim of the helmet.

Masks of the Eskimo

In the ceremonial dances of the Eskimo of western Alaska many wooden masks are used. These take the forms of the human face, often with one or

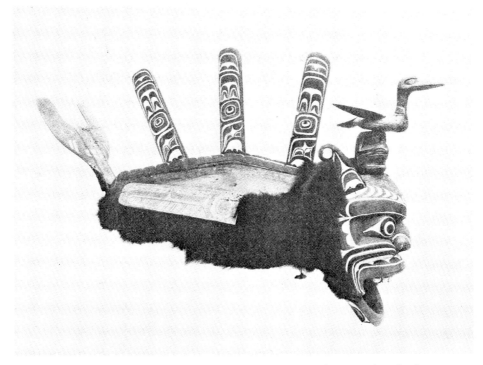

Mask-headdress of the Kwakiutl. Length, 5 ft., 9 inches. British Columbia
(Museum of the American Indian, Heye Foundation)

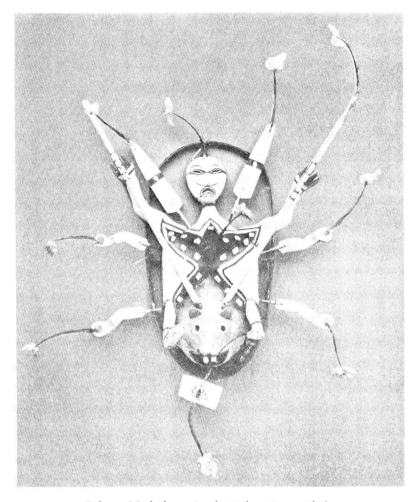

Eskimo Mask from Anvik, Yukon River, Alaska
(Museum of the American Indian, Heye Foundation)

more features grotesquely distorted; the heads of animals or birds; and the imaginary faces of spirits and mythical monsters.

Individuals of two groups of spirits are represented in these masks: the *yu-á*, spirits of the elements, of places, and of inanimate things in general; and the *tunghät*, which are wandering genii, or the shades of people and animals. The *yu-á* are seen by the clairvoyant vision of the shamans in lonely places, but they rarely appear about villages.

Many of these spirits or shades, especially of the *tunghät* group, are of evil character, bringing sickness and misfortune upon the people. Mythological beasts also inhabit both land and sea, but are rarely seen. Accounts of them appear in legends and they are sometimes represented in masks. Masks showing totemic animals are also made, and during ceremonies the wearers believe themselves to be transformed into these animals, or at least to be endowed with their spiritual essence.

153

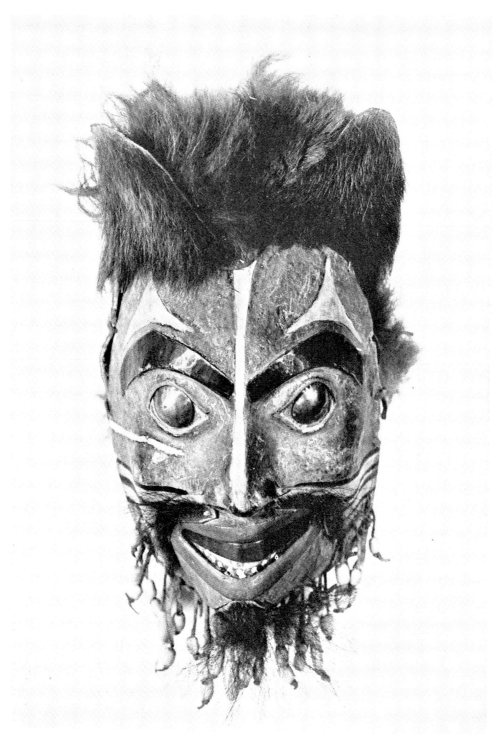

Mask of Man who was Transformed Into a Land Otter. Tsimshian, British Columbia
(University Museum, Philadelphia)

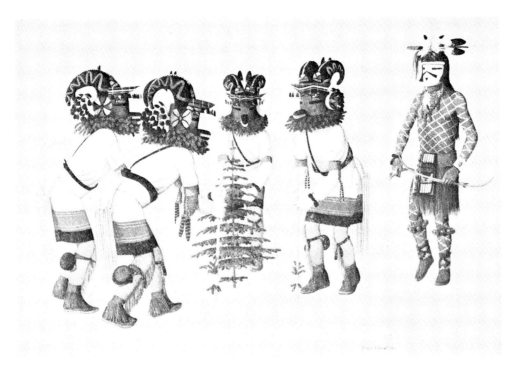

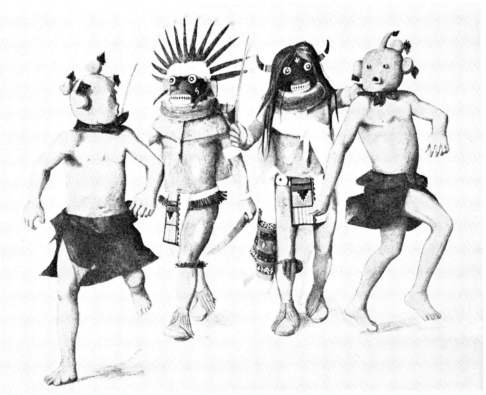

Masked Performers in Hopi Ceremonies. Painted by Fred Kabotie, Hopi Artist
(Museum of the American Indian, Heye Foundation)

155

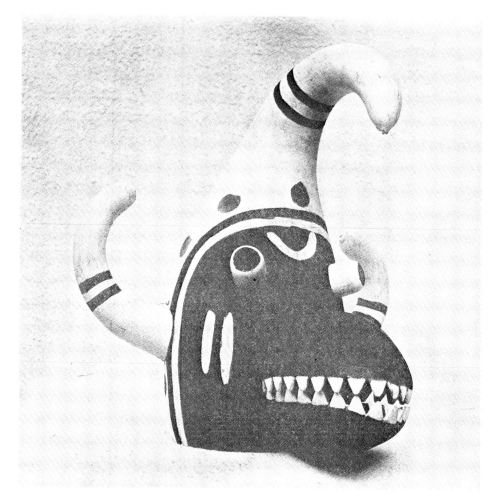

Gourd Mask of the Hopi of Arizona
(Museum of the American Indian, Heye Foundation)

It is believed that most animate beings have a dual existence and if an animal or a bird wishes to assume the human form, it can do so by raising its forearm or wing and placing it before its muzzle as if it were a mask. By this means the creature became man-like in form and feature. This man-like form was called *inua* and was thought to represent the thinking part of the creature, and on death to become its shade. Shamans were believed to have the power of seeing through the animal mask to the man-like features behind it.

Many of the masks of the Eskimo, like those of the Kwakiutl and other tribes of the Northwest, are arranged with strings or pegs, so the outer one can be quickly thrown back or removed, symbolizing the transformation of the dancer. So far as known the masked dances of this people are thanksgivings or propitiations to the shades and powers of nature, both good and evil, which are thought to influence the daily lives of the people.

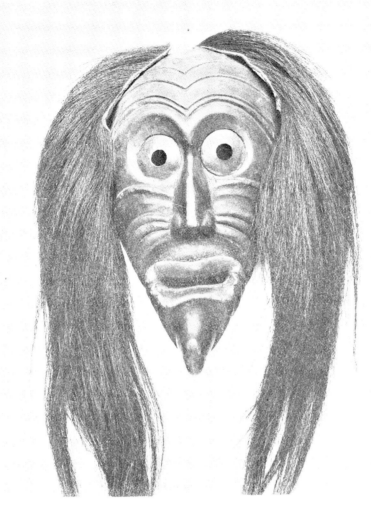

Seneca Wooden Mask. New York
(Museum of the American Indian, Heye Foundation)

Masks of the Pueblo Tribes

The masks of the Southwestern pueblos are different from those described above. The foundation is often a cylinder of hide large enough to fit comfortably over the head. This is furnished with openings for the eyes and mouth, and attached to it are various symbolic appendages of wood, feathers, hair, and other material. The masks are also painted in colors and with figures appropriate to the spirits or shades which they represent. The few masks in the form of animal heads which are used are often constructed of pieces of large gourds ingeniously joined together and decked with feathers and other attachments.

A Kachina dancer wearing his mask and other accouterments, his body painted in appropriate colors, is a very striking object. This name is applied

157

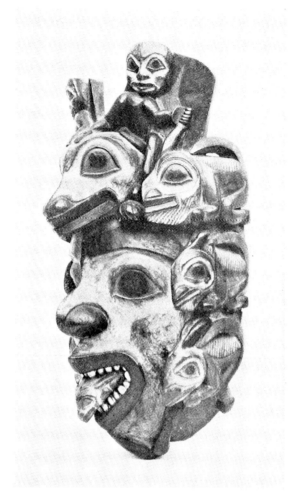

Mask of the Tlingit. Alaska
(Museum of the American Indian, Heye Foundation)

to a masked man personating a supreme being, as well as to the being itself. Kachina ceremonies occur among both the Hopi and the New Mexican pueblos.

A Kachina taking part in a dance is supposed to be the spirit of a deceased member of a clan reincarnated in its traditional form and wearing its appropriate paraphernalia and symbols. These spirits live in an underworld of shades blessed beyond that of their earthly residence. From this underworld come at birth the souls of the newborn, and at death they return to it. A Kachina personates the returned spirit of the ancient dead, and it acts as an intercessor between men and the gods.

There is supposed to be an intimate relation between the dead and the living, the former possessing supernatural powers. The relatives of a deceased Hopi say to him before he is interred, "You have become a Kachina; bring us rain."

158

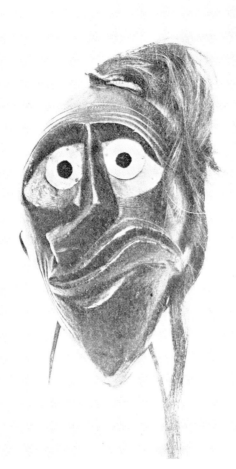

Wooden Mask of the Seneca, New York
(Museum of the American Indian, Heye Foundation)

The Pueblo ceremonial dances take place at intervals throughout the year. Among the Hopi those occurring between August and November are not Kachina festivals and no masks are worn. The Kachina ceremonies begin in February with the advent of the Sun or Sky God personified by a dancer wearing a sun mask. They are ended in July by the departure of the Germ God, ruler of the underworld, who carries a planting stick and wears a sprig of green in his bag-like mask. In the interval between February and July the Kachinas are supposed to remain in the village or its neighborhood, publicly appearing from time to time in masked dances lasting usually a single day.

The little figurines representing the different masked dancers are generally made by the participants in the dances and presented to the children at the time of the celebration of the farewell of the Kachinas in July. The

little girls may often be seen carrying these dolls about on their backs as babies are carried by their mothers. Some of the more elaborate ones are sometimes hung in a room as an ornament.

It will be seen that this is an effective way of teaching the younger generation the intricate symbolism of the Kachinas and of perpetuating a knowledge of these interesting ceremonies among the people.

Masks of the Navaho

Many ceremonial dances occur among the Navaho. They are principally for the purpose of healing the sick, although in the accompanying prayers the gods are invoked for abundant rain, good crops, and other blessings. Most of the gods appearing in the dances originated in the myths of these Indians, though some may have been borrowed from their neighbors.

In the Night Chant, the principal winter ceremony of the Navaho, sixteen different kinds of masks are used. They are of two general sorts. Those which represent male gods are mainly of deerskin in the form of an inverted bag with holes for the eyes and mouth, and are of a size to fit comfortably over the head and neck. Those representing goddesses are of rawhide and quite stiff. They cover the face and throat only, the hair being allowed to flow freely over the shoulders. The openings for the eyes are triangular and that for the mouth is square. Every Navaho god is supposed to have a wife. In the Night Chant these goddesses appear in rites of succor and exorcism. In the sand-paintings which form so important a part of the ceremonies, the males are always shown with round masks or heads, while those of the females are square. The masks of the men vary considerably in color and attachments. Those of the Fringe Mouth and Hunchback gods are surmounted with a kind of crown made of a basket bowl with the bottom removed; this is fastened to the body of the mask by means of thongs. When in place the edge of the basket turns upward like the brim of a hat. This is painted black and has zigzag markings to symbolize a thunder-cloud and lightning. Radiating from the rim are ten quills of the red-shafted woodpecker, which represent sun rays appearing above the clouds.

Iroquois False-Face Society

There is an ancient Iroquois tradition of a strange human-like creature in the form of a great head covered with long hair and made terrible by great staring eyes. His home was upon a huge rock, over which his long hair streamed. During storms the howling of the wind was thought to be his voice. He was an awful being, for he destroyed all who went near him.

Other traditions say there were several of these bodiless spirits with ugly visages who had the power to inflict ailments and to send diseases among the people. They lurked in dark nooks among the rocks and in hollow trees, and had the ability to flit from place to place.

Other accounts limit their number to three, two brother heads, one red in color and the other black, and a cousin, half red and half black.

160

To counteract the malign influences of these flitting heads secret associations known as false-face societies were maintained to appease these evil spirits. When anyone was sick and dreamed that he saw a false face, he knew that through their instrumentality he was to be cured. A feast was prepared by the family of the sick one at which the members of the society appeared marching in Indian file, each wearing a grotesque mask with streaming hair, and a tattered blanket over his shoulders. Then followed the customary ceremonies and dance.

The secret societies at which cornhusk masks are worn are based on an ancient legend which tells of a traveler who met thirty strange people in the woods, each wearing a cornhusk mask which grew naturally upon him. This appears to be a sort of mutual aid society and the membership is usually limited to thirty.

Esthetic Qualities of Indian Masks

It is among the older and finer masks of the Northwest Coast tribes that we find those superior qualities which place them in the first rank of wood sculptures originating among our native people north of Mexico. The fine craftsmanship, good modeling, and artistic coloring of the best of the older examples representing animal, bird, and human faces, are unexcelled by any of our northern Indians. Such masks, however, are not common and are usually found only in our larger museums. Most of the modern work is inferior, the modeling is crude and the colors are glaring. Recent examples brought from Alaska by tourists but poorly illustrate the older work.

The only other group of northern Indians whose masks seem to have compared favorably with those of the Northwest were the prehistoric dwellers at Key Marco, Florida. Unfortunately we know but little of the superior craftsmanship of these natives, as but few of their masks have been recovered from the mud and water which now cover their old habitation sites.

While the masks of the Pueblo region are of great interest ethnologically, their artistic merits are largely restricted to the painted designs which appear upon them, and the excellent color combinations of the primitive pigments used in their decoration.

Peabody Museum of American Archaeology and Ethnology,
Cambridge, Massachusetts

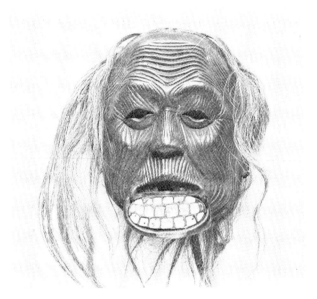

Mask of the Niska of Nass River, British Columbia
(Museum of the American Indian, Heye Foundation)

INDIAN BASKETRY

By

E. W. GIFFORD

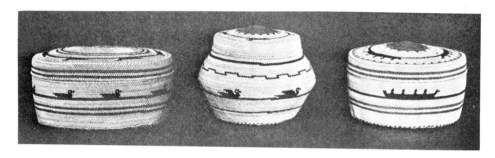

Makah Baskets. Washington
(Collection of The Exposition of Indian Tribal Arts, Inc.)

THE EXPOSITION OF INDIAN TRIBAL ARTS, Inc.

Permanent Office, 578 Madison Avenue

New York, N. Y.

INDIAN BASKETRY

By

E. W. GIFFORD

VIRTUALLY all peoples, civilized and primitive, make basketry. Even the aboriginal Tasmanians, living in an old stone-age culture—the lowliest culture in the modern world—were acquainted with the art of basket-making. Whether man lives under the equatorial sun or in the frigid circumpolar regions, he carries with him knowledge of this universal art, an art that must have an antiquity measurable in tens of thousands of years.

Esthetic taste manifests itself in two ways in basketry, in form and in decorative design. Civilized man dispenses with the decorative design in his utilitarian baskets. Primitive man (or more correctly woman, for she, as a rule, is the basket-maker) usually employs it, even in such prosaic utensils as cooking-baskets.

Unlike sculpture and painting, basketry imposes on the artist certain restrictions and limitations. The fact that basketry is a textile and is formed of interwoven materials, results in a certain angularity in the designs woven into the basket. The finer the materials used in weaving the more may this angularity be overcome. In some of the finest coiled baskets of California there are seventy stitches to the inch. Compared with such work the baskets of modern white people are extremely coarse. Indeed, no modern basket-maker would think of spending on one basket the vast amount of time that an Indian woman spends.

North American Indians rank high as basket-makers, equaling or excelling the aborigines of other continents in variety and mastery of techniques. Our knowledge of aboriginal basketry in eastern North America is deficient because of the early white settlement of the region. Although the various weaves were known, there seems not to have been so high a development of the art as in western North America, where esthetic motives seem to have played a more important role.

There are three outstanding basketry areas in North America north of Mexico. These are California, the North Pacific Coast, and the Southwest, with the Atlantic and Gulf States forming a fourth area, though without the superb achievements in basketry found in the others.

Atlantic and Gulf Coast basketry has a character of its own, owing to the extensive employment of checker weave and the related processes of

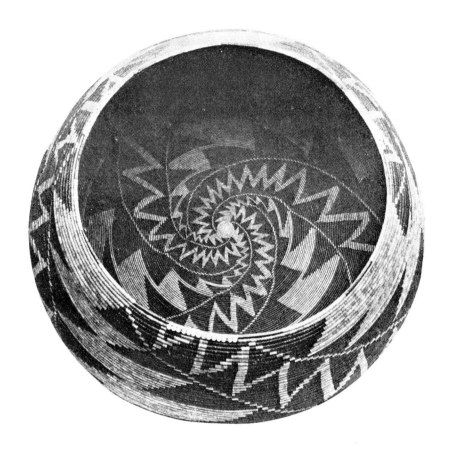

Pomo Storage Basket. California
(Museum of the American Indian, Heye Foundation)

twilling and wicker. Twilling is the process employed in the making of our tablecloth patterns. The fact that checker and twilled basket makers usually employ flat and relatively broad weaving materials prevents the delicacy of pattern possible in cloth woven in the same techniques. Checkerwork and twilling make possible the extensive use of rectangular outlines in basketry, while coiled and twined baskets are usually circular in outline, although there are some striking exceptions as in the case of the rectangular coiled baskets of interior British Columbia.

In southwestern United States (principally Arizona and New Mexico) the art of basketry flourishes least among the cultured Pueblo Indians (except the Hopi) and most among the less sedentary Apache tribes. The opposite is true in the case of pottery. The settled, but non-Pueblo, Pima and Papago make baskets that are popular with collectors, especially their coiled ware with its black design in devil's claw plant (*Martynia*).

Basketry water jugs, made water-tight with a coating of pine pitch, are manufactured in the Southwest and the Great Basin. Often these are of

166

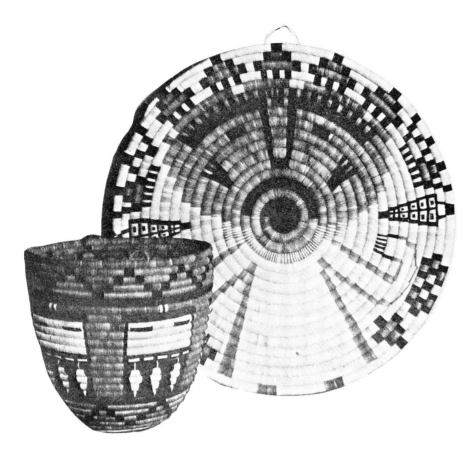

Hopi Coiled Basket and Plaque. Arizona
(Collection of The Exposition of Indian Tribal Arts, Inc.)

very graceful shapes, with pointed bottom, for they are made only to rest upon the carrier's back. They will not stand alone.

Unique in America and the more interesting because duplicated in North Africa are the thick coiled plaques of certain of the Hopi Indians of Arizona. One wonders if Moorish influences, operating through the medium of the early Spanish settlers in the Southwest, can possibly be the cause of this resemblance. The finding of definitely pre-Columbian examples, however, would deal the deathblow to such a theory accounting for the resemblance.

To the Pomo Indians and their neighbors of the Coast Range of north central California many basket enthusiasts apply such best-avoided designations as "the world's best basket-makers." At any rate it can be said of the Pomo women that they went farther than most basket-weavers and played with their art, developing features which necessity alone did not require. As with other Californians, months might be devoted to the manufacture of magnificent baskets destined as funeral offerings to be burned with the dead. The remarkable thing about Pomo basketry is the lack of specializa-

Basket of the Tlingit. Alaska
(Museum of the American Indian, Heye Foundation)

tion in one technique. Both twining and coiling were equally developed from an esthetic standpoint.

From the Pomo region come the true gems of basketry—the feather-mosaic coiled baskets. Their exteriors are completely covered with brilliant plumage, each little feather held in place by being caught under a stitch of the coiling. Favorite feathers are the iridescent green feathers of the mallard drake's neck, the lemon-yellow feathers of the meadowlark's breast, the scarlet feathers of the woodpecker's scalp. It is gratifying to note that the demand for these "sun" baskets seems to perpetuate their manufacture. Their invention is probably ancient, for they were being made in the 16th century when Sir Francis Drake visited California. They are reminiscent of the beautiful feather cloaks of Hawaii, though so far as known the Hawaiian art and the Californian art are of independent origin.

In northwestern California no coiled baskets are made, but we find there the southern limit of North Pacific Coast overlay twining, a style of weaving which causes the decorative design to appear only on the exterior of the basket. The most pleasing designs of the Californian examples employ

Basketry Hat of the Nootka with Whale-hunting Design
(Museum of the American Indian, Heye Foundation)

the black glossy stems of the maidenhair fern and the red of alder-dyed materials. The basket caps of women exemplify this art at its best.

On the North Pacific Coast, among the Tlingit of southeastern Alaska, the art of overlay twining reaches its highest development. Flexible baskets of fine weave, often fitted with tops, are characteristic. Although woodcarving is extensively practised and the animal forms of the totem-poles are a conspicuous feature of the art of the region, woven basketry designs remain conventionally geometric and are not intended to represent totems. The ornamentation is by overlaying with bleached grass stems or maidenhair fern stems either in natural colors or dyed. A black dye was furnished by the mud of sulphur springs or by the use of hemlock; a yellow dye came from a tree moss; alder yielded red; and huckleberries purple. Esthetically Tlingit baskets are among the most pleasing.

Contrasting with the twined baskets with overlay designs are the plain twined baskets in which the design shows inside as well as outside. Such are

the twined baskets of the Pomo and the twined baskets of the Klamath Lake Indians of southern Oregon. In these latter, tule reeds from the extensive swamps of the region are used. This material produces a soft and pliable basket. Yellow-dyed porcupine-quills are among the materials used for designs.

Although twined baskets are characteristic of the North Pacific Coast, the interior of British Columbia is the home of a peculiar type of coiled basket, the imbricated basket. The imbrication is an overlay decoration applied as the sewing of the coiled basket proceeds. Another feature of the basketry of the interior is a departure as to form; the rectangle, or more correctly the rounded rectangle, takes the place of the usual circular form, in spite of the fact that coiling naturally adapts itself to a circular form.

In California, coiled baskets are sometimes made in elliptical form, a shape esthetically more pleasing than the squarish baskets of interior British Columbia.

There are numerous local design differences, some obvious, others recognizable only when one is seeking them. For example, southern Californian designs tend to be annular, bold, and heavy; those of central California are often disposed vertically as well as horizontally. In the Great Basin, animals and men are sometimes represented. Also, one North Pacific Coast people, the Nootka of Vancouver Island, wove representations of men and boats into their basketry hats. On some of the basket hats of the Tlingit totemic designs were painted.

Examining a limited area more closely we find that there were local basketry arts. Thus, in California there were a half dozen distinct basketry arts. Closer examination reveals minor differences for each of the several

A Pima and an Apache Basket. Arizona
(Museum of the American Indian, Heye Foundation)

17 0

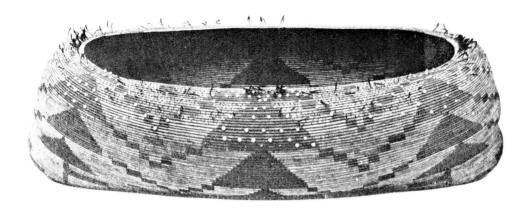

Elliptical Basket of the Pomo with Interwoven Feathers
(Museum of the American Indian, Heye Foundation)

tribes practising one art. Within each tribe, this differentiation goes even further and each basket-weaver can recognize her own work and that of several of her neighbors. In this last category the differences are not in artistic style so much as they are in minor details with which the weavers are familiar.

As an example of local style let us consider the coiled basketry of the Mission Indians of southern California. This is rather coarse in weave, but nevertheless pleasing in appearance. The principal background against which designs are woven is the Juncus rush, which comes in a variety of pleasing colors ranging from creamy white to dark brown. The designs against the background are applied more for mass effect than for delicacy. Sometimes the darker Juncus is used for the design and the lighter Juncus for the background. No dyeing of material is necessary except to obtain black.

Although there is a certain amount of symbolism in basket designs, it is usually not of the mystic quality which so many laymen imagine. In fact many designs have no more symbolism to their owners than a linoleum design has to us. One region in North America in which symbolism in decorative art is highly developed is the Plains Indian region. It is the very region in which basketry is virtually lacking.

In the Southwest, where pottery as well as basketry is made and where the religious side of culture has received its fullest development, there is some slight development of symbolism in basketry decoration. Unlike the prosaic Californians in this matter of symbolism are the Hopi Pueblo Indians of Arizona who weave rain-cloud and other religious symbols into certain baskets used for ceremonies to induce rainfall. Navaho baskets with an encircling design have an opening in the design, left by the maker lest her soul be imprisoned therein.

171

More frequently a design bears a name indicating merely what it resembles in the mind of the maker rather than as a symbol.

The art of basketry in North America is essentially a development by women, men having had little hand therein. It is an art, too, which requires infinite patience and painstaking care. The basketry of aboriginal North America, especially California, stands as a monument to the artistic genius of primitive women and usually has no parallel in the work of men in the same low stage of civilization.

University of California,
Berkeley

INDIAN WEAVING

By

MARY LOIS KISSELL

THE EXPOSITION OF INDIAN TRIBAL ARTS, Inc.
Permanent Office, 578 Madison Avenue
New York, N. Y.

174

INDIAN WEAVING

By

MARY LOIS KISSELL

WEAVING by the Indians of North America, as by all aboriginal peoples, responds to clothing and household needs. These in turn depend largely on regional conditions—the physical environment with its geographic and climatic features, its fauna and flora. Thus one determining textile agent is fiber supply. In addition to economic influences and pure esthetic expression, woven ornament in many instances is inspired by social and religious life, stimulated by established ceremonial custom and tribal beliefs.

Weaving is so ancient that its origin is unknown. But in North America it had long passed crude beginnings before the arrival of white men; even fragments of fabrics made by its extinct peoples show technical advance. Yet in one locality is the world's most elemental loom, employing basket technics, though these are adroitly transferred to the more highly developed two-beam loom and are well executed.

Of first importance in loom-work is the arrangement of the warp-strands, or foundation; secondly, the weave of the uniting weft as it moves across the warp. From this, weaving on the continent may be divided into three groups. The first is woven with basketry warp and twine technics, on the elemental one-beam loom's unstretched warp; the process was practised north of the semi-arid Southwest wherever loom-work is present. The second is true weaving, on a two-beam loom's stretched warp; it is found in the Southwest. The third employs both true weaving and basketry twine, on warp stretched over a roller-loom, and is restricted to a small area about Puget Sound. In many areas the textile industry is waning or has ceased. Here we record it as still continuing.

Chilkat Weavings

The famous Chilkat blanket with animal design is the greatest achievement of the elemental loom area, and from its outstanding weaving center far to the north on the Pacific Coast. It is a fantastic ceremonial dance robe of oblong shawl shape, heavily fringed on three edges, and overspread with an animal pattern in blue-green, yellow, dark brown, and cream. The design is totemic and represents the family or clan symbol. Many animals of the region serve as Indian totems, among them the bear, killerwhale, raven,

175

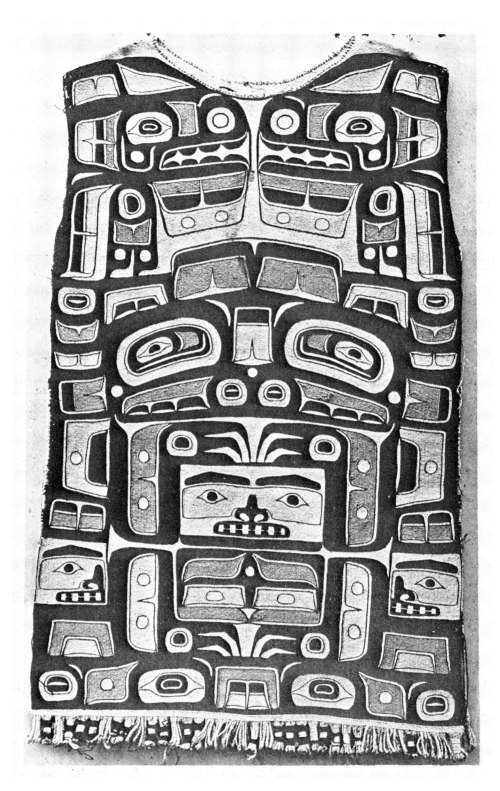

Shirt-Tunic with Bear Design. Chilkat, Alaska
(Museum of the American Indian, Heye Foundation)

176

and thunderbird. These, or a purely mythological being, form the mosaic-like blanket pattern.

The robe is now believed to be a creation of Tsimshian Indians of British Columbia, whose weaving spread to the Tongas, Stikine, and Chilkat tribe of the Tlingit Indians living on Lynn canal in southeastern Alaska. The Chilkat then became its chief weavers, hence the name which rightfully belongs to the Tsimshian. The popularity of the garment among other coast tribes carried it through trade far to the south.

On momentous occasions only is the blanket worn, and with it a similarly patterned sleeveless shirt, dance apron, and leggings, all either woven or made of painted leather. Edging the last two are rattling puffin-bills, deer-dewclaws, and bits of ivory or bone that tinkle with each movement of the dancers. If the Indian is a chief, the headdress is an abalone or metal set crown, topped by a row of sea-lion whiskers and hung behind with ermine streamers. If he be an Indian of prominence, he wears the totemic painted spruce-root basket-hat, mounted by a tier of discs, each signifying a ceremony in which he has participated.

When thus dressed for dance or ceremony in a costume replete with totemic design, traditional color, and rhythmic fringes, does one wonder that Indian gratification is supreme? The favorite robe again renders service as shades of death draw near, and when lying in state during days of mourning, and yet again as it hangs on grave house or mortuary column preserving the ashes, there to weather the elements until the last shred disappears.

Technically the animal Chilkat is unique, with nothing like it in primitive or historic textiles. In this tapestry, though a twine-woven one, aboriginal story-telling creation reaches a climax. With shredded cedar-bark and wool of the wild goat that must be hunted on steep mountain slopes, is it made. All the textile work is carried on by hand: spinning by rolling fiber with palm on the thigh; weaving by the fingers, without heddle, shuttle, or batten.

From the slender loom-beam, supported at each end by upright posts, hang loosely spun warp-strands of shredded cedar lightly covered with goat wool. Across them the weaver works a weft of two well spun wool yarns in twilled twine weave, laying the design to correspond with that on her pattern board, previously painted by the men. Each small section of the mosaic-like design is woven separately and framed with a line of three-ply twine weave. Northern dyes are hemlock or alder bark for black, lichen-moss (*Evernia vulpina*) for yellow, and oxidized copper or blue clay-stone for blue-green.

But an earlier Chilkat blanket has been recently discovered among old northern weavings. Equally fantastic and more brilliant than the animal patterned garment copied from the Tsimshian is this older indigenous Chilkat, overspread with intricate geometric designs and sometimes surface tassels. Vancouver reported the early frogged or tasseled robe worn by a high chief on Lynn canal in 1794, and described him as the most splendid and elaborately costumed Indian he had met on the coast. Later, in 1805, Lisianski found several Indians similarly dressed at Sitka. Other visitors

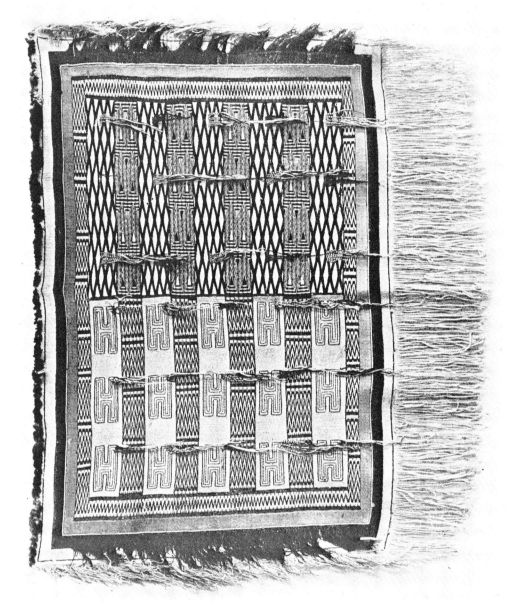

Early Chilkat Ceremonial Blanket. Alaska
(Peabody Museum, Harvard University)

178

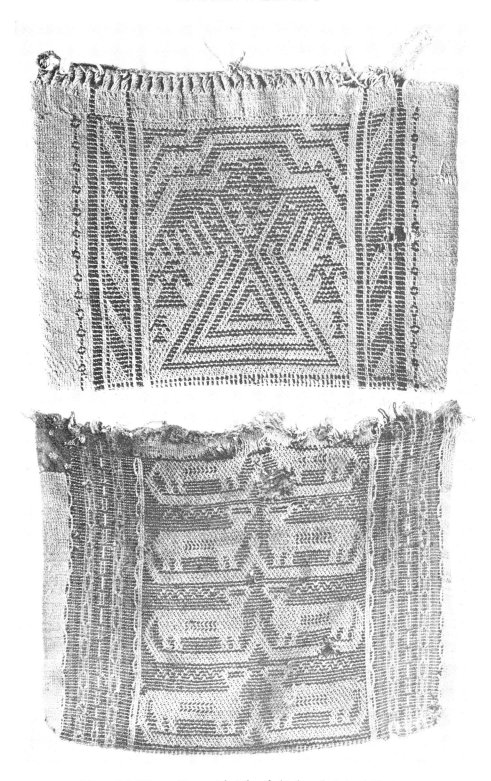

Menomini Woven Bags with Thunderbird and Animal Designs
(American Museum of Natural History)

noted only the later robe; thus by the opening of the nineteenth century the newer totemic Chilkat was supplanting the older geometric type.

The blanket designs are those of the spruce-root baskets of the Tlingit. These sister arts—weaving and basketry—carry the same motifs and a similar refined elegance seldom expressed in aboriginal art. The robe is entirely of goat wool, and the highly perfected technics are several twine weaves and that much-favored widespread embellishing method of one-beam loom-work—latticed wrap weave. To this older Chilkat type is related Aleutian Island weaving, whose burial mattings of wild rye utilize plain and cross-warp twines, as well as false embroidery.

The shredded-bark mantle, the coast garment mostly worn, is a gift of the great cedar tree. Indeed, never were regional resources reflected more convincingly than in the native clothing of the Northwest Coast. For the mantle, the bark is stripped from the cedar trunk, soaked, and shredded by beating. Warp-strands of this fiber are suspended from the loom-beam and woven in plain twine. The weft yarn of cedar or other vegetal fiber, mixed with goat wool or duck down to render pliable, is spun by hand or by a recently introduced spindle. The small circular rain-coat is also of twine-woven cedar bark-fiber. The mantle among the Kwakiutl and Bellacoola Indians may have narrow brown and yellow borders in latticed wrap weave, and huge totemic animal figures painted in red and black.

Mattings of cedar-bark strip in checker and twill are woven for household use and for boat travel. The tree itself contributes to the rough-hewn timber house, the dugout canoe hollowed from a single trunk, and the tall totem poles, carved and brightly painted with clan animals, that stand before each native village.

Woodland and Eastern Areas

The soft weavings and stiff mattings of Woodland and Eastern textile centers do not differ materially from those of cedar-fiber and cedar-splint of the Pacific coast. Only in the various tree basts, plant fibers, and buffalo hair materials, and in design, is there a change. The mantles, skirts, and textile markings on pottery from Mound-builder burials, together with the loom-work of today's Indians, tell the same story of adapting basket technics to the simple loom. There is much twill and plain twine weaving, but texture interest centers in three decorative weaves: latticed wrap, so superbly manipulated in the early Chilkat blanket; zigzag warp twine; and cross-warp twine, exquisitely used in Aleutian burial mattings.

The last is the popular weave in Woodland medicine wallets. Woodland bags serve many utilitarian purposes; and when finely made they may encase the ceremonial medicine bundle, since hunting, war, and other important acts are ritualistic performances. The hunting bundle holds medicine to charm game in the chase; the war bundle's many medicines may include a snake-skin for power of stealthy approach, a swallow's skin for swiftness, the root of invisibility, or the root that brings victory. And only with songs and prayers, much fasting and dancing, are these medicines effective.

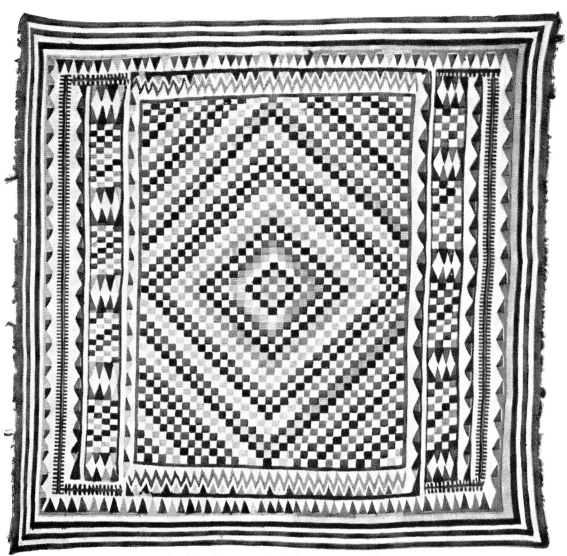

Splendid Old Type of Salish Ceremonial Blanket
(Museum of the American Indian, Heye Foundation)

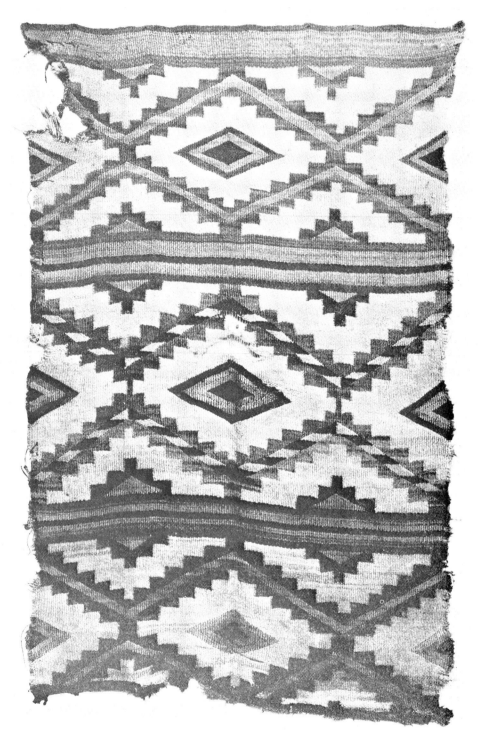

Old Navaho Blanket
(Museum of the American Indian, Heye Foundation)

INDIAN WEAVING

Salish Weaving

Salish weaving about the Strait of Juan de Fuca, Puget Sound, and lower Fraser River, presents a most novel and late industry, for these Indians are not creators, but the greatest of borrowers. The cumbersome roller-loom, with unique release cord to free the finished web, is foreign. In reality this cord is a single beam, from which and to which the warp extends after passing to and fro over the rollers. Cuna Indians in Panama are its nearest users, and it is not impossible that some early explorer's ship brought north this loom idea. A huge spindle is also a Salish enigma, with its processes so rudimentary it can spin nothing but heavy coarse yarns. Strangest of all is the long-haired textile dog, tended in dog-folds and sheared like a sheep, that some think came from Asia. Rarely is dog-hair spun alone, but softened with goat wool or bird down.

The Salish general blanket of twill weave, whether plain, crossed by slender stripes, or similarly checked, is a natural industrial outgrowth. But the nobility blanket in combined wicker-twine weaves well illustrates the roller-loom's unfitness for elaborate patternmaking, and Salish borrowing propensity along design lines. The loans are from Indians of the northern plains and Northwest Coast, and tribes of Asia. The introduction of commercial yarns at first brought greater freedom in carrying out old Salish patterns; but through later use the entire industry deteriorated.

Fur and feather cord robes also are woven on the roller-loom. Narrow strips of furred and feathered skins are twisted about a stout cord to form warp-strands, and these are united by widely spaced rows of twine-weave. The robe is one of the earliest types of woven garments, with a distribution extending southward to the Mexican line. Naturally, in these many localities, the materials utilized, loom implement, and technical details, vary greatly, though the twine-woven robe holds to type.

Navaho Weaving

Our weaving drama now shifts to new scenes in the semi-arid Southwest. Here colorful Navaho blankets still supply Indian needs and bright rugs for the American home. Long after the Spaniards brought sheep to the Southwest in the sixteenth century did the Navaho begin to weave. The first sheep he procured by pillage; but gradually he acquired a liking for pastoral life, until now his flocks number many hundred thousand. Grazing lands on the parched stretches are scarce; only by keeping the flocks moving to fresh pastures can they live. The entire family moves with them. At once the loom is set up and weaving continues, though delay may occur from disastrous mishaps between pastures—the weaver may lose some of her colors or even forget her pattern.

Ordinarily the loom set-up is simple—a straight pole lashed between two trees, from which hang the warp-strands between the two beams, anchored with stones to the ground. Two shedding devices part alternate warp-strands into sheds: a primitive cordheddle and blade-like batten turned broadwise. The batten when turned edgewise also beats close the weft rows.

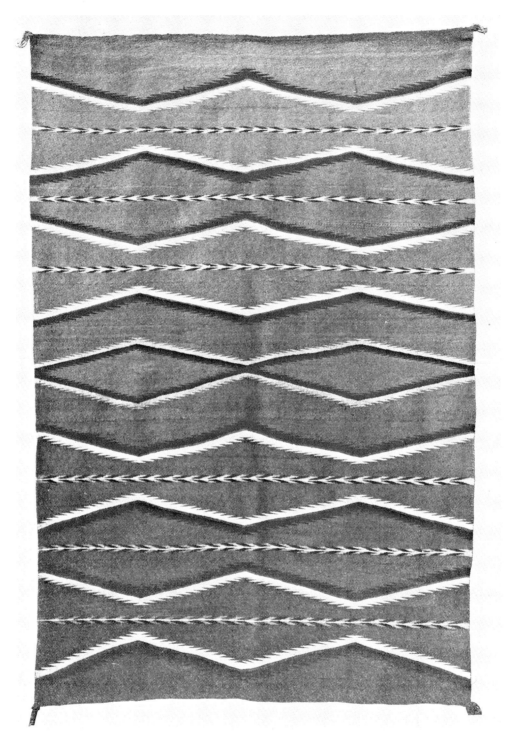

Old Navaho Blanket
(Collection of Miss Amelia Elizabeth White)

Through the open sheds the weft moves easily, put in with the fingers in over-and-under weave, done in tapestry technic that completely covers the warp. The aboriginal spindle rolled on the thigh spins the yarn; but two white man's implements prepare for spinning—the commercial sheep-shears and European hand-cards for arranging the wool fiber.

Previous to 1800, Navaho blankets of undyed wool only were made. At first they were all white, then striped with rusty black wool of the black sheep, and later with sheep's gray through mixing the two wools. A radical change came in 1800; trade brought cochineal-dyed bayeta cloth, or baize, which aroused a liking for color. This English cloth was imported to Spain for soldier uniforms, and from there reached Mexico where it was bartered to the Indian trader. This cloth the weavers raveled, then respun the yarns and rewove them. It was expensive, and at first sparingly used in narrow stripes alternating with wider ones of natural wools.

About 1820 saw a second transformation, from an interest in symbolism which brought pattern. Mountains, lightning, clouds, crosses, and other forms are interpreted in geometric design, with larger quantities of the bayeta. Often this required yarns from several pieces in various crimson and scarlet shades. Thus a blanket may have several of these reds. The prized "pink bayeta" found in old webs earlier than 1850 is not cochineal dye, but another that has faded to pink under bright sunlight. By 1860 bayeta blankets became fewer, until 1875 almost saw their end.

As early as 1800 the Navaho began experimenting in native dyes. As these were discovered, they worked hand in hand with bayeta red in design development. Yellows were obtained from peach leaves and from flower-heads of *Bigelovia graveolens*; indigo came through trade with Mexico; green by mixing yellow and indigo dyes. Black was procured by combining sumac leaves, roasted ochre, and piñon gum; and dull red with the imported Brazil-wood or alder bark with mountain mahogany. In 1875 Germantown yarns and commercial dyes reached the Navaho, after which old methods were gradually abandoned, though the first blankets of the new materials retained many fine distinctive qualities.

The large impressive "chief's blanket" is individually patterned. It is crossed by broad horizontal stripes and has a wider elaborate stripe-grouping that forms center and border bands. These bands carry the special motif, placed at the blanket's center with repeating half-motifs at the edges and quarter-motifs at the corners. In early blankets this special design is rectangular, in later ones it is in a stepped diamond or pentagon pattern. The small Navaho saddle-blanket differs from all other blankets in its twill-weave technic.

The woven "squaw dress" is also stylized. The black center is bordered with wide red panels that are broken by small blue or black designs. It consists of two rectangular pieces, stitched on the left side and left open on the right, with the upper corners fastened over the shoulder. The ornamental belt finds wide use among Indians in the Southwest; the Navaho weave it on a small forked tree-branch loom-frame.

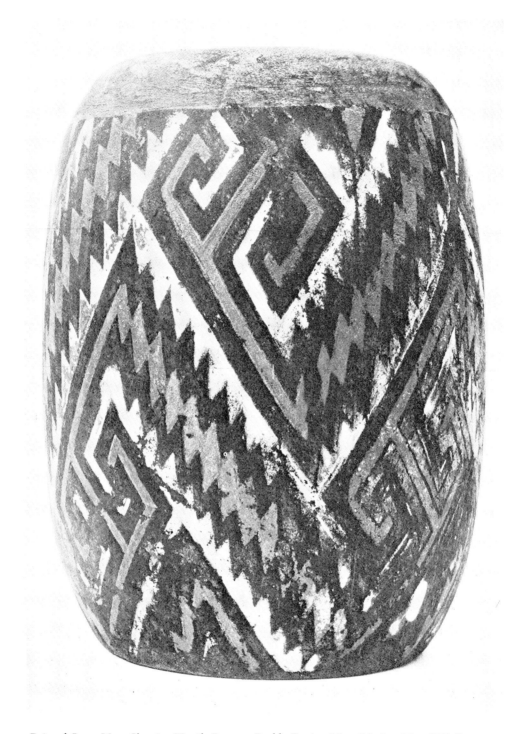

Painted Stone Vase Showing Textile Pattern. Pueblo Bonito, New Mexico. X to XII Century
(Museum of the American Indian, Heye Foundation)

INDIAN WEAVING

Pueblo Weaving

An older Pueblo textile center in the Southwest antedates that of the Navaho, who learned the art of these neighbors. Textile study of the older peoples opens an enchanting vista. Here amid an arid land's exuberant sunshine and color we may still see Indian priests in dramatic ceremonials, fantastically costumed in barbaric splendor, supplicating the gods of rain.

The most expert of the present-day Pueblo weavers are the Hopi, among whom the men do the weaving. Their blankets are simply striped in a few colors— blue, white, black, and sometimes a bit of red. Long ere the Spaniards arrived in 1540 the Hopi cultivated cotton and wove it on a loom fitted with several cord-heddles that permitted twill weave. The woman's early blanket-dress is yet worn, though no longer of cotton but of wool. Its brownish center is of plain weave and the blue panels above and below are "birdseye" twill, since many pleasing textures may be woven by combining different twills. The garment reaches from shoulder to knee and is fashioned by bringing together two opposite edges and so stitched as to leave openings for the head and one arm.

With the dress is worn the long patterned belt. For its making the Hopi use a small frameless loom that stretches the warp between a distant post and a yoke passing across the weaver's back, while a cord-heddle or reed-heddle aids in the plain weaving. But for the narrow center design band, the fingers must lift each warp-strand separately. Very picturesque are these Hopi women in blanket-dress, belt, white deerskin moccasins that wrap to the knee, and hair arranged in huge whorls above each ear when a maiden, or in braid-like rolls when a matron. The custom of cropping the hair of school children however, has brought this form of hairdress practically to an end.

The most beautiful Hopi web is the bride's snow-white wedding blanket of canvas-like cotton. During the year following marriage it is embroidered in wide panels with inserted cloud, rain, squash flower, and butterfly symbols in green, red, and black worsteds, and further enriched with a huge tassel at each corner. In this way the colorful blanket becomes a special garment for the women's ceremony.

Woven clothing of the men in early days consisted of a cotton kilt or apron tasseled at the corners, and a robe of cotton or rabbitskin, that now is replaced by the Navaho blanket. Later was worn a poncho-like shoulder cloth of blue or black, and this later was converted into the shirt-coat by adding sleeves. For the dance the Hopi weave kilts of thick cotton, painted or embroidered in bright symbolic design; these find their way by trade to many Pueblo tribes.

Marvelous fragments of twill-woven garments with complex ornaments have been recovered from Basket-maker and Cliff-dweller burials, attesting the skill and esthetic sense of these ancient craftsmen. Today the most elaborate attempt of Hopi weavers is the wide ceremonial sash with white center and patterned end panels, that require extra heddle shedding. This is the sash worn by priests of the Antelope fraternity in that most

astonishing ritual, the Antelope and Snake dance. During the many Hopi ceremonies that take place in seasonal order, observers crowd the roofs and terraces of their pueblos, while amid feathers, paint, and costume paraphernalia of the priests, glisten forth the woven and embroidered prayers to the gods in kilt, robe, and sash.

New York City

INDIAN
PORCUPINE-QUILL
AND
BEADWORK

By

WILLIAM C. ORCHARD

THE EXPOSITION OF INDIAN TRIBAL ARTS, Inc.

Permanent Office, 578 Madison Avenue

New York, N. Y.

190

INDIAN PORCUPINE-QUILL AND BEADWORK

By

WILLIAM C. ORCHARD

ANY years before the arrival of Europeans on the North American continent the natives had developed, among other accomplishments, a form of decoration which they applied to their clothing, footwear, and such other objects as pouches, pipe-stems, and particularly a great array of things which had to do with sacred ceremonies—in fact, apparently anything appropriate to the application of decoration was selected so long as its use would not be impaired. The sharp-pointed, barbed quills of the porcupine were used for this particular style of embellishment, seemingly the last medium one would select to produce any kind of ornamentation. Nevertheless the American Indians, who are generally supposed to have led such lives that one might think they had little inclination or incentive to give expression to art for art's sake, had a high esthetic sense.

However, the Indians found a way to make use of the cruel quills of the porcupine with admirable results. The earliest travelers have mentioned this art of quill embroidery in their writings, and in a rather vague way have described some of the beautiful designs they had seen, thus establishing the fact that the Indians had developed the art before the coming of white men. How far back in prehistoric times the art had its origin cannot now be estimated, as the material is of a perishable nature and few pieces of unquestioned antiquity have survived. The examples that have been handed down to us are unsurpassed in excellence of workmanship and design. In historic times porcupine-quill embroidery was women's work, hence one may reasonably say that it was the work of women in time of comparative antiquity.

As may be seen by specimens in our museum collections, porcupine-quill work has been produced in modern times, but is now very much on the wane, the present generation of Indians having apparently lost interest, although a number of people with laudable intentions have been trying to bring to life some of the old arts, but with no great success. To describe in detail the methods of working porcupine-quills would require more space than is available. The Indian artists devised so many ways of turning, folding and twisting the quills that words alone would not do justice to their work. A well illustrated book on the subject has been published by the Museum of the American Indian in New York.

So far as can be seen in the now available material, there were four

191

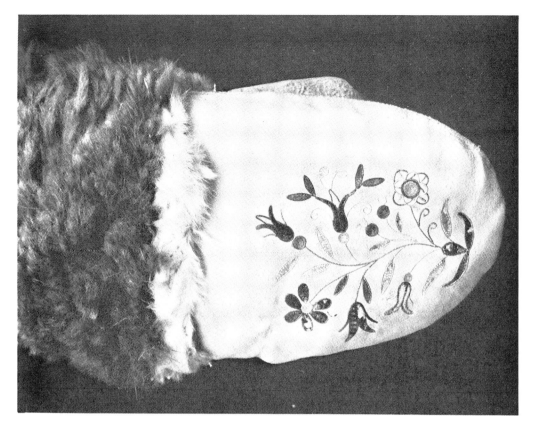

Cree Mitten Embroidered with Unusually Fine Porcupine-quill Work

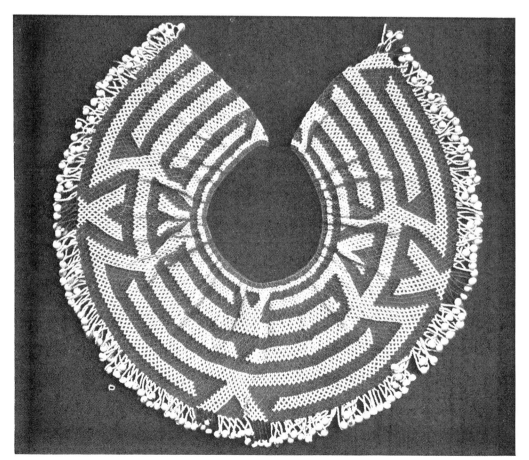

Neck Ornament of Woven Beadwork. Mohave. Arizona

(Museum of the American Indian, Heye Foundation)

general methods of using the quills—sewing, weaving, wrapping, and, as applied to birch-bark, by perforating the bark and pushing the ends of the quills in the perforations. The quills were colored with a choice assortment of dyes or pigments obtained from berries, roots, bark, flowers, and some minerals, and in more recent times with commercial dyes supplied by traders; but the latter are not nearly so beautiful as the examples colored with materials manufactured by the Indians themselves.

Sewing is perhaps the most common method of using the quills. By this process the quills are always attached to leather, which may be a shirt, leggings or moccasins, a pouch, or a hood for a cradle—in fact many things having a flat surface of leather. The technique employed in sewing is purely appliqué, which, as many women will appreciate, is a folding and sewing of one material to a foundation of another. In this manner the quills are sewed to the surface of the leather. The quills are so folded and wrapped as the work proceeds as to conceal the stitches.

In sewing, a thin strip of sinew was used for a thread, which was kept moist, except one end, which was twisted to a sharp point and allowed to dry. The stiffened end of the sinew was easily passed through the perforation and was the only form of "needle" used. Perforations were made in the leather with an awl fashioned from bone or from a thorn. In modern times an awl of steel or one made from a nail ground to a point answered the purpose. But no matter how thin the leather, the perforation did not go through from front to back, but just beneath the surface, so that the stitches did not show on the reverse side.

The quills were moistened to make them pliable, and were flattened before used by the simple method of drawing them between the teeth or over the thumb-nail. In either case the wicked point was first broken off and consigned to a safe place, often the fire, out of the way of bare feet or of crawling children. Of course it must be understood that in nearly all cases in which quills were used, they were first dyed and stored in a receptacle, usually the bladder of a deer or an elk, until needed.

With the sewing technique broad surfaces could be so covered as to entirely conceal the leather, if so desired, or a delicate tracery of fine lines could be laid on to represent vines, leaves, and flowers, with the leather as a background.

It may here be mentioned that very often the leather was so perfectly tanned by the Indians that, with all the appliances and methods of today, no better or more desirable leather has been produced. I have before me an example, at least a hundred years old, that is as soft and pliable as the day it left the tanner's hands. It is doubtful indeed whether, a century hence, one will be able to say as much of any leather tanned by civilized man at the present time.

Designs and the distribution of colors alone do not afford more than a suggestion of the amount of work involved in producing the surviving examples of quill appliqué. The piece before me is one of a pair of mittens, the backs of which are ornamented with a spray of leaves and flowers in remarkably fine lines; indeed some of the lines are less than a sixty-fourth

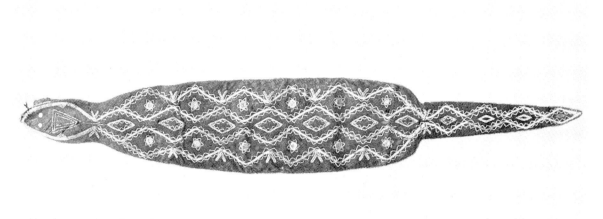

Porcupine-quilled Medicine-bag of the Otter Society. Iroquois

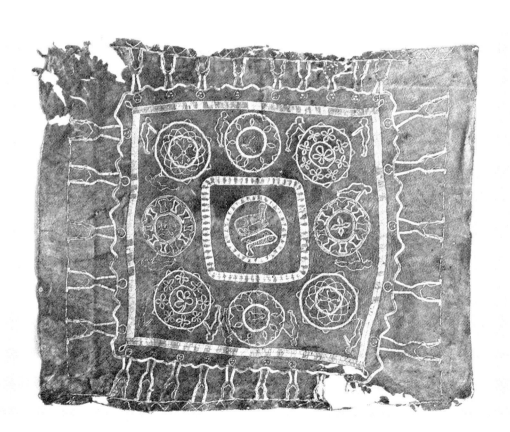

Porcupine-quilled Deerskin Mat Depicting a Ceremony and Emblems of the Otter Society. Iroquois

(Museum of the American Indian, Heye Foundation)

194

Shoulder Pouch. Chippewa

Breast Ornament. Shasta. California

Examples of Fine Beadwork of Woven Technique
(Museum of the American Indian, Heye Foundation)

195

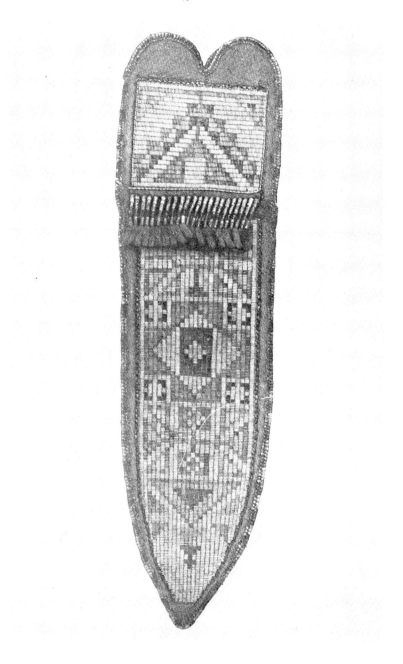

Knife Sheath Decorated with Porcupine-quill Work in a Woven Technique.
Chippewa. Region of the Great Lakes
(Museum of the American Indian, Heye Foundation)

of an inch in width, or about the size of a medium-sized thread such as is ordinarily used for sewing on a shirt button. The quills are turned and folded so that the stitches are concealed beneath the upper folds.

196

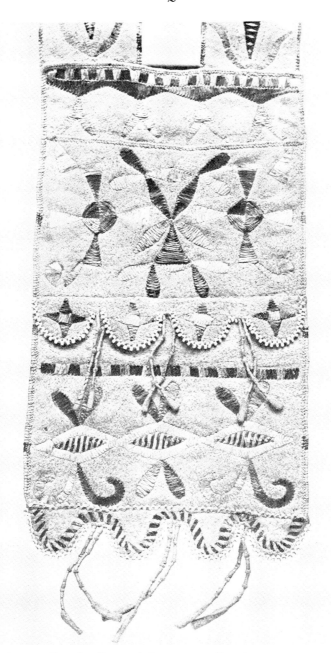

Iroquois Deerskin Bag with Porcupine-quill and Beaded Decoration
(Museum of the American Indian, Heye Foundation)

New quills have to be supplied every one or two inches, in each instance their ends being concealed under the foldings. A magnifying glass is necessary to fully appreciate this exquisite work, which without doubt consumed much time and the exercise of an infinite degree of patience—all for the love of art and as an expression worthy of a dear one.

197

The woven technique is without a leather foundation, consisting of a series of warp and weft strands as in ordinary weaving. The strands, however, are of sinew. Such work is usually made in strips of about one inch to three inches in width and sixteen to twenty inches or more in length. The warp strands are sometimes stretched between the ends of a bow, with pieces of perforated birch-bark or a piece of stiff leather to serve as spreaders in keeping the warp strands equidistant. The weft is woven across the warp in the usual manner, while the quills are interwoven lengthwise. Here again any verbal description would be inadequate—one must see the work to appreciate it fully. As might be expected of the technique of this process of weaving, the designs are decidedly geometric, yet at the same time they are very pleasing both in color and pattern, and often are quite intricate.

Such pieces have been used as headbands and in places on garments where strips could be applied, as over the shoulders or on the sleeves. When worn as a headband the finished weave had a soft leather backing.

In addition to this type of independent weaving, another form is found in which quills have been incorporated in a basket weave; that is, a basket is woven of the ordinary materials and the quills inserted in such a way as to show on the front or outside of the basket only, in what is commonly termed an imbricated weave. This, however, is not very common, but the examples that have been preserved have an extremely pleasing appearance, and show remarkable skill and ingenuity.

Wrapped work is present in a number of forms, and is perhaps most frequently seen on pipe-stems. The quills have been wrapped around the objects as one would wrap a continuous string around a stick. The quills would be given one or more turns around, according to the diameter of the object, and when new quills were added the ends were twisted together and hidden under the wrappings. A variation of the method was to make a braided string of the quills, which was wrapped around the object.

A clever manner of forming a pattern in the braid was evolved by inserting quills of contrasting colors; for instance, broad flat pipe-stems often show such recognizable objects as men or animals worked out in this manner, the braiding and insertion of the various colors occurring coincidently with the wrapping.

Another common use of wrapping was applied to leather fringe on garments, each strand having its own individual wrapping. Sometimes the colors were so arranged as to form a pattern.

Very effective decorations were applied to birch-bark objects, such as boxes for trinkets of more or less value. In this case a pattern was outlined on the surface of the bark; then perforations were made, following the lines. The ends of the quills were punched through the perforations and the quills were laid across the pattern and pulled down tight to the bark. The design worked out by thus laying the quills side by side, arranged according to colors, presented a surface entirely covered. The projecting ends of the quills on the back were cut off.

The Indians accomplished some remarkable results in porcupine-quill work, as may be seen in the accompanying illustrations. A close study of the

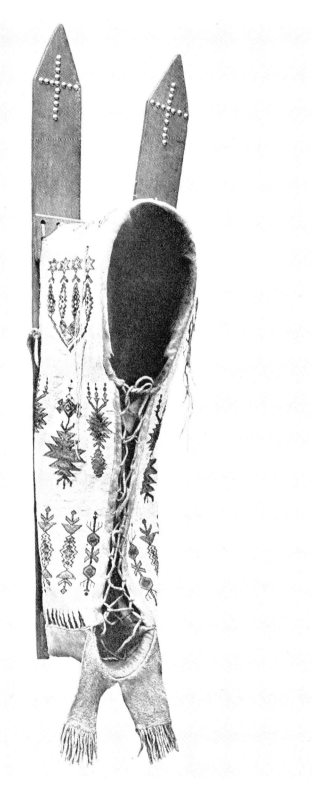

Comanche Baby-carrier Decorated with Beadwork in which
120,000 Beads were Used
(Museum of the American Indian, Heye Foundation)

technique might well cause one to wonder what manner of people were they who could patiently produce such works of art, and will help to correct one of the common fallacies regarding the Indians that have been so prevalent.

Two of the articles of special interest here illustrated are a mat and a medicine-bag of the Iroquois. The former, of soft-tanned deerskin, is a unique example of pictography in porcupine-quills of excellent workmanship, representing phases of a ceremony within a lodge. Two otters are depicted within the inner circle, surrounded with various emblems. Members of the order are shown with joined hands, enclosing the precinct of the society. The other object referred to is a medicine-bag of deerskin made in the form of an otter and delicately embroidered with porcupine-quills. These two specimens were presented to Dr. Samuel Latham Mitchill about the year 1790 by a body of Iroquois, in connection with a ceremony of initiation into the Otter Society, in recognition of services rendered by Dr. Mitchill in their behalf.

Beadwork

Following the custom of travelers in strange lands among primitive peoples, those who came to this country in the earliest days brought European glass beads in many colors, forms, and sizes. The smaller beads especially were so readily accepted by the Indians that in time they became an important item of trade. The larger varieties were made into necklaces, a class of ornamentation already in vogue, for the native tribes had been in the habit of making beads for that and other purposes for generations. Beads of native manufacture were of shell, bone, stone, seeds, and other usable materials, in many instances at a great expenditure of time and labor, so it may be easily understood how the multicolored beads of the white man took their fancy.

The smaller varieties were adapted to their already well-known porcupine-quill embroidery to such an extent that gradually the work in quills was threatened with the danger of becoming a lost art. Fortunately, however, some of the Indians in isolated areas retained their fancy for quillwork. The work produced by means of trade beads has proved to be as remarkable and as artistic as the quillwork in designs and selection of color combinations.

The sewing and wrapping methods employed in beadwork are similar to, if not the same as, those for quillworking. In addition a number of different methods for weaving were invented, and perhaps some were learned through European contact. In any event, the weaving of beads into netted fabrics and in flat, plain weaving, at the same time incorporating a wide variety of designs and appropriate coloring, inspires a feeling of profound respect for the Indian artisan. Like quillwork, the beadwork must be examined closely, with a thought for the technique, to be fully appreciated. To the casual observer, however, it must be apparent that the aboriginal inhabitants of this continent were possessed of a deep appreciation of beauty and of a high degree of skill in representing the objects which were pleasing to their esthetic sense.

INDIAN PORCUPINE-QUILL AND BEADWORK

Beadwork is here illustrated with photographs of several specimens. An excellent example of skill and patience is exhibited in an elaborate baby-carrier of the Comanche, consisting of beadwork of woven technique with a leather backing. The beaded surface covers 430 square inches and contains 280 beads to the square inch, hence the aggregate number of beads is 120,-000. This technique requires the passage of a thread of sinew through each bead twice. While the pattern is being worked in, the beads must be counted in order to insure the correct placing of the design in the numerous colors. It seems almost incredible that a woman belonging to a roving tribe could have found time to perform such an elaborate piece of work; yet it only illustrates the love which all Indian mothers have for their offspring.

Museum of the American Indian, Heye Foundation,
New York City

BOOKS ON INDIAN ARTS
NORTH OF MEXICO

Compiled by

RUTH GAINES

NEW YORK
THE EXPOSITION OF INDIAN TRIBAL ARTS, Inc.
Permanent Office, 578 Madison Avenue
1931

BOOKS ON INDIAN ARTS
NORTH OF MEXICO

This collection represents the generosity of publishers, authors, and other friends who have given or lent these books to The Exposition of Indian Tribal Arts, but owing to limitations of space only a selection thereof is exhibited. Except in the case of limited or subscription editions, and some few out-of-print works included because of their significance, orders will be taken at the Exposition for any book listed below.

RUTH GAINES
Librarian of the Huntington Free Library
and Reading Room, New York.

LISTS AND INDEXES

AMERICAN ANTHROPOLOGIST. General index, 1888-1928. Menasha, Wis., 1930.

AMERICAN MUSEUM OF NATURAL HISTORY. Publications. New York, American Museum of Natural History, 1930.

FIELD MUSEUM OF NATURAL HISTORY. List and prices of illustrated leaflets. Chicago, Field Museum of Natural History.

—— List and prices of publications. Chicago, Field Museum of Natural History.

THE GUARDIAN. Grand Rapids, Camp Fire Girls, January, 1930, September, 1931.

MATTFELD, Julius. The folk music of the western hemisphere. New York, Public Library, 1923.

MILWAUKEE PUBLIC MUSEUM, Milwaukee, Wisconsin. Bulletins, list of publications.

MUSEUM OF THE AMERICAN INDIAN, HEYE FOUNDATION. List of publications. New York, 1931.

PEABODY MUSEUM OF HARVARD UNIVERSITY, Cambridge, Mass. Papers.

SCHOOL OF AMERICAN RESEARCH, Santa Fe, N. M. Publications [List].

U. S. BUREAU OF AMERICAN ETHNOLOGY. List of publications . . . Washington, G. P. O., 1930.

—— OFFICE OF INDIAN AFFAIRS. American Indian legends. Phoenix, Native American Press, 1930.

—— OFFICE OF INDIAN AFFAIRS. Indian arts and industries. Chilocco, Indian Print Shop, 1927.

—— OFFICE OF INDIAN AFFAIRS. Indian music. Chilocco, Indian Print Shop, 1928.

—— SUPT. OF DOCUMENTS. Indians. Washington, G. P. O., 1931.

UNIVERSITY OF CALIFORNIA. Publications in American archaeology and ethnology. Berkeley, Calif., 1929.

ARTS AND THEIR INTERPRETATION

ALEXANDER, Hartley B. L'art et la philosophie des Indiens de l'Amérique du Nord. Paris, Leroux, 1926.

—— The pictorial and pictographic art of the Indians of North America. Denver, Denver Art Museum, 1927.

APPLEGATE, Frank G. Indian stories from the Pueblos. Philadelphia, Lippincott, 1929.

ARMER, Laura A. Waterless Mountain. New York, Longmans Green, 1931.

AUSTIN, Mary. The arrow-maker. Boston, Houghton Mifflin, 1915.

—— Taos. San Francisco, Grabhorn, 1931.

BARBEAU, Marius. Totem poles of the Gitksan, Upper Skeena river, British Columbia. Ottawa, Geological Survey, 1929.

BARRETT, S. A. The material culture of the Klamath lake and Modoc Indians of northeastern California and southern Oregon. Berkeley, Univ. Press, 1910.

—— Pomo Indian basketry. Berkeley, Univ. of California Press, 1908.

—— The Washo Indians. Milwaukee, Public Museum, 1917.

BIRKET-SMITH, Kaj. The Caribou Eskimo. Copenhagen, Fifth Thule Expedition, 1929.

BLUMENTHAL, Walter H. In old America. New York, Walton Book Company, 1931.

BOAS, Franz. Contributions to the ethnology of the Kwakiutl. New York, Columbia Univ. Press, 1925.

—— The decorative art of the Indians of the North Pacific coast. New York, American Museum of Natural History, 1897.

—— Facial paintings of the Indians of northern British Columbia. New York, American Museum of Natural History, 1898.

—— The Kwakiutl of Vancouver island. Leyden, Brill, 1909.

—— Primitive art. Oslo, Aschehoug, 1927.

BRANDEIS, Madeline. The little Indian weaver. Chicago, Flanagan, 1930.

BREAZEALE, John M. An Arizona cliff-dweller's shawl. Washington, Archaeological Society, 1925.

BROWN, Charles E. Indian flower toys and games. Madison, author, 1931.

BRYAN, Bruce. Excavation of the Galaz ruin, Mimbres Valley, New Mexico. Washington, Archaeological Society, 1931.

BUFFALO Child Longlance. Longlance. New York, Cosmopolitan, 1928.

BUNZEL, Ruth L. The Pueblo potter. New York, Columbia Univ. Press, 1929.

BUSHNELL, D. I. Jr. The Cahokia and surrounding mound groups. Cambridge, Peabody Museum, 1904.

—— The "mound-builders." Washington, Archaeological Society, 1925.

CADZOW, Donald A. Native copper objects of the Copper Eskimo. New York, Museum of the American Indian, Heye Foundation, 1920.

CARR, Lucien. Dress and ornaments of certain American Indians. Worcester, Mass., Charles Hamilton, 1897.

(CATLIN, George.) Indian-loving Catlin. Wilkes-Barre, Wyoming Historical and Geological Society, 1930.

CLARKE, Noah T. The Indian groups at the New York State Museum. Albany, Eldred, 1930.

—— The Thacher wampum belts of the New York State Museum. Albany, Univ. of the State of New York, 1929.

—— The wampum belt collection of the New York State Museum. Albany, Univ. of the State of New York, 1931.

COLLINS, Henry B. Jr. Prehistoric art of the Alaskan Eskimo. Washington, Smithsonian institution, 1929.

COOLIDGE, Dane *and* COOLIDGE, Mary R. The Navajo Indians. Boston, Houghton Mifflin, 1930.

COTE, R. E. Mound-builders' designs. Milwaukee, Bruce, 1930.

CRANE, Leo. Indians of the enchanted desert. Boston, Little-Brown, 1929.

CURRIER AND IVES PRINTS. The red Indian, with an introduction by W. S. Hall. New York, Rudge, 1931.

CURTIS, Edward S. The North American Indian . . . Edited by Frederick Webb Hodge. Field work conducted under the patronage of J. Pierpont Morgan. 20 vols., 20 portfolios, 1907-1930.

CUSHING, Frank Hamilton. Zuñi breadstuff. New York, Museum of the American Indian, Heye Foundation, 1920.

DAVIDSON, D. S. Decorative art of the Têtes de Boule of Quebec. New York, Museum of the American Indian, Heye Foundation, 1928.

DAVIS, Emily C. Ancient Americans. New York, Holt, 1931.

DEHUFF, Elizabeth Willis. Swift-Eagle of the Rio Grande. Chicago, Rand McNally, 1928.

DEMING, Therese O. Little Eagle. New York, Laidlaw, 1930.

—— Many snows ago. New York, Stokes, 1929.

DIXON, Roland B. Basketry designs of the Indians of northern California. New York, American Museum of Natural History, 1902.

—— The Shasta. New York, American Museum of Natural History, 1907.

DOUGLAS, Frederic H., *and* JEANÇON, J. A. Leaflets, 1-36, Denver, Colorado, Denver Art Museum, 1930-31.

DUMAREST, *Rev.* Noël. Notes on Cochiti, New Mexico. Lancaster, Pa., American Anthropological Association, 1919.

ECKFORD, Eugenia. Wonder windows. New York, Dutton, 1931.

EMMONS, George T. The basketry of the Tlingit. New York, American Museum of Natural History, 1903.

—— The Chilcat blanket. New York, American Museum of Natural History, 1907.

—— Jade in British Columbia and Alaska, and its use by the natives. New York, Museum of the American Indian, Heye Foundation, 1923.

—— Slate mirrors of the Tsimshian. New York, Museum of the American Indian, Heye Foundation, 1921.

—— The Tahltan Indians. Philadelphia, University Museum, 1911.

—— The whale house of the Chilkat. New York, American Museum of Natural History, 1916.

FAIRLIE, Margaret C. Stories of the Seminoles. Chicago, Rand McNally, 1928.

FARRAND, Livingston. Basketry designs of the Salish Indians. New York, American Museum of Natural History, 1900.

FEWKES, J. Walter. Designs on prehistoric Hopi pottery. Washington, Bureau American Ethnology, 1919.

—— Additional designs on prehistoric Mimbres pottery. Washington, Smithsonian Institution, 1924.

GAYTON, A. H. Yokuts and western Mono pottery-making. Berkeley, Univ. of California Press, 1929.

GIFFORD, E. W. Pottery-making in the Southwest. Berkeley, Univ. of California Press, 1928.

—— *and* SCHENCK, W. Egbert. Archaeology of the southern San Joaquin valley, California. Berkeley, Univ. of California Press, 1926.

[GLADWIN, Harold S.]. An archaeological survey of Verde valley. Globe, Ariz., 1930.

—— A method for the designation of Southwestern pottery types. Globe, Ariz., 1930.

—— The red-on-buff culture of the Gila basin. Pasadena, Calif., 1929.

—— The red-on-buff culture of the Papagueria. Globe, Ariz., n.d.

—— Some southwestern pottery types. Globe, Ariz., 1930-31.

—— The use of potsherds in an archaeological survey of the Southwest. Pasadena, Calif., 1928.

—— The western range of the red-on-buff culture. Globe, Ariz., 1930.

GODDARD, Pliny E. Indians of the northwest coast. New York, American Museum of Natural History, 1924.

—— Indians of the Southwest. New York, American Museum of Natural History, 1931.

—— Life and culture of the Hupa. Berkeley, Univ. Press, 1903.

—— Pottery of the southwestern Indians. New York, American Museum of Natural History, 1931.

GORDON, G. B. Notes on the western Eskimo. Philadelphia, Univ. of Pennsylvania, 1906.

GUERNSEY, Samuel J. Explorations in northeastern Arizona. Cambridge, Peabody Museum, 1931.

—— and KIDDER, Alfred V. Basketmaker caves of northeastern Arizona. Cambridge, Peabody Museum, 1921.

GUTHE, Carl E. Pueblo pottery making. New Haven, Yale Univ. Press, 1925.

HAEBERLIN, Hermann and GUNTHER, Erna. The Indians of Puget Sound. Seattle, Univ. of Washington Press, 1930.

HARRINGTON, M. R. Archaeological explorations in southern Nevada. Los Angeles, Southwest Museum, 1930.

—— An archaic Iowa tomahawk. New York, Museum of the American Indian, Heye Foundation, 1920.

—— A bird-quill belt of the Sauk and Fox Indians. New York, Museum of the American Indian, Heye Foundation, 1920.

—— Certain Caddo sites in Arkansas. New York, Museum of the American Indian, Heye Foundation, 1920.

—— Cherokee and earlier remains on upper Tennessee River. New York, Museum of the American Indian, Heye Foundation, 1922.

—— Iroquois silverwork. New York, American Museum of Natural History, 1908.

—— Old Sauk and Fox beaded garters. New York, Museum of the American Indian, Heye Foundation, 1920.

—— Sacred bundles of the Sac and Fox Indians. Philadelphia, University Museum, 1914.

—— A sacred warclub of the Oto. New York, Museum of the American Indian, Heye Foundation, 1920.

HATT, Gudmund. Moccasins and their relation to arctic footwear. Lancaster, Pa., American Anthropological Association, 1916.

HEWETT, Edgar L. Ancient life in the American Southwest. Indianapolis, Bobbs-Merrill, 1930.

—— Native American artists. Washington, Archaeological Society, 1922.

HEYE, George G. Certain aboriginal pottery from southern California. New York, Museum of the American Indian, Heye Foundation, 1919.

—— Certain artifacts from San Miguel Island, California. New York, Museum of the American Indian, Heye Foundation, 1921.

—— A Mahican wooden cup. New York, Museum of the American Indian, Heye Foundation, 1921.

—— and ORCHARD, William C. A rare Salish blanket. New York, Museum of the American Indian, Heye Foundation, 1926.

——, HODGE, F. W., and PEPPER, George H. The Nacoochee mound in Georgia. New York, Museum of the American Indian, Heye Foundation, 1918.

HODGE, F. W. Hawikuh bonework. New York, Museum of the American Indian, Heye Foundation, 1920.

—— Turquois work of Hawikuh, New Mexico. New York, Museum of the American Indian, Heye Foundation, 1921.

HOLMES, William H. Mortars. Washington, G. P. O., 1912.

—— Ornament. Washington, G. P. O., 1912.

—— Pottery. Washington, G. P. O., 1912.

HOOTON, Earnest A. Indian village site and cemetery near Madisonville, Ohio . . . with notes on the artifacts by Charles C. Willoughby. Cambridge, Peabody Museum, 1920.

HOUGH, Walter. The Hopi Indian collection in the United States National Museum. Washington, Smithsonian Institution, 1918.

HUFFMAN, John W. Turquoise mosaics from Casa Grande. Washington, Archaeological Society, 1925.

JACOBSON, Oscar B. Kiowa Indian art. Nice, C. Szwedzicki, 1929.

JAMES, George Wharton. Indian blankets and their makers. Chicago, McClurg, 1927.

—— A little journey to New Mexico and Arizona. Chicago, Flanagan, 1930.

JEANÇON, Jean A. Archaeological investigations in the Taos valley, New Mexico, during 1920. Washington, Smithsonian Institution, 1929.

JESKE, John A. The Grand river mound group and camp site. Milwaukee, Public Museum, 1927.

KELLY, Isabel T. The carver's art of the Indians of northwestern California. Berkeley, Univ. of California Press, 1930.

—— Yuki basketry. Berkeley, Univ. of California Press, 1930.

KIDDER, Alfred V. An introduction to the study of southwestern archaeology with a preliminary account of the excavations at Pecos. New Haven, Yale Univ. Press, 1924.

—— Pottery of the Pajarito plateau and of some adjacent regions in New Mexico. Lancaster, Pa., American Anthropological Association, 1915.

—— Pottery of Pecos. Vol. I. New Haven, Yale Univ. Press, 1931.

KISSELL, Mary L. Basketry of the Papago and Pima. New York, American Museum of Natural History, 1916.

KRIEGER, Herbert W. American Indian costumes in the United States National Museum. Washington, Smithsonian Institution, 1929.

KROEBER, Alfred L. The Arapaho. New York, American Museum of Natural History, 1902-07.

—— Basket designs of the Indians of northwestern California. Berkeley, Univ. of California Press, 1905.

—— Basket designs of the Mission Indians of California. New York, American Museum of Natural History, 1922.

—— Basketry designs of the Mission Indians. New York, American Museum of Natural History, 1926.

—— Elements of culture in native California. Berkeley, Univ. of California Press, 1922.

—— Ethnography of the Cahuilla Indians. Berkeley, Univ. Press, 1908.

—— Native culture of the Southwest. Berkeley, Univ. of California Press, 1928.

—— The valley Nisenan. Berkeley, Univ. of California Press, 1929.

—— Zuñi potsherds. New York, American Museum of Natural History, 1916.

LA FARGE, Oliver. Laughing Boy. Boston, Houghton Mifflin, 1929.

LEMOS, Pedro J. Indian decorative designs. Worcester, School Arts Magazine, 1926.

LOEB, Edwin M. Pomo folkways. Berkeley, Univ. of California Press, 1926.

LOUD, Llewellyn L. Enthnogeography and archaeology of the Wiyot territory. Berkeley, Univ. of California Press, 1918.

—— The Stege mounds at Richmond, California. Berkeley, Univ. of California Press, 1924.

—— *and* HARRINGTON, M. R. Lovelock cave. Berkeley, Univ. of California Press, 1929.

LOWIE, Robert H. Crow Indian art. New York, American Museum of Natural History, 1922.

LUDINS, Ryah. The wonder rock. New York, Coward-McCann, 1931.

McKERN, W. C. The Kletzien and Nitschke mound groups. Milwaukee, Public Museum, 1930.

—— The Neale and McClaughry mound groups. Milwaukee, Public Museum, 1928.

—— A Wisconsin variant of the Hopewell culture. Milwaukee, Public Museum, 1931.

MADISON, Harold L. Indian homes. Cleveland, Cleveland Museum of Natural History, 1925.

—— Mound builders. Cleveland, Cleveland Museum of Natural History, 1925.

MANGAM, E. W. Indian handicraft. New York, Boy Scouts of America, 1930.

MARTIN, George C. *and* POTTER, Wendell H. Preliminary archaeological survey of a portion of the Texas coast . . . in 1927-1928-1929. Author, [1930].

MASON, J. Alden. The ethnology of the Salinan Indians. Berkeley, Univ. Press, 1912.

MASON, Otis T. Arts and industries. Washington, G. P. O., 1912.

—— Basketry. Washington, G. P. O., 1912.

—— Beadwork. Washington, G. P. O., 1912.

—— Weaving. Washington, G. P. O., 1912.

—— Woman's share in primitive culture. New York, Appleton, 1929.

—— *and* HOUGH, Walter. Blankets. Washington, G. P. O., 1912.

MATTHEWS, Washington. The night chant. New York, American Museum of Natural History, 1902.

MOONEY, James. Skin and skin dressing. Washington, G. P. O., 1912.

MOORE, Clarence B. Additional mounds of Duval and of Clay counties, Florida. New York, Museum of the American Indian, Heye Foundation, 1922.

MOORE, J. B. The Navajo. Denver, Colo., 1911.

MOOREHEAD, Warren K. Archaeology of the Arkansas river valley . . . with supplementary papers on the prehistoric cultures of Oklahoma by Joseph B. Thoburn and the exploration of Jacobs Cavern by Charles Peabody. New Haven, Yale Univ. Press, 1931.

—— The Hopewell mound group of Ohio. Chicago, Field Museum of Natural History, 1922.

—— Preliminary report on the Merrimack valley expedition. Salem, Peabody Museum, 1931.

—— A report on the archaeology of Maine. Andover, Andover Press, 1922.

—— Stone ornaments used by Indians in the United States and Canada . . . with chapters by Arthur C. Parker, Esquire, and Professor Edward H. Williams, Jr. Andover, Andover Press, 1917.

MORRIS, Earl H. The beginnings of pottery making in the San Juan area; unfired prototypes and the wares of the earliest ceramic period. New York, American Museum of Natural History, 1927.

—— Preliminary account of the antiquities of the region between the Mancos and La Plata rivers in southwestern Colorado. Washington, Bureau of American Ethnology, 1919.

MORSS, Noel. The ancient culture of the Fremont river in Utah. Cambridge, Peabody Museum, 1931.

—— Notes on the archaeology of the Kaibito and Rainbow plateaus in Arizona. Cambridge, Peabody Museum, 1931.

MUSEUM OF THE AMERICAN INDIAN, HEYE FOUNDATION. Guide to the Museum. First Floor. Second Floor. New York, 1922.

NELSON, N. C. The Ellis Landing shellmound. Berkeley, Univ. Press, 1910.

NESBITT, Paul H. The ancient Mimbreños. Beloit, Logan Museum, 1931.

NEWCOMBE, W. A. British Columbia totem poles. Victoria, B. C., Provincial Museum, 1931.

—— Thunder-bird and whale. Victoria, B. C., Provincial Museum, 1930.

NUSBAUM, Deric. Deric with the Indians. New York, Putnam, 1927.

NUSBAUM, Jesse J. A basket-maker cave in Kane county, Utah. New York, Museum of the American Indian, Heye Foundation, 1922.

OLBRECHTS, Frans M. Kunst van Vroeg en van Verre. Brugge, "Excelsior," 1929.

OLSON, Ronald L. Adze, canoe, and house types of the northwest coast. Seattle, Univ. of Washington Press, 1927.

ONTARIO. Archaeological reports. Toronto, Minister of Education, 1915-28.

ORCHARD, William C. Beads and beadwork of the American Indians. New York, Museum of the American Indian, Heye Foundation, 1929.

—— Sandals and other fabrics from Kentucky caves. New York, Museum of the American Indian, Heye Foundation, 1920.

—— The technique of porcupine-quill decoration among the North American Indians. New York, Museum of the American Indian, Heye Foundation. 1916.

OTIS, Raymond. Indian art of the Southwest. Published and distributed by the Southwest Indian Fair. (Santa Fe, 1931.)

PARKER, Arthur C. The amazing Iroquois. Washington, Archaeological Society, 1927.

—— The archeological history of New York. Albany, Univ. of the State of New York, 1922.

—— The Indian how book. Garden City, Doubleday Doran, 1931.

PEABODY, Charles. Exploration of mounds, Coahoma County, Mississippi. Cambridge, Peabody Museum, 1904.

PEPPER, George H. The making of a Navajo blanket. New York, 1902.

—— Native Navajo dyes. New York, Papoose, 1903.

—— A stone effigy pipe from Kentucky. New York, Museum of the American Indian, Heye Foundation, 1920.

—— A wooden image from Kentucky. New York, Museum of the American Indian, Heye Foundation, 1921.

POGUE, Joseph E. The turquoise . . . Washington, National Academy of Sciences, 1915.

POPE, Saxton T. A study of bows and arrows. Berkeley, Univ. of California Press, 1923.

—— Yahi archery. Berkeley, Univ. of California Press, 1918.

PUTNAM anniversary volume. New York, Stechert, 1909.

RADIN, Paul. Crashing Thunder. New York, Appleton, 1926.

—— The story of the American Indian. New York, Boni & Liveright, 1927.

RENAUD, E.-B. Les origines de la céramique indienne du Sud-Ouest américain, Paris, 1928.

ROBERTS, Frank H. H., Jr. The ruins at Kiatuthlanna, eastern Arizona. Washington, Bureau American Ethnology, 1931.

—— Shabik'eshchee village. Washington, Bureau American Ethnology, 1929.

ROBERTS, Helen H. Basketry of the San Carlos Apache. New York, American Museum of Natural History, 1929.

ROGERS, David B. Prehistoric man of the Santa Barbara coast. Santa Barbara, Santa Barbara Museum of Natural History, 1929.

RUSSELL, Frank. The Pima Indians. Washington, Bureau American Ethnology, 1908.

SALOMON, Julian Harris. The book of Indian crafts and Indian lore. New York, Harper, 1928.

SAVILLE, Marshall H. Archeological specimens from New England. New York, Museum of the American Indian, Heye Foundation, 1919.

SCHENCK, W. Egbert. The Emeryville shellmound. Berkeley, Univ. of California Press, 1926.

—— and DAWSON, Elmer J. Archaeology of the northern San Joaquin valley. Berkeley, Univ. of California Press, 1929.

THE SCHOOL-ARTS MAGAZINE. Special Indian numbers. Worcester, November, 1927, and March, 1931.

SCHRABISCH, Max. Aboriginal rock shelters and other archaeological notes of Wyoming Valley and vicinity. Wilkes-Barre, Wyoming Historical and Geological Society, 1926.

SHETRONE, Henry C. The mound-builders. New York, Appleton, 1930.

SKINNER, Alanson. An antique tobacco-pouch of the Iroquois. New York, Museum of the American Indian, Heye Foundation, 1920.

—— Ethnology of the Ioway Indians. Milwaukee, Public Museum, 1926.

—— An Illinois quilled necklace. New York, Museum of the American Indian, Heye Foundation, 1920.

—— An Iroquois antler figurine. New York, Museum of the American Indian, Heye Foundation, 1920.

—— The Mascoutens or prairie Potawatomi Indians. Milwaukee, Public Museum, 1924-27.

—— Material culture of the Menomini. New York, Museum of the American Indian, Heye Foundation, 1921.

—— Medicine ceremony of the Menomini, Iowa, and Wahpeton Dakota, with notes on the ceremony among the Ponca, Bungi Ojibwa, and Potawatomi Indians. New York, Museum of the American Indian, Heye Foundation, 1920.

—— A native copper celt from Ontario. New York, Museum of the American Indian, Heye Foundation, 1920.

—— Notes on Iroquois archeology. New York, Museum of the American Indian, Heye Foundation, 1921.

—— Notes on Mahican ethnology. Milwaukee, Public Museum, 1925.

—— Observations on the ethnology of the Sauk Indians. *Ibid.*, 1925.

—— The pre-Iroquoian Algonkian Indians of central and western New York. New York, Museum of the American Indian, Heye Foundation, 1919.

—— Two antler spoons from Ontario. New York, Museum of the American Indian, Heye Foundation, 1920.

—— Two Lenape stone masks from Pennsylvania and New Jersey. New York, Museum of the American Indian, Heye Foundation, 1920.

SMITH, Dama Margaret. Hopi girl. Stanford University, University Press, 1931.

SMITH, Harlan I. An album of prehistoric Canadian art. Ottawa, National Museum, 1923.

—— The archaeology of Puget Sound. Leyden, Brill, 1906.

—— The archaeology of the Yakima Valley. New York, American Museum of Natural History, 1910.

—— *and* WINTEMBERG, W. J. Some shellheaps in Nova Scotia. Ottawa, National Museum, 1929.

SPECK, Frank G. The Creek Indians of Taskigi town. Lancaster, Pa., American Anthropological Association, 1907.

—— Decorative art and basketry of the Cherokee. Milwaukee, Public Museum, 1920.

—— Decorative art of Indian tribes of Connecticut. Ottawa, Geological Survey, 1915.

—— The double-curve motive in northeastern Algonkian art. Ottawa, Geological Survey, 1914.

—— Ethnology of the Yuchi Indians. Philadelphia, University Museum, 1909.

—— The functions of wampum among the eastern Algonkian. Lancaster, Pa., American Anthropological Association, 1919.

—— Symbolism in Penobscot art. New York, American Museum of Natural History, 1927.

—— *and* HEYE, George G. Hunting charms of the Montagnais and the Mistassini. New York, Museum of the American Indian, Heye Foundation, 1921.

—— *and* ORCHARD, William C. The Penn wampum belts. New York, Museum of the American Indian, Heye Foundation, 1925.

SPIER, Leslie. Klamath ethnography. Berkeley, Univ. of California Press, 1930.

—— Southern Diegueño customs. Berkeley, Univ. of California Press, 1923.

—— *and* SAPIR, Edward. Wishram ethnology. Seattle, Univ. of Washington Press, 1930.

STEWARD, Julian H. Petroglyphs of California and adjoining states. Berkeley, Univ. of California Press, 1929.

STOW, Edith. Boys' games among the North American Indians. New York, Dutton, 1924.

STRONG, William Duncan. Aboriginal society in southern California. Berkeley, Univ. of California Press, 1929.

—— , SCHENCK, W. Egbert, *and* STEWARD, Julian H. Archaeology of the Dalles-Deschutes region. Berkeley, Univ. of California Press, 1930.

SWANTON, John R. The Haida of Queen Charlotte islands. Leyden, Brill, 1905.

—— Totem. Washington, G. P. O., 1912.

TEIT, James. The Lillooet Indians. Leyden, Brill, 1906.

—— The Shuswap. Leyden, Brill, 1909.

—— The Thompson Indians of British Columbia. New York, American Museum of Natural History, 1900.

THEVENIN, René *and* COZE, Paul. Moeurs et histoire des Indiens Peaux-Rouges. Paris, Payot, 1928.

THROOP, Addison J. Mound builders of Illinois. East St. Louis, Ill., Call Printing Co., 1928.

UHLE, Max. The Emeryville shellmound. Berkeley, Univ. of California Press, 1907.

U. S. OFFICE OF INDIAN AFFAIRS. Indian art and industries. Chilocco, Indian Print Shop, 1927.

UTZINGER, Rudolf. Indianer-Kunst. München, Recht-Verlag, 1921.

VOLK, Ernest. The archaeology of the Delaware valley. Cambridge, Peabody Museum, 1911.

WATERMAN, T. T. The Yana Indians. Berkeley, Univ. of California Press, 1918.

—— *and* GREINER, Ruth. Indian houses of Puget Sound. New York, Museum of the American Indian, Heye Foundation, 1921.

WEST, George A. Copper: its mining and use by the aborigines of the Lake Superior region. Milwaukee, Public Museum, 1929.

WESTLAKE, Inez B. American Indian designs. First series. New York, Perleberg, 1925.

——American Indian designs. Second series. Philadelphia, Perleberg, 1930.

WHITNEY, Charles F. Indian designs and symbols. Salem, Mass., Newcomb and Gauss, 1925.

WILL, G. F. *and* SPINDEN, H. J. The Mandans. Cambridge, Peabody Museum, 1906.

WILLOUGHBY, Charles C. The Turner group of earthworks, Hamilton County, Ohio. Cambridge, Peabody Museum, 1922.

—— Indian burial place at Winthrop, Massachusetts. Cambridge, Peabody Museum, 1924.

WISSLER, Clark. The American Indian. New York, Oxford Univ. Press, 1922.

—— Archaeology of the Polar Eskimo. New York, American Museum of Natural History, 1918.

—— Costumes of the plains Indians. New York, American Museum of Natural History, 1915.

—— Distribution of moccasin decorations among the plains tribes. New York, American Museum of Natural History, 1927.

—— Indian beadwork. New York, American Museum of Natural History, 1931.

—— Indian costumes in the United States. New York, American Museum of Natural History, 1931.

—— The Indians of Greater New York and the lower Hudson. New York, American Museum of Natural History, 1909.

—— North American Indians of the plains. New York, American Museum of Natural History, 1927.

—— Some protective designs of the Dakota. New York, American Museum of Natural History, 1907.

—— Structural basis to the decoration of costumes among the plains Indians. New York, American Museum of Natural History, 1916.

WREN, Christopher. A study of North Appalachian Indian pottery. Wilkes-Barre, Wyoming Historical and Geological Society, 1914.

YOUNG, Levi E. The ancient inhabitants of Utah. Washington, Archaeological Society, 1929.

DANCES AND CEREMONIES

ALEXANDER, Hartley Burr. The ritual dances of the Pueblo Indians. Denver, Denver Art Museum, 1927.

BARRETT, S. A. Ceremonies of the Pomo Indians. Berkeley, Univ. of California Press, 1917.

—— The dream dance of the Chippewa and Menominee Indians of northern Wisconsin. Milwaukee, Public Museum, 1911.

—— Myths of the Southern Sierra Miwok. Berkeley, Univ. of California Press, 1919.

—— The Wintun Hesi ceremony. Berkeley, Univ. of California Press, 1919.

BUTTREE, Julia M. The rhythm of the redman. New York, Barnes, 1930.

DANGBERG, Grace. Washo texts. Berkeley, Univ. of California Press, 1927.

DeHUFF, Elizabeth W. Five little Katchinas. Boston, Houghton Mifflin, 1930.

DELORIA, Ella Cora. The Wohpe festival. n.p. c. 1928.

DESERONTYON, John. A Mohawk form of ritual of condolence, 1782. New York, Museum of the American Indian, Heye Foundation, 1928.

DORSEY, George A. The Cheyenne . . . The sun dance. Chicago, Field Museum, 1905.

—— The Ponca sun dance. Chicago, Field Museum, 1905.

DUBOIS, Constance G. The religion of the Luiseño Indians of southern California. Berkeley, Univ. of California Press, 1908.

EASTERN ASSOCIATION ON INDIAN AFFAIRS. Concerning Indian dances. New York, 1924.

EVANS, May G. *and* EVANS, Bessie. American Indian dance steps. New York, Barnes, 1931.

FERGUSSON, Erna. Dancing gods. New York, Knopf, 1931.

FEWKES, J. Walter. A few ceremonials at Zuñi Pueblo. Boston, Houghton Mifflin, 1891.

—— A few summer ceremonials at the Tusayan Pueblos. Boston, Houghton Mifflin, 1892.

—— Hopi Katcinas. Washington, Bureau of American Ethnology, 1903.

—— The snake ceremonials at Walpi. Boston, Houghton Mifflin, 1894.

GAYTON, A. H. The ghost dance of 1870 in south-central California. Berkeley, Univ. of California Press, 1930.

GODDARD, Pliny E. Dancing societies of the Sarsi Indians. New York, American Museum of Natural History, 1914.

—— Notes on the sun dance of the Cree in Alberta. New York, American Museum of Natural History, 1919.

—— Notes on the sun dance of the Sarsi. New York, American Museum of Natural History, 1919.

GOLDFRANK, Esther Schiff. The social and ceremonial organization of Cochiti. Menasha, Wis., American Anthropological Association, 1927.

GUNTHER, Erna. A further analysis of the first salmon ceremony. Seattle, Univ. of Washington Press, 1928.

HAEBERLIN, H. K. The idea of fertilization in the culture of the Pueblo Indians. Lancaster, Pa., American Anthropological Association, 1916.

HARRINGTON, M. R. Religion and ceremonies of the Lenape. New York, Museum of the American Indian, Heye Foundation, 1921.

HAWKES, E. W. The dance festivals of the Alaskan Eskimo. Philadelphia, University Museum, 1914.

LINTON, Ralph. Annual ceremony of the Pawnee medicine men. Chicago, Field Museum of Natural History, 1923.

—— The sacrifice to the morning star by the Skidi Pawnee. Chicago, Field Museum of Natural History, 1922.

—— The thunder ceremony of the Pawnee. Chicago, Field Museum of Natural History, 1922.

LOEB, Edwin M. Tribal initiations and secret societies. Berkeley, Univ. of California Press, 1929.

LOWIE, Robert H. Dance associations of the eastern Dakota. New York, American Museum of Natural History, 1913.

—— Dances and societies of the Plains Shoshone. New York, American Museum of Natural History, 1915.

—— Societies of the Arikara Indians. New York, American Museum of Natural History, 1915.

—— Societies of the Crow, Hidatsa and Mandan Indians. New York, American Museum of Natural History, 1913.

—— Societies of the Kiowa. New York, American Museum of Natural History, 1916.

—— The sun dance of the Crow Indians. New York, American Museum of Natural History, 1915.

—— Sun dance of the Shoshoni, Ute, and Hidatsa. New York, American Museum of Natural History, 1919.

MICHELSON, Truman. The mythical origin of the white buffalo dance of the Fox Indians. Washington, Bureau American Ethnology, 1925.

MURIE, James R. Pawnee Indian societies. New York, American Museum of Natural History, 1914.

PARSONS, Elsie Clews. Notes on Zuñi. Lancaster, Pa., American Anthropological Association, 1917.
—— The scalp ceremonial of Zuñi. Menasha, Wis., American Anthropological Association, 1928.
—— The social organization of the Tewa of New Mexico. Menasha, Wis., American Anthropological Association, 1929.
—— Winter and summer dance series in Zuñi in 1918. Berkeley, Univ. of California Press, 1922.
RADIN, Paul. Wappo texts. Berkeley, Univ. of California Press, 1924.
SKINNER, Alanson. Associations and ceremonies of the Menomini Indians. New York, American Museum of Natural History, 1915.
—— Notes on the sun dance of the Sisseton Dakota. New York, American Museum of Natural History, 1919.
—— Political organization, cults and ceremonies of the Plains-Ojibway and Plains-Cree Indians. New York, American Museum of Natural History, 1914.
—— Societies of the Iowa, Kansa, and Ponca Indians. New York, American Museum of Natural History, 1915.
—— The sun dance of the Plains-Cree. New York, American Museum of Natural History, 1919.
SPIER, Leslie. The ghost dance of 1870 among the Klamath of Oregon. Seattle, Univ. of Washington Press, 1927.
—— Notes on the Kiowa sun dance. New York, American Museum of Natural History, 1921.

—— The sun dance of the Plains Indians. New York, American Museum of Natural History, 1921.
THALBITZER, William. Les magiciens esquimaux, leurs conceptions du monde, de l'âme et de la vie. Paris, Société des Américanistes, 1930.
VOTH, H. R. The Oraibi Marau ceremony. Chicago, Field Museum of Natural History, 1912.
—— The Oráibi Oáqol ceremony. Chicago, Field Museum, 1903.
—— The Oraibi summer snake ceremony. Chicago, Field Museum, 1903.
WALKER, J. B. The sun dance and other ceremonies of the Oglala division of the Teton Dakota. New York, American Museum of Natural History, 1917.
WALLIS, W. D. The sun dance of the Canadian Dakotas. New York, American Museum of Natural History, 1919.
WATERMAN, T. T. The religious practices of the Diegueño Indians. Berkeley, Univ. of California Press, 1910.
WISSLER, Clark. General discussion of shamanistic and dancing societies. New York, American Museum of Natural History, 1916.
—— Societies and ceremonial associations in the Oglala division of the Teton-Dakota. New York, American Museum of Natural History, 1912.
—— Societies and dance associations of the Blackfoot Indians. New York, American Museum of Natural History, 1913.
—— The sun dance of the Blackfoot Indians. New York, American Museum of Natural History, 1918.

LEGENDS AND FOLKLORE

ALEXANDER, Hartley B. The mythology of all races. North America. Boston, Marshall Jones, 1916.
ALLEN, Philippa. Whispering wind. Chicago, Rockwell, 1930.
BALLARD, Arthur C. Mythology of southern Puget Sound. Seattle, Univ. of Washington Press, 1929.
—— Some tales of the southern Puget Sound Salish. Seattle, Univ. of Washington Press, 1927.
BEAUCHAMP, William M. Iroquois folk lore. Syracuse, Onondaga Historical Association, 1922.
BECKWITH, Martha W. Myths and hunting stories of the Mandan and Hidatsa. Poughkeepsie, Vassar College, 1930.
BENEDICT, Ruth. Tales of the Cochiti Indians. Washington, Bureau American Ethnology, 1931.
BLOOMFIELD, L. Sacred stories of the Sweet Grass Cree. Ottawa, National Museum, 1930.
BOAS, Franz. Bella Bella texts. New York, Columbia Univ. Press, 1928.
—— Kwakiutl tales. New York, Columbia Univ. Press, 1910.

—— Kwakiutl texts. New York, American Museum of Natural History, 1902.
—— The mythology of the Bella Coola Indians. New York, American Museum of Natural History, 1898.
—— Tsimshian mythology. Washington, Bureau American Ethnology, 1916.
—— Keresan texts. Part I. New York, Stechert, 1928.
—— Keresan texts. Part II. New York, Stechert, 1925.
BROWN, Charles E. Indian star lore. Madison, Wis., author, 1930.
—— Indian tales of "little Indians," windigos and witches. Madison, author, 1928.
—— Wigwam tales. Madison, author, 1930.
BURKHOLDER, Mabel. Before the white man came. Toronto, McClelland and Stewart, 1923.
CONNELLEY, William E. Indian myths. Chicago, Rand McNally, 1928.
COWLES, Julia D. Indian nature myths. Chicago, Flanagan, 1927.
CURTIN, Jeremiah and HEWITT, J. N. B. Seneca fiction, legends and myths. Washington, Bureau American Ethnology, 1918.

CUSHING, Frank H. Zuñi folk tales. New York, Knopf, 1931.

DEHUFF, Elizabeth W. Taytay's memories. New York, Harcourt, 1924.

—— Taytay's tales. New York. Harcourt, 1922.

DEMING, Edwin W. Red folk and wild folk. New York, Stokes, 1902.

DENSMORE, Frances. Two Indian legends dramatized for children. New York, Woman's Press, 1926.

DIXON, Roland B. Maidu myths. New York, American Museum of Natural History, 1902.

DORSEY, George A. Traditions of the Skidi Pawnee. New York, American Folklore Society, 1904.

—— Traditions of the Osage. Chicago, Field Museum, 1904.

—— and KROEBER, Alfred L. Traditions of the Arapaho. Chicago, Field Museum, 1903.

EASTMAN, Charles A. and EASTMAN, Elaine G. Smoky Day's wigwam evenings. Boston, Little Brown, 1931.

—— —— Wigwam evenings. Boston, Little Brown, 1930.

EASTMAN, Elaine G. Indian legends retold. Boston, Little Brown, 1929.

FARRAND, Livingston. Traditions of the Chilcotin Indians. New York, American Museum of Natural History, 1900.

—— Traditions of the Quinault Indians. New York, American Museum of Natural History, 1902.

FISKE, W. A. A. Indian legends. Ithaca, Slingerland-Comstock, 1930.

FRACHTENBERG, Leo J. Coos texts. New York, Columbia Univ. Press, 1913.

—— Lower Umpqua texts. New York, Columbia Univ. Press, 1914.

GIFFORD, Edward Winslow. Miwok myths. Berkeley, Univ. of California Press, 1917.

—— and BLOCK, Gwendoline Harris. Californian Indian nights entertainments. Glendale, Calif., Clark, 1930.

GILMORE, M. R. Prairie smoke. New York, Columbia Univ. Press, 1929.

GODDARD, Pliny E. Beaver texts; Beaver dialects. New York, American Museum of Natural History, 1917.

—— Chilula texts. Berkeley, Univ. Press, 1914.

—— Hupa texts. Berkeley, Univ. Press, 1904.

—— Jicarilla Apache texts. New York, American Museum of Natural History, 1911.

—— Kato texts. Berkeley, Univ. Press, 1909.

—— Myths and tales from the San Carlos Apache. New York, American Museum of Natural History, 1918.

—— San Carlos Apache texts. New York, American Museum of Natural History, 1919.

—— Sarsi texts. Berkeley, Univ. Press, 1915.

—— Texts and analysis of Cold Lake dialect, Chipewyan. New York, American Museum of Natural History, 1912.

—— White Mountain Apache texts. New York, American Museum of Natural History, 1920.

GRAVES, Charles S. Lore and legends of the Klamath river Indians. Yreka, Press of the Times, 1929.

GRINNELL, George Bird. Blackfoot lodge tales. New York, Scribner's, 1892.

—— By Cheyenne camp fires. New Haven, Yale Univ. Press, 1926.

—— Pawnee hero stories and folk-tales. New York, Scribner's, 1893.

HARRINGTON, John P. Picurís children's stories. Washington, Bureau American Ethnology, 1928.

HASKELL INSTITUTE. Indian legends by pupils of Haskell Institute. Lawrence, Kansas, Haskell Printing Dept., 1914.

HEN-TOH. Tales of the bark lodges. Oklahoma City, Harlow, 1920.

JACOBS, Melville. Northwest Sahaptin texts. Seattle, Univ. of Washington Press, 1929.

JAMES, Ahlee. Tewa firelight tales. New York, Longmans Green, 1927.

JOHNSON, Elizabeth B. Animal stories the Indians told. New York, Knopf, 1927.

JOHNSON, E. Pauline. Legends of Vancouver. Toronto, McClelland and Stewart, 1926.

JOURNAL OF AMERICAN FOLKLORE. New York, American Folklore Society. (*Various issues.*)

JUDD, Mary C. Wigwam stories told by North American Indians. Boston, Ginn, 1931.

KENNEDY, Howard Angus. The new world fairy book. New York, Dutton, 1927.

—— The Red Man's wonder book. New York, Dutton, 1931.

KROEBER, Alfred L. Gros Ventre myths and tales. New York, American Museum of Natural History, 1907.

—— Indian myths of south central California. Berkeley, Univ. Press, 1907.

LA MERE, Oliver and SHINN, Harold B. Winnebago stories. Chicago, Rand McNally, 1928.

LEE, F. H. The children's Hiawatha. London, Harrap, 1930.

LINDERMAN, Frank B. Indian lodge-fire stories. New York, Scribner's.

—— Indian old-man stories. New York, Scribner's.

—— Indian why stories. New York, Scribner's.

—— Kootenai why stories. New York, Scribner's.

—— Old man coyote. New York, Day, 1931.

LOWIE, Robert H. Chipewyan tales. New York, American Museum of Natural History, 1912.

—— A Crow text. Berkeley, Univ. of California Press, 1930.

—— Myths and traditions of the Crow Indians. New York, American Museum of Natural History, 1918.

—— The religion of the Crow Indians. New York, American Museum of Natural History, 1922.

LUMMIS, Charles Fletcher. Pueblo Indian folk-stories. New York, Century, 1910.

LYBACK, Johanna R. M. Indian legends. Chicago, Lyons and Carnahan, 1925.

MACKAY, Isabel E. Indian nights. Toronto, McClelland and Stewart, 1930.

MATTHEWS, Washington. Navaho legends. New York, American Folklore Society, 1896.
—— Navaho myths, prayers and songs. . . . Berkeley, Univ. Press, 1907.
MAURY, Jean W. Old Raven's world. Boston, Little Brown, 1931.
MORCOMB, Margaret E. Red feather stories. Chicago, Lyons and Carnahan, 1916.
NUSBAUM, Aileen. Zuñi Indian tales. New York, Putnam, 1926.
OLCOTT, Frances J. The Red Indian fairy book. Boston, Houghton Mifflin, 1917.
OLDEN, Sarah Emilia. The people of Tipi Sapa. Milwaukee, Morehouse, 1918.
PAGET, Amelia M. The people of the plains. Toronto, Ryerson, 1909.
PALMER, Katherine V. W. Honne, the spirit of Chehalis. Ithaca, Slingerland - Comstock, 1925.
PARKER, Arthur C. Rumbling wings, and other Indian tales. Garden City, Doubleday Doran, 1928.
—— Skunny Wundy and other Indian tales. Garden City, Doubleday Doran, 1930.
PARSONS, Elsie Clews. Kiowa tales. New York, American Folklore Society, 1929.
—— Tewa tales. New York, American Folklore Society, 1926.
POWERS, Mabel. Around an Iroquois story fire. New York, Stokes, 1923.
SAPIR, Edward. Takelma texts. Philadelphia, University Museum, 1909.
—— Yana texts. Berkeley, Univ. Press, 1910.
SCHOOLCRAFT, H. R. Indian fairy book. New York, Stokes, 1916.
SCHULTZ, James W. Blackfeet tales of Glacier National Park. Boston, Houghton Mifflin, 1916.
SIMMS, S. C. Traditions of the Crows. Chicago, Field Museum, 1903.
SKINNER, Alanson *and* SATTERLEE, John V. Folklore of the Menomini Indians. New York, American Museum of Natural History, 1915.
SNELL, Ray J. Eskimo legends. Boston, Little Brown, 1929.
SPENCE, Lewis. The myths of the North American Indians. Toronto, McClelland, n.d.
STOKES, Winston. The story of Hiawatha. New York, Stokes, 1910.
SWANTON, John R. Haida texts. Leyden, Brill, 1908.

TANNER, Dorothy. Legends from the Red Man's forest. Chicago, Flanagan, 1931.
TEIT, James. Traditions of the Thompson River Indians of British Columbia. New York, American Folklore Society, 1898.
—— , GOULD, Marian K.; FARRAND, Livingston; SPINDEN, Herbert J. Folk-tales of Salishan and Sahaptin tribes. New York, American Folklore Society, 1917.
THALBITZER, William. Légendes et chants esquimaux du Groenland. Paris, Leroux, 1929.
THOMPSON, Jean M. Over Indian and animal trails. New York, Stokes, 1918.
THOMPSON, Stith. Tales of the North American Indians. Cambridge, Harvard Univ. Press, 1929.
THOMPSON, William. Wigwam wonder tales. New York, Scribner's, 1919.
VESTAL, Stanley, *pseud.* Happy hunting grounds. Chicago, Lyons and Carnahan, 1928.
VOTH, H. R. The traditions of the Hopi. Chicago, Field Museum, 1905.
WA-BE-NO O-PEE-CHEE. Chippewa tales. Vols. 1 and 2. Los Angeles, Wetzel, 1928, 1930.
WAGNER, Günter. Yuchi tales. New York, Stechert, 1931.
WARREN, Maude R. Manabozho, the great white rabbit. Chicago, Rand McNally, 1918.
WASHBURNE, Marion F. Indian legends. Chicago, Rand McNally, 1915.
WHITMAN, William. Navaho tales. Boston, Houghton Mifflin, 1925.
WILSON, Gilbert L. Myths of the Red children. Boston, Ginn, 1907.
WISSLER, Clark *and* DUVALL, D. C. Mythology of the Blackfoot Indians. New York, American Museum of Natural History, 1908.
WOOD, Charles E. S. A book of tales. New York, Vanguard, 1929.
WRIGHT, Harold B. Long ago told. New York, Appleton, 1929.
WYNN, David. The magic kettle. London, Harrap, 1931.
YOUNG, Egerton R. Algonquin Indian tales. New York, Abingdon, 1903.
—— Stories from Indian wigwams. New York, Abingdon, 1892.
ZITKALA-SA. Old Indian legends. Boston, Ginn, 1929.

MUSIC AND SONGS

ALEXANDER, Hartley Burr. God's drum, New York, Dutton, 1927.
—— Manito masks. New York, Dutton, 1925.
ANDREWS, Addison F. Lullaby of the Iroquois. Boston, Ditson, 1904.
ANSON, Hugo. Nga Patu-Paiarehe (The children of the mist). New York, Fischer.
—— Rawhiti, a song of the sun. New York, Fischer.

AUSTIN, Mary. The American rhythm; studies and reëxpressions of Amerindian songs. Boston, Houghton Mifflin, 1930.
BARNES, Nellie. American Indian love lyrics. New York, Macmillan, 1925.
—— American Indian verse. Lawrence, Univ. of Kansas, 1921.
BEACH, *Mrs.* H. H. A. From Blackbird Hills. Boston, Schmidt, 1922.

—— An Indian lullaby. Boston, Ditson, 1924.

BLISS, Paul. Mon-dáh-min. Philadelphia, Presser, 1923.

BOTSFORD, Florence H. Botsford collection of folk-songs. Vol. 1. New York, Schirmer, 1922.

BURLEIGH, Cecil. Pow-Wow. New York, Fischer.

BURTON, Frederick R. American primitive music. New York, Dodd Mead, 1909.

BUSCH, Carl. A Chippewa love song. New York, Fischer.

—— A Chippewa lullaby. New York, Fischer.

—— A Chippewa vision. New York, Fischer.

—— Indian legend. Boston, Ditson, 1907.

—— Indian lullaby. Boston, Ditson, 1917.

—— Omaha Indian love song. New York, Fischer.

BYNNER, Witter. Indian earth. New York, Knopf, 1930.

CADMAN, Charles W. The advance of the Amazons. Boston, White-Smith, 1913.

—— Four American Indian songs. Boston, White-Smith, 1909.

—— From the land of the sky blue water. Boston, White-Smith, 1912.

—— From wigwam and tepee. Boston, White-Smith, 1914.

—— Idealized Indian themes for pianoforte. Boston, White-Smith, 1912.

—— An Indian camp. Boston, Ditson, 1907.

—— Indian mountain song. Boston, Ditson, 1909.

—— Indian summer. Boston, Ditson, 1914.

—— Legend of the canyon. Boston, White-Smith, 1920.

—— Little papoose on the windswung bough. Boston, Ditson, 1908.

—— Prairie night. Boston, Ditson, 1928.

—— The prayer of the great chief. Boston, White-Smith, 1929.

—— The robin woman. Boston, White-Smith, 1918.

—— The sunset trail. Boston, White-Smith, 1920.

—— Thunderbird. Boston, White-Smith, 1917.

—— The thunder god's child. Boston, White-Smith, 1923.

—— Wah wah taysee. Boston, White Smith, 1911.

CARDIN, Fred. Cree war dance. New York, Fischer.

CONVERSE. Frederick S. The peace pipe. Boston, Birchard, 1915.

CRONYN, George W. The path on the rainbow . . . with an introduction by Mary Austin. New York, Boni and Liveright, 1918.

CURTIS, Natalie. The Indians' book. New York, Harper, 1907.

—— Victory song. New York, Schirmer, 1920.

DEHUFF, Elizabeth W. *and* GRUNN, Homer. From desert and pueblo. Boston, Ditson, 1924.

DE LEONE, Francesco B. When day is done. Boston, Ditson, 1929.

DELOETZ, P. Indian ride. New York, Fischer.

DENSMORE, Frances. The American Indians and their music. New York, Woman's Press, 1926.

—— Handbook of the collection of musical instruments in the United States National Museum. Washington, Smithsonian Institution, 1927.

—— Indian action songs. Boston, Birchard, 1921.

—— Mandan and Hidatsa music. Washington, Bureau American Ethnology, 1923.

—— Northern Ute music. Washington, Bureau American Ethnology, 1922.

—— Pawnee music. Washington, Bureau American Ethnology, 1929.

DOBSON, E. Aldrich. Papoose. Boston, Schmidt, 1930.

—— Song of the wilderness hosts. Boston, Schmidt, 1926.

—— Sons of Manitou. Boston, Schmidt, 1925.

DVORAK, Anton. Indian lament. New York, Fischer.

FARWELL, Arthur. American Indian melodies. New York, Schirmer, 1901.

—— Dark her lodge door. Boston, Ditson, 1927.

FLETCHER, Alice C. Indian games and dances with native songs. Boston, Birchard, 1915.

—— Indian story and song from North America. Boston, Small, 1900.

—— Music and musical instruments. Washington, G. P. O., 1912.

—— *and* LA FLESCHE, Francis. Omaha Indian music. Cambridge, Peabody Museum, 1893.

FLETCHER, Percy E. The bridal of Weetamoo. Boston, Ditson, 1929.

GILMAN, Benjamin I. Hopi songs. Boston, Houghton Mifflin, 1908.

GORDON, Dorothy. Sing it yourself. New York, Dutton, 1928.

GORDON, W. H. Indian campaign. New York, Fischer.

GRANT-SCHAEFER, G. A. Night wind's message. Boston, Schmidt, 1928.

GRUNN, Homer. Desert suite. New York, Fischer.

—— Indian lament. Boston, Ditson, 1922.

—— Indian nocturne. New York, Fischer.

—— In the lodges of the Sioux. Boston, Ditson, 1924.

—— Toúaloúwa. Boston, Ditson, 1913.

—— Zuñi impressions. Boston, Boston Music Co., 1917.

—— Zuñi Indian suite. I, II. Boston, Boston Music Co., 1921.

GUION, David W. Hopi Indian cradle song. New York, Boosey, 1917.

HAMBLEN, Bernard. Crying water. New York, Boosey, 1925.

HEN-TOH. Yon-doo-shah-we-ah. Oklahoma City, Harlow, 1924.

HERMAN, A. Tomahawk dance. New York, Fischer.

JEANÇON, Jean Allard. Indian song book. Denver, Colo., Denver Allied Arts, n.d.

JOHNSON, Lee. Ramona. New York, Fischer.

KLEMM, Gustave. Indian lullaby. New York, Fischer.

LAKE, M. L. Indian love song. New York, Fischer.

LAWSON, Roberta C. Indian music programs. Nowata, author, 1926.

LEHMER, Derrick N. Down the stream and other Indian songs. Berkeley, Calif., author, 1927.
—— Indian camp fire songs. Berkeley, Calif., author, 1930.
—— Indian songs from the Northland. Berkeley, Calif., author, 1931.
—— Music for Indian mask. Berkeley, Calif., author.
—— Seven songs from the Yosemite Valley. Berkeley, Calif., author, 1924.
—— Two Indian choruses. Berkeley, Calif., author.
LESTER, William. Se-a-wan-a. Boston, Ditson, 1921.
—— Trail to the Shadowland. New York, Fischer.
LIEURANCE, Thurlow. Aooah. Philadelphia, Presser, 1913.
—— At the foot of the mound. Philadelphia, Presser, 1917.
—— At the sundown. Philadelphia, Presser, 1915.
—— By the waters of Minnetonka. Philadelphia, Presser, 1921.
—— By the weeping waters. Philadelphia, Presser, 1916.
—— Canoe song. Philadelphia, Presser, 1920.
—— Chant of the corn grinders. Philadelphia, Presser, 1925.
—— Drama from the Yellowstone. Philadelphia, Presser, 1921.
—— Dying moon flower. Philadelphia, Presser, 1919.
—— Far off I see a paddle flash. Philadelphia, Presser, 1923.
—— From Ghost Dance Canyon. Philadelphia, Presser, 1921.
—— From an Indian village. Philadelphia, Presser, 1919.
—— Ghost pipes. Philadelphia, Presser, 1923.
—— A gray wood dove is calling. Philadelphia, Presser, 1923.
—— Her blanket. Philadelphia, Presser, 1913.
—— Hymn to the sun god. Philadelphia, Presser, 1917.
—— Indian flute call and love song. Philadelphia, Presser, 1914.
—— Indian love songs. Philadelphia, Presser, 1925.
—— Indian melodies. Philadelphia, Presser, n.d.
—— Indian songs. Philadelphia, Presser, 1913.
—— Indian spring bird. Philadelphia, Presser, 1920.
—— In mirrored waters. Philadelphia, Presser, 1918.
—— In my bark canoe. Philadelphia, Presser, 1923.
—— I sing in my heart at the weaving. Philadelphia, Presser, 1925.
—— Love song, from the Red Willow Pueblos. Philadelphia, Presser, 1913.
—— Lullaby. Philadelphia, Presser, 1913.
—— My silver-throated fawn. Philadelphia, Presser, 1913.
—— Neenah. Philadelphia, Presser, 1926.
—— On Cherry Hill. Philadelphia, Presser, 1923.
—— The owl hoots on a tepee pole. Philadelphia, Presser, 1926.

—— Pakoble. Philadelphia, Presser, 1913.
—— Pa-pup-ooh. Philadelphia, Presser, 1913.
—— Rainbow land. Philadelphia, Presser, 1916.
—— The red birds sing o'er the crystal spring. Philadelphia, Presser, 1917.
—— A rose on an Indian grave. Philadelphia, Presser, 1919.
—— Rue, a Pueblo love song. Philadelphia, Presser, 1920.
—— The sacrifice. Philadelphia, Presser, 1915.
—— Sa-ma-wee-no. Philadelphia, Presser, 1924.
—— She stands there smiling. Philadelphia, Presser, 1925.
—— Sioux Indian fantasie. Philadelphia, Presser, 1921.
—— A Sioux maiden's dream. Philadelphia, Presser, 1924.
—— A Sioux serenade. Philadelphia, Presser, 1916.
—— Songs of the North American Indian. Philadelphia, Presser, 1920.
—— The spirit of Wanna. Philadelphia, Presser, 1919.
—— Spring song of the Crow. Philadelphia, Presser, 1926.
—— To a ghost flower. Philadelphia, Presser, 1926.
—— Two hundred years ago in Santa Fe. Philadelphia, Presser, 1921.
—— Wasté wala ka kelo. Philadelphia, Presser, 1923.
—— The weaver. Philadelphia, Presser, 1913.
—— Where cedars rise. Philadelphia, Presser, 1921.
—— Where the papoose swings. Philadelphia, Presser, 1918.
—— Winnebago lament. Philadelphia, Presser, 1924.
—— Wi-um. Philadelphia, Presser, 1921.
—— Wounded fawn. Philadelphia, Presser, 1919.
—— The year of dry leaves. Philadelphia, Presser, 1922.
—— , CADMAN, Charles W. *and* NEVIN, Arthur. Indian music. Philadelphia, Presser, 1928.
LOOMIS, Harvey W. Laughing water. Boston, Ditson, 1918.
—— Little papoose. Boston, Ditson, 1918.
—— The scalp dance. Boston, Ditson, 1918.
LOSEY, F. H. Minnehaha. New York, Fischer.
MACDOWELL, Edward. From an Indian lodge. Boston, Schmidt, 1896.
—— Indian idyl. Boston, Schmidt, 1902.
—— Second Indian suite. New York, Associated Music Publishers, 1910.
METCALF, John W. Jibiwanisi. Boston, Schmidt, 1920.
MILLER, Horace A. Four Indian themes. New York, Associated Music Publishers, 1916.
NEIHARDT, John G. The song of the Indian wars. New York, Macmillan, 1928.
OREM, Preston W. American Indian rhapsody. Philadelphia, Presser, 1918.
ORTH, Carl. Indian chief. Boston, Ditson, 1914.
—— Winniwawa. Boston, Ditson, 1913.
PALMER, Winthrop B. American songs for children. New York, Macmillan, 1931.

216

POCHON, Alfred. Indian suite. New York, Fischer.

ROBERTS, Helen H. *and* JENNESS, D. Songs of the Copper Eskimos. Ottawa, Canadian Arctic Expedition, 1925.

SEVERN, Edmund. In picture land. New York, Fischer.

—— A wild Indian. New York, Fischer.

SHOEMAKER, Henry W. Pennsylvania Indian folk-songs. [Philadelphia, McGirr.]

SKILTON, Charles S. Deer dance. New York, Fischer.

—— Kickapoo social dance. New York, Fischer.

—— Muckwa the bear. New York, Fischer.

—— Sioux flute serenade. New York, Fischer.

—— Suite primeval on tribal Indian melodies. New York, Fischer.

—— Three Indian sketches. New York, Fischer.

—— Two Indian dances. New York, Fischer.

—— War dance. New York, Fischer.

—— We leave the winds to tell. New York, Fischer.

SPECK, Frank G. Ceremonial songs of the Creek and Yuchi Indians. Philadelphia, University Museum, 1911.

STEWART, H. J. Legends of Yosemite in song and story. Boston, White-Smith, 1910.

—— Spirit of the evil wind. Boston, White-Smith, 1910.

STRICKLEN, E. G. Notes on eight Papago songs. Berkeley, Univ. of California Press, 1923.

THALBITZER, William. Eskimoiske digte fra Ostgrönland. Köbenhavn, Aschehoug, 1920.

—— Melodies from East Greenland. Greenland, Godthaab Printing House, 1931.

—— Poetry of the East Greenlanders, the East Greenland texts translated into West Greenlandic in collaboration with Jonathan Petersen, Julius Olsen and Henrik Lund. Greenland, Godthaab Printing House, 1931.

TITUS, Maude E. A treatise on American Indian music. Indianapolis, author, 1920.

TROYER, Carlos. The coming of Montezuma. Philadelphia, Presser, 1904.

—— The festive sun dance of the Zuñis. Philadelphia, Presser, 1904.

—— Ghost dance of the Zuñis. Philadelphia, Presser, 1904.

—— The great rain dance of the Zuñis. Philadelphia, Presser, 1904.

—— Hymn to the sun. Philadelphia, Presser, 1909.

—— Incantation upon a sleeping infant. Philadelphia, Presser, 1907.

—— Indian fire drill song. Philadelphia, Presser, 1907.

—— Indian music lecture. Philadelphia, Presser, 1913.

—— Invocation to the sun-god. Philadelphia, Presser, 1904.

—— Kiowa Apache war dance. Philadelphia, Presser, 1907.

—— The sunrise call. Philadelphia, Presser, 1904.

—— Sunset song. Philadelphia, Presser, 1912.

—— Zuñian ("Kor-kok-shi") clown dance. Philadelphia, Presser, 1913.

—— Zuñi lover's wooing. Philadelphia, Presser, 1904.

TSIANINA. The chattering brook. Boston, White-Smith, 1925.

UNTERMEYER, Louis. American poetry from the beginning to Whitman. New York, Harcourt, 1931.

WALTON, Eda L. Dawn Boy . . . with an introduction by Witter Bynner. New York, Dutton, 1926.

WHITELEY, Bessie M. Hiawatha's childhood. Boston, Birchard, 1914.

WOOD, Clement. Hunters of heaven. New York, Stokes, 1929.

The Rio Grande Press, Inc.,

has published the following titles on the

Arts and Crafts

of the

AMERICAN INDIAN

1. Amsden, Charles Avery	*Navaho Weaving, its Technique and History*	$12.00
2. Barrett, S.A.	*Pomo Indian Basketry*	$10.00
3. Bourke, John Gregory	*Medicine Men of the Apaches*	$15.00
4. Cremony, John C.	*Life Among the Apaches*	$10.00
5. Fewkes, Jesse Walter	*Hopi Katcinas Drawn by Native Artists*	$15.00
6. Howbert, Irving	*Indians of the Pikes Peak Region*	$ 7.50
7. James, George Wharton	*Indian Basketry, and How to Make Baskets*	$10.00
8. James, George Wharton	*Indian Blankets and Their Makers*	$25.00
9. James, H. L. (New Title)	*Acoma, People of the White Rock*	$10.00
10. LaFarge, Oliver (and others)	*Introduction to American Indian Art*	$10.00
11. Mason, Otis Tufton	*Aboriginal American (Indian) Basketry*	$25.00
12. Matthews, Washington	*Mountain Chant of the Navajo Indians*	$15.00
13. Reichard, Gladys Amanda	*Navajo Shepherd and Weaver*	$ 8.00
14. Reichard, Gladys Amanda	*Spider Woman*	$ 8.00
15. Stevenson, Matilda C.	*The Zuni Indians, BAE Report No. 23*	$25.00

219

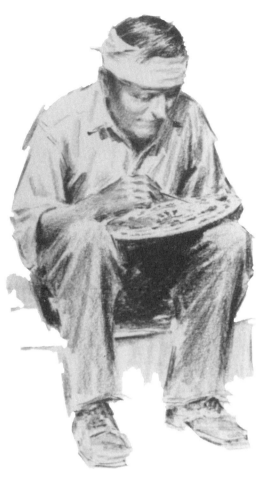

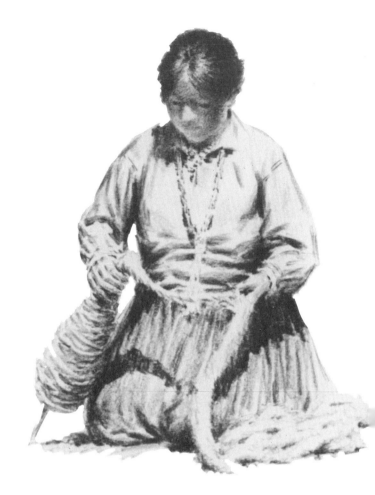

DONALD MILLS

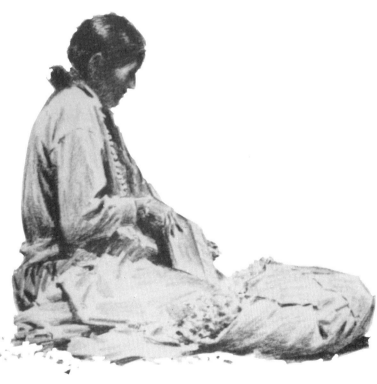

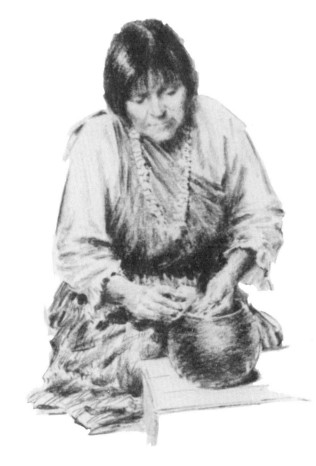